Romanesque & Gothic

Romanesque
& Gothic

Gloria Fossi

Romanesque & Gothic

STERLING

New York / London
www.sterlingpublishing.com

Translated from the Italian by Angela Arnone

STERLING and the distinctive Sterling logo are registered
trademarks of Sterling Publishing Co., Inc.

Library of Congress Cataloging-in-Publication Data

Fossi, Gloria.
 [Romanico e gotico. English]
 Romanesque and gothic / Gloria Fossi.
 p. cm.
 Includes bibliographical references and index.
 ISBN 978-1-4027-5924-6
 1. Art, Romanesque. 2. Art, Gothic I. Title. II. Title: Romanesque & gothic.
 N6280.F6513 2008
 709.02'16--dc22
 2008018512

1 0 9 8 7 6 5 4 3 2 1

Original Italian edition *Romanico e Gotico* by Gloria Fossi
Published by Giunti Editore S.p.A.
© 2005 by Giunti Editore S.p.A., Florence-Milan, Italy
www.giunti.it

English translation published by Sterling Publishing Co., Inc.
387 Park Avenue South, New York, NY 10016
© 2008 by Sterling Publishing Co., Inc.
Distributed in Canada by Sterling Publishing
C/o Canadian Manda Group, 165 Dufferin Street
Toronto, Ontario, Canada M6K 3H6
Distributed in the United Kingdom by GMC Distribution Services
Castle Place, 166 High Street, Lewes, East Sussex, England BN7 1XU
Distributed in Australia by Capricorn Link (Australia) Pty. Ltd.
P.O. Box 704, Windsor, NSW 2756, Australia

Printed in China
All rights reserved

Sterling ISBN 978-1-4027-5924-6

For information about custom editions, special sales, premium and
corporate purchases, please contact Sterling Special Sales
Department at 800-805-5489 or specialsales@sterlingpublishing.com.

Italian edition: Project Manager, Gloria Fossi; Graphics, Lorenzo Pacini; Layout, Lorenzo Pacini,
Elisabet Ribera; Indexes, Maria Lucrezia Galleschi; Iconographical Research, Cristina Reggioli.

Romanesque 6

Romanesque: Meaning of the Term 8
A Pure White Mantle of Churches 10

Romanesque:
Key Figures, Artists, and Artworks 23

 Buscheto 24
 Bernardo Gilduino 26
 Lanfranco 28
 Vuiligelmo 30
 Gislebertus 32
 Gerlachus 34
 Roberto and Nicodemo 35
 The Cabestany Master 36
 Guglielmo 38
 Bonanno Pisano 39
 Master Mateo 40
 Nicolaus de Verdun 42
 Benedetto Antelami 44

The Romanesque Period:
Styles, Arts, and Techniques 47

Churches on a Grand Scale for Pilgrims 48
The Road to Santiago and Beyond 50
The Roads to Saint Michael the Archangel 52
The Marvels of the City of Rome 54
The Sumptuary Arts 56
Forms and Techniques 58
Ivories 60
The Art of Bronze Craft 62
Wood Sculpture 64
Mosaics 66
Wooden Ceilings and Panel Paintings 68
Wall Paintings 70
The Painter and the Miniaturist 72
A World in Miniature 74
Typologies and Techniques 76
The World in Sculpture 78
Sculpture in the Service of the Faith:
 The Great Masterpieces 80
Ornamental Sculpture 82
Precious Facades 84
Cupolas and Towers 86
Narthexes, Porticoes, Portals, and Porches 88
Church Morphology 90
Supporting Structures 92
Fortresses, Castles, and Stave Churches 94

Gothic 96

A "Torrent" of Light 98
The Smile that Triumphed 106
Gothic: The Origin of the Word 110
Italianate, "Latinized" Gothic 119
Artistic Culture in the Time of Frederick II 126
The Figurative Vision 128

Gothic:
Key Figures, Artists, and Artworks 135

 Nicola and Giovanni Pisano 136
 Arnolfo di Cambio 138
 Pietro Cavallini 140
 Cimabue 142
 Duccio di Buoninsegna 146
 Giotto 150
 Simone Martini 154
 Pietro and Ambrogio Lorenzetti 158
 Andrea di Cione (L'Orcagna) 162
 Buonamico Buffalmacco 164
 Giottino (Giotto di Maestro Stefano) 166
 Tino di Camaino 167
 Spinello Aretino 168
 Altichiero 169
 Lorenzo Maitani 170
 Melchior Broederlam 171
 Claus Sluter 172
 Jaime and Pedro (or Pere) Serra 174
 Lluís Borrassà 175

The Gothic Period:
Styles, Arts, and Techniques 177

Life and Death in the City 178
Schools of Painting and Miniatures 180
International Gothic 182

Bibliography 184
Index of Names 188
Index of Places 189
Photographs 192

Romanesque

Romanesque

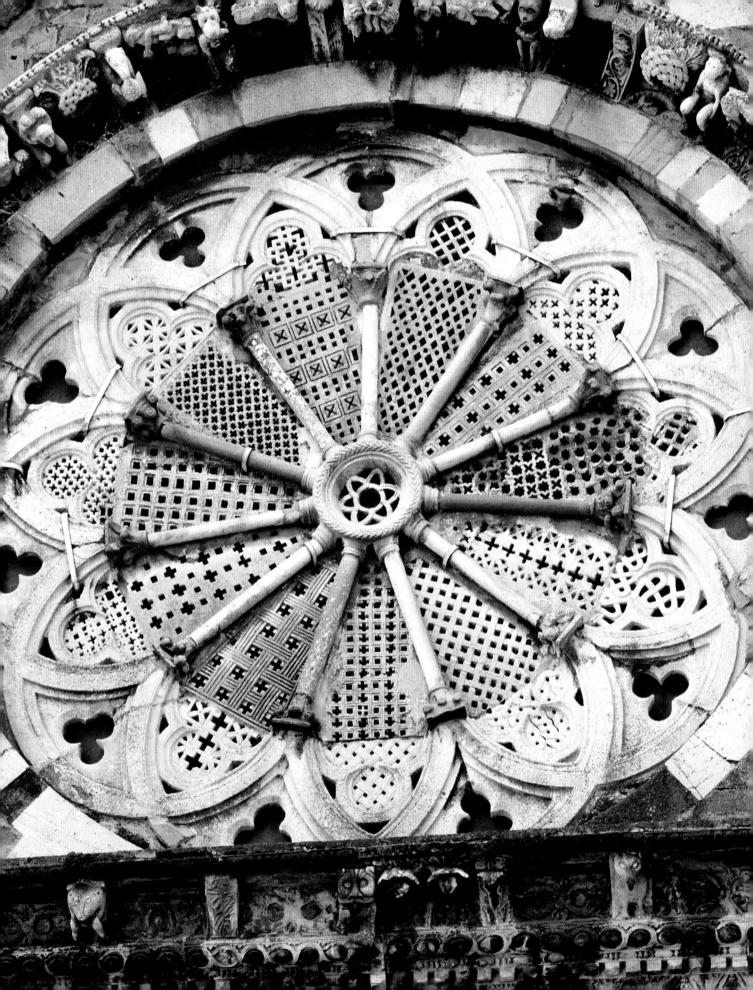

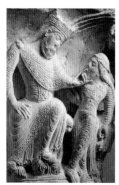

Gilabertus
Herod and Salome
detail of a capital
illustrating the stories
of Salome and John the
Baptist, from the Saint-
Etienne church cloister,
c. 1120–40, stone.
Toulouse
(Haute-Garonne),
Musée des Augustins.

Right:
Abbey church and convent
mid-eleventh century
(monks' quarters
restructured at later dates).
Saint Martin du Canigou
(Pyrénées Orientales).

Previous page:
Rose window
mid-twelfth century,
facade detail.
Troia (Foggia), cathedral
of Santa Maria Assunta.

Romanesque: Meaning of the Term

A king on his throne, his robe brushing up against a refined lion's-head armrest. He leans towards a young woman, and cups (or perhaps caresses) her chin with his hand, in a gesture that is both imperious and tender. This is a lesser known detail, but also one of the most elevated and expressive of Toulouse Romanesque sculpture; but there is more: Encapsulated in these interlocked gazes is the intense synopsis of the episode of Salome in the presence of Herod. It can be seen on the edge of a capital, a fragment on display at the Toulouse Museum in Languedoc, sculpted by *Gilabertus, vir non incertus,* as this great artist signs himself elsewhere.

A hilltop monastery, a church with a pitched roof, stone apses with simple decoration, a belfry that resembles a castle tower, the silent atmosphere of a cloister, an open gallery of slim-columned capitals that faces sheer onto a spectacular view: These delights await us as we climb up to Saint Martin du Canigou, in the Eastern Pyrénées, bordering on Spanish Catalonia. A country road, the ruins of an abbey, massive structures, crumbling galleries and arches, Nature reclaiming land once built upon: we are among the remains of Notre Dame de Jumièges, in Normandy. The wall of a facade, pale stones alternating with pink-hued bricks, in a color contrast enhanced by majolica-tiled domes of Islamic origin and the marble relief of a peacock, the symbol of Christ. Long ribbons skirting walls, decorated with animals and monks entwined with leaf volutes. Here we have Pomposa Abbey, on the Po Plain, near Ferrara.

Lovers of Romanesque art will retain memories of many images similar to these; nonetheless, we should debunk the romantic myth of "picturesque Romanesque" or, worse still, one that is "primitive" and severe, that has endured since at least the nineteenth century and which is difficult to uproot, like all clichés. Romanesque is characterized by a myriad of expressions: a country church, a magnificent cathedral, bare stone that covers the simplest of structures or, equally, "figured" facades, sumptuously sculpted like precious caskets. In actual fact, real precious caskets were produced in this multifaceted era, so dense with creativity, and which has bequeathed to us gold and silver jeweled and

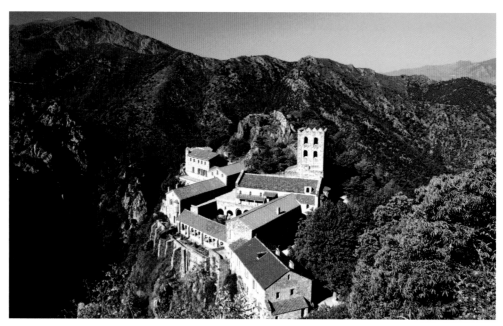

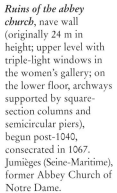

Ruins of the abbey church, nave wall (originally 24 m in height; upper level with triple-light windows in the women's gallery; on the lower floor, archways supported by square-section columns and semicircular piers), begun post-1040, consecrated in 1067. Jumièges (Seine-Maritime), former Abbey Church of Notre Dame.

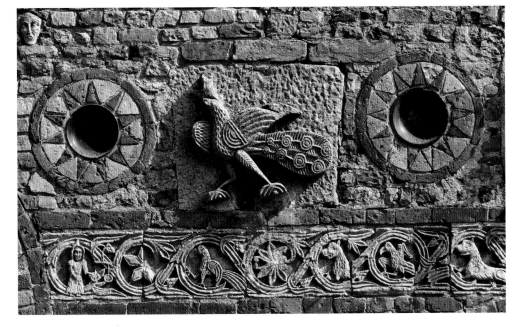

Polychrome majolica basins and bas reliefs atrium detail, first half of the eleventh century, marble, brick, stone and terracotta. Pomposa (Ferrara), abbey church of Santa Maria.

Master Matteo of Pisa
Lunette with eagle,
acanthus leaf frieze and
architrave depicting
Meleagris hunting
1173–77, stone lunette,
marble architrave,
inspired by an ancient
sarcophagus depicting
the *Caledones boar hunt*
(*Imagines*, Philostrates
the Younger, 15).
Campiglia Marittima
(Livorno), Pieve di San
Giovanni, side portal.

enameled reliquaries, as well as refined ivories. Not to mention portals, tympanums, architraves, capitals, pulpits, and telamons; sculptures in marble, bronze, alabaster, wood; altarpieces and crucifixes on panels; miniature codices; stained glass; and frescoes. Numerous influences: Carolingian, Ottonian, Byzantine, Islamic, and the ancient world also, evident chiefly in architrave and altar bas-reliefs. We might risk a paradox: that Romanesque is not a single style, but an infinity of styles, tried out over the two hundred years that span the eleventh and twelfth centuries. Romanesque (from the Late Latin *romanicus*, derived from the classical *romanus*, "Roman," in contrast to *gothicus*), is by now an outdated term. It was coined by Norman archeologists Gerville and Le Prévost in 1819, to identify a figurative culture that had replaced the ancient civilization and that later flourished with shared characteristics in countries speaking the new Romance idioms that had replaced Latin. Although there is no doubt that Romanesque art and Romance languages developed more or less in parallel, today we tend

to assess the new style's genesis and evolution under different aspects.

A Pure White Mantle of Churches

The beginnings of this noble civilization are generally dated to the early eleventh century, to the period when historians perceive that the signs of healthy demographic recovery associated with the renewal of agriculture, trade, and overseas traffic, and consequently of significant economic growth. Building techniques progressed in leaps and bounds thanks to the implementation of watermills, perfecting of animal harnessing, and the more frequent use of iron. The use of shaped stone, for instance, made for significant innovations to vaults and arches. The "rebirth" of towns also played a significant contribution to the progressive intensification of the arts and architecture, which came in step with the enormous expansion of Benedictine monasticism, and in the wake of influential monasteries like Montecassino in Southern Italy, "the wonder of the West," and Cluny Abbey in Burgundy

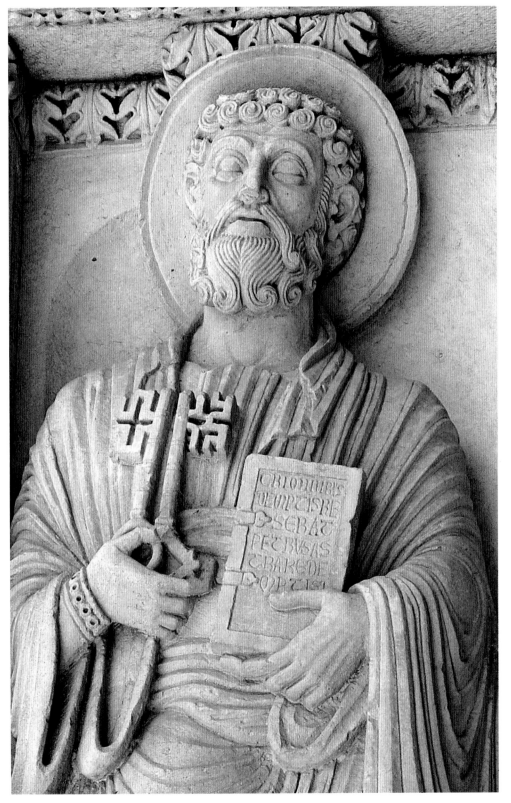

Provencal artist
Saint Peter
detail of the full-figure
statue of the apostle,
in the left niche of
the facade portal
post-1150, stone.
Arles
(Bouches-du-Rhône),
Saint-Trophime.

Aisle vault in the church's lengthwise block begun post-1125. Poitiers (Vienne), Notre Dame la Grande.

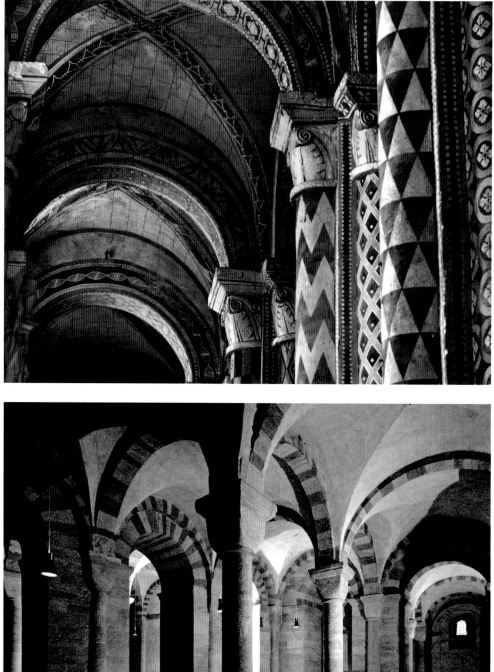

Ottonian era crypt first half of the eleventh century (begun under Abbot Bernward in 1010, finished in 1033), dado capitals, alternating pale and red stone arches. Hildesheim (Lower Saxony), abbey church of Saint Michael.

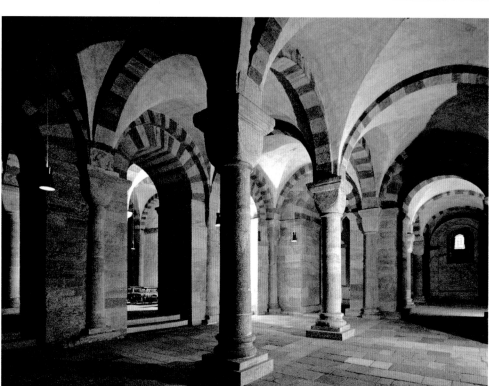

(destiny decreeing, tragically, that both would later be destroyed). In the history of Romanesque art, the most noteworthy figures were the abbots of Cluny, "certainly not as the inventors of a morphology and a style with deeper roots, but as its organizers," in the words of Henri Focillon, a pioneer of Romanesque studies. Cluny was a truly powerful Benedictine monastery, connected directly to the Holy See, and had actually been at the forefront of the reform of the Order, undertaking planning of itineraries for pilgrims headed for Santiago de Compostela, lining the routes with churches and monasteries installed with hostels and guest quarters, so that stopovers were an obligatory part of the pilgrimage, and thereby increasing sites of worship. This massive mobility of people and ideas, linked not only to the worship of Saint James the Great in Galicia, but also to the Crusades, the veneration of other sites of Christianity (including Jerusalem), and a general

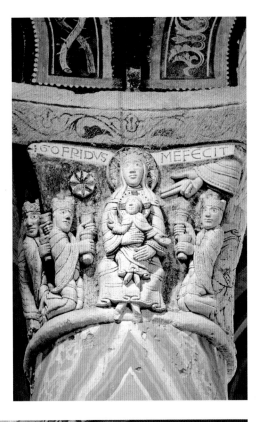

Gofridus
Adoration and Offering of the Magi
mid-twelfth century, detail from the polychrome stone capital, signed by its maker: GOFRIDVS ME FECIT.
Chauvigny (Vienne), collegiate church of Saint Pierre, capital on the sixth central ambulatory, east choir.

13

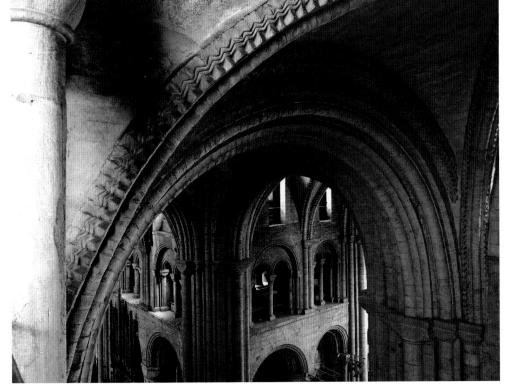

View from the clerestory of the women's galleries and the vaults spanning the transept intersection
1153–95.
Durham Cathedral (County Durham), (see also enlarged illustration on page 46).

Islamic workshop of Palermo
Roger II's coronation cloak
1133–34, gold embroidery on red silk. Vienna, Kunsthistorisches Museum.

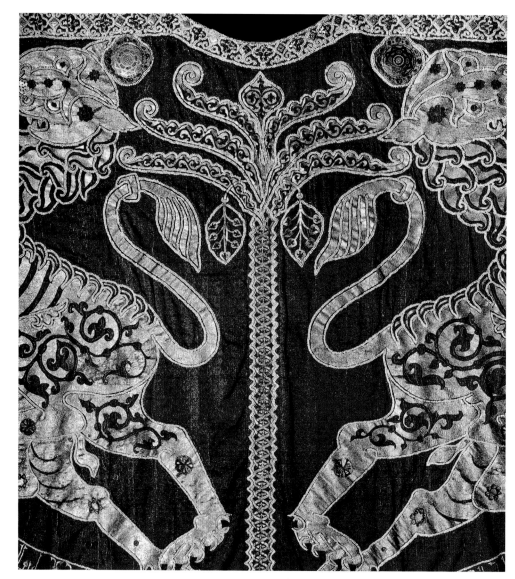

revived interest in relics, certainly fostered the creation of increasingly spacious monuments, and of artistic creations, especially reliquaries, that became progressively more sumptuous. In such works the various cultural contributions often seem to cross regional confines, even those of western culture. For instance, the "Moorish" traces in Spanish art are clear, as is the widespread penetration of Arab artistic culture in Norman Sicily. In any case, much of what we know is somehow linked to the religious sphere and very little secular material survives, especially civilian monuments and fortified

settlements. Nevertheless, there are small objects, which we will see were probably commissioned by lay patrons: a number of chess pieces in ivory, fragments of embroidered fabrics, tapestries like the great Bayeux work, which depicted scenes of war—the Norman conquest of England in 1066— even though intended to be shown in church on religious feast days, and found precisely under the flooring of Bayeux cathedral, in Normandy. On the other hand, all that is left to us of the unique mosaic floor in the apartments of the Countess of Blois is a description that tells us it depicted a sort of lively

Castilian artist (?)
Crozier crook of
Saint Julian de Cuenca
twelfth century, gold and enamel.
Cuenca (Castile La Mancha),
Museo Diocesano Catedralicio.

Norman manufacture
Bayeux tapestry
1077–82, detail, wool
embroidery on linen.
Bayeux (Calvados),
Musée de la Tapisserie.

Aragonese Stonework
Angel Waking a Magi
1094–1100, capital detail,
stone.
Jaca (Aragon),
San Pedro Cathedral
cloister.

(symbolic) geographical map of the world. In a word, it seems that over two centuries, it was mainly churches and monasteries that were built or renovated, in their thousands, across a vast area that included Scandinavia, Britain, the Iberian peninsula, France, and the territories that nowadays we know as Germany, Austria, and Switzerland, also embracing the Slav belt and all Italian regions and islands. We might also wonder how it was possible to create such elaborate artworks and erect such daring buildings, almost in emulation of Roman architecture, in an era where material scarcity must have existed, despite the technical progress we have mentioned. This "rebirth" was often described in the fascinating narration of the eleventh-century Burgundian chronicler, Ralph Glaber (*Glaber Rodulfus*): "As the third year after the year 1000 drew nigh, restoration and renovation of churches were undertaken almost all over the world, and above all in Italy and in Gaul; although most were well-built and required no restoration, a true spirit of emulation was driving every Christian community to make its church more sumptuous than that of its neighbors. It seemed almost as if the world itself were shrugging off the relics of age and garbing itself with a white mantle of churches. Thus, almost all the churches of the episcopal sees, those of monasteries consecrated to all manner of saints, and even small village oratories, were rebuilt to be more beautiful by the devout."

"A white mantle of churches" that cloaked all of western Christendom, at the dawn of the second millennium: It is not easy to set aside the fine metaphor when introducing the reader to the Romanesque world. Ralph Glaber, who died at Cluny in about 1050, was actually referring to this

Romanesque A Pure White Mantle of Churches

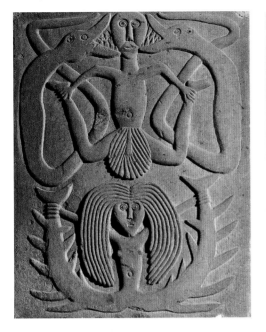

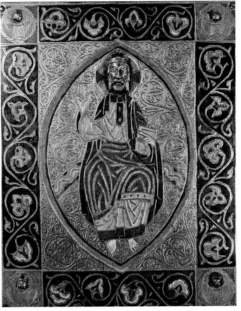

Left:
Tuscan artist
*Man in skirt attacked
by serpents and siren
with forked tail*
detail from a
pulpit panel,
end of the twelfth
century, sandstone.
Gropina (Arezzo),
Pieve di San Pietro.

Right:
Limoges art
Christ in Majesty
pre-1150, champlevé
plaque on gilt, engraved
background.
Madrid, Museo
Fundación Lázaro
Galdiano.

"awakening" in his not very reliable history of the world covering the period 900–1045, in contrast to the apocalyptic visions that were to precede the arrival of 1000: an interpretation that created quite a number of clichés about the millenary theories that were to terrorize and paralyze the entire Christian community of the western world as the new era drew nigh. The imagery of "a white mantle of churches" was fascinating, even though we should not interpret it in a literal sense: Cathedrals were not always white and neither were the sculptures, the capitals, or the ambos. Recent research and restoration in various regions, even quite far apart, pointed to a definite partiality to brightly colored decoration of reds, blues, and greens. These were not just architectural constructions with painted plasterwork (sometimes creating a sort of trompe l'oeil effect of faux brickwork to suggest the stones under the plaster), or colored capitals, like those in Vienne, but also "unexpectedly multicolored" tympanums like those of Conques, Lausanne, Ferrara, and Verona, to mention just some of the most significant examples. In this context we are better able to understand Bernard de Clairvaux's invective

against excessive decoration. From 1112, Bernard was Abbot of Citeaux, and he later founded the monastery of Clairvaux; he was considered the driving force behind the establishment of the Cistercian movement, established in the early twelfth century and approved by the Pope in 1119, in order to promote austerity and oppose the "lavish style" of Cluny. So, let us listen to Bernard's heartfelt words in his apologia to William, Abbot of Saint Thierry, written in 1124: "What are those ridiculous monsters, bizarre deformed beauties, and wondrous deformities doing in cloisters, in sight of studying monks? What is the meaning of those sordid monkeys, ferocious lions, strange centaurs who are only half man, those tigers covered in stripes, those battling horsemen, those hunters blowing hard into their horns? Here we see bodies under just one head and there, heads for just one body. Here there is a four-legged beast with a serpent's tail; there, a fish with a beast's tail. Or here the front of a horse with a goat's rear half, an animal with horns that ends in a horse's hindquarters. The diversities in these forms are surprising and rich, and so manifold and marvelous that it becomes more satisfying

to decipher the marbles than to read the manuscripts, and the day passes in the contemplation of these curiosities, one by one, rather than reflection on God's laws." Bernard's invective confirms that the grandeur and magnificence of the Benedictine surroundings must have been truly astonishing. And there is more. The concept of the eternal meaning of ancient Rome was already emerging, and the intellectual "recovery" of the classical world, formerly only seen in Ottonian Germany, was slowly arriving. One of the main artificers of this revival was certainly Desiderius, Abbot of Montecassino from 1058 to 1086, who was later crowned Pope Victor III. His receptiveness to the ancient world was such that it forged an overwhelming "intellectual ascendant," comparable only with that of Abbot Suger of Saint Denis (c. 1081–1151), which came soon after, and to that of the philosophical "spearhead movement" led by the episcopal school of Chartres. The latter's daring defense of the study of the classics thwarted ecclesiastical discomfiture with the pagan world and was then defined as "protohumanism" or the "twelfth-century rebirth." We also know that Desiderius and Suger purchased ancient marbles and fragments in Rome to be used in the new buildings for their monasteries. They already viewed

Southern mosaicist
Serpent, opus sectile
mosaic floor detail,
end of the eleventh–early
twelfth century, various
types of marble.
San Demetrio Corone
(Cosenza, Calabria).

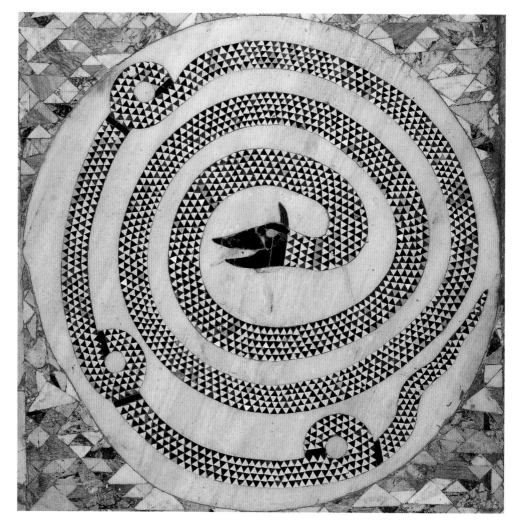

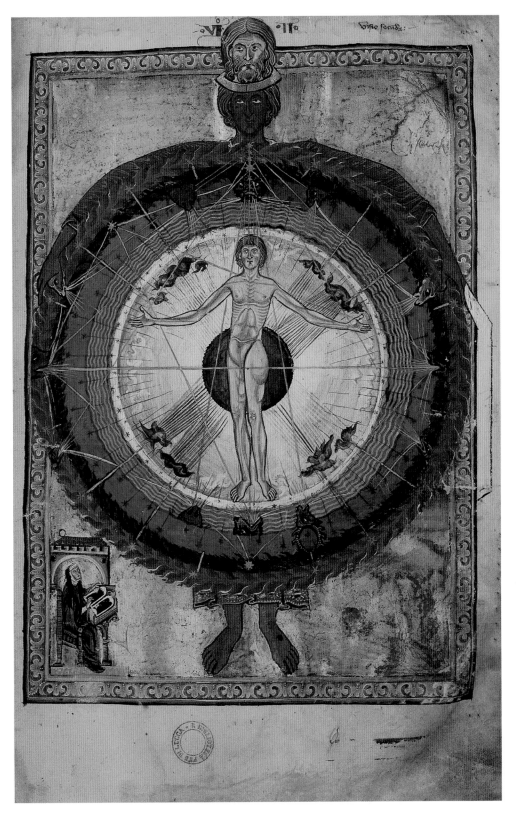

Southern German miniaturist
Man in the Circle of Cosmic Powers
illuminated page from the *Sancte Hildegardis Revelationes,* written in 1163, manuscript of c. 1230.
Lucca, Biblioteca Statale, *Liber Divinorum Operum*, ms. 1942, c. 9r.

Rome and its vestiges, despite its state of ruin, as *sub specie aeternitatis*. This is perhaps the perspective for considering the classical style of the churches of Arles and Saint Gilles, in Provence, a region littered with Roman ruins, as well as the sublime abstraction of the marble intarsia of San Miniato al Monte in Florence, which is also steeped in the Neoplatonic philosophies of Saint Peter Damian. Then we have the recovery of ancient epigraphic models from the plaques in Salerno Cathedral, commissioned in 1070 by the erudite Bishop Alfano, a scholar of classical texts, as well as those on the facade of the duomo in Pisa, a city that was flourishing at that time, and whose political policies most definitely aimed to emulate ancient Rome. Buscheto, architect of Pisa's marvelous cathedral, was even compared to legendary figures of antiquity and was considered to have excelled them. Moreover, Buscheto remains one of the rare names of Romanesque art to have come down through history (there are no more than forty in the western world, including architects, sculptors, master glaziers, goldsmiths, bronzesmiths, and miniaturists). Romanesque seems to have developed mainly in anonymity, and judging by the scant biographies that have come down to us, as we will now see, it is an art that consists not so much of artisans as of symbols.

Right:
Tuscan marble-worker
Geometrical intarsia
end of the twelfth century, detail of wall finished in green Prato and white Carrara marble. Florence, basilica of San Miniato al Monte.

Facing page top left:
Catalan Stonework
Monstrous animals
twelfth century, cloister capital, stone with polychrome traces. Saint Michel de Cuxa (Pyrénées Orientales).

Top right:
Gofridus
A Man devoured by monsters
mid-twelfth century, stone.
Chauvigny (Vienne).

Facing page bottom:
Franco-Apulian Stonework
Man with crane
central portal archivolt detail, post-1175, stone. Trani (Bari), cathedral of San Nicola Pellegrino.

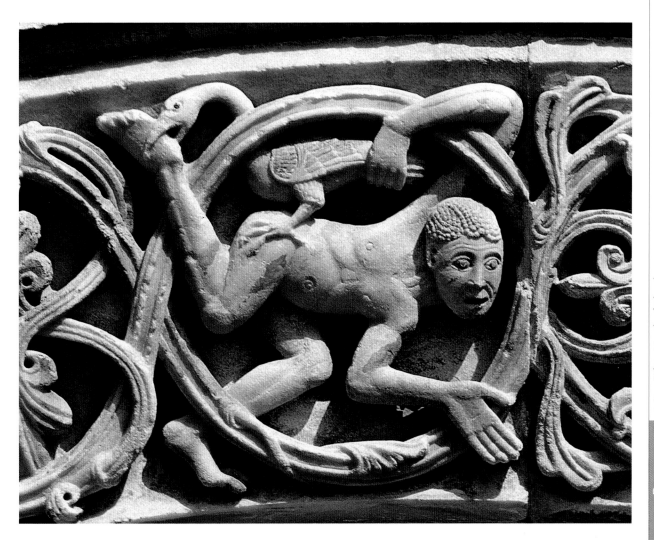

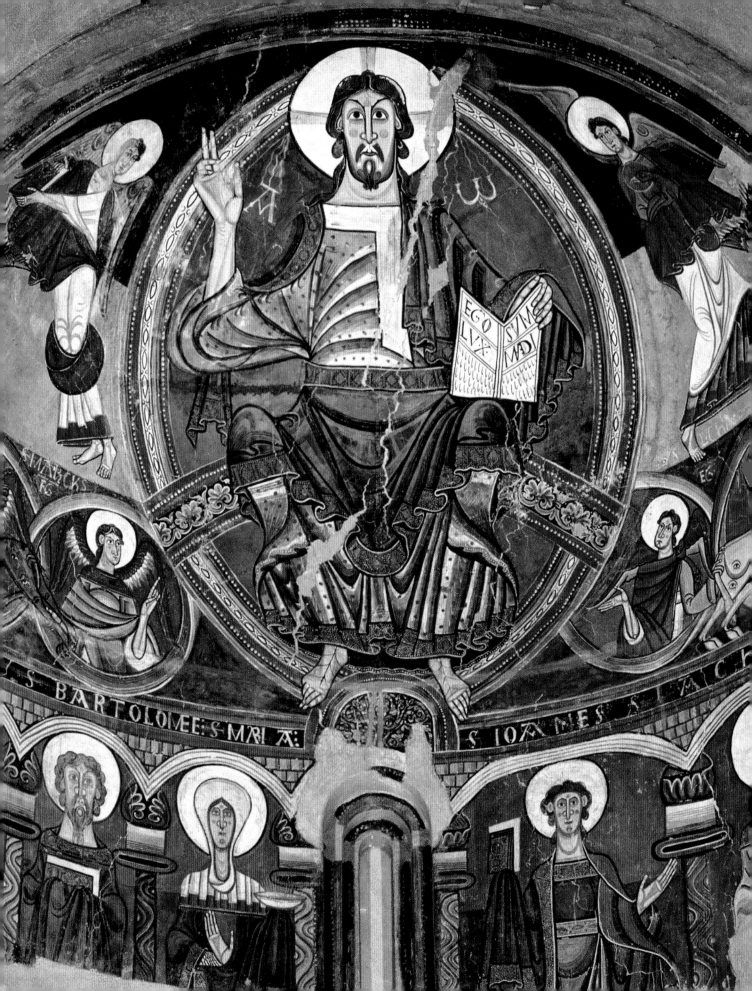

Romanesque:
Key Figures, Artists, and Artworks

Catalan master
Christ in Glory with Mary and Apostles
c. 1123, apse fresco from the church of San Clemente
de Tahull (province of Lérida, Cataluña).
Barcelona, Museu d'Art de Catalunya.

*Tomb of the architect Buscheto,
with eulogistic inscription*
end of the eleventh century.
Pisa, Duomo, first arch of lower
facade register.

Buscheto

(documented from 1063–c. 1110, Pisa)

"As astute as Ulysses, as ingenious as Daedalus," the soaring tribute to Buscheto marks his burial place in the facade of Pisa cathedral. He was the designer of that all-marble building (*niveo de marmore templum*) and the first architect whose talent was acknowledged by his contemporaries. As declared by the epigraph on his tomb, a splendid ancient sarcophagus, he invented machines so ingenious that ten girls were able to raise monolithic columns that otherwise required the strength of a thousand oxen. Giovanni Dondi (1375) also wrote that Buscheto became famous in Rome for the machine that allowed ten girls to raise the Vatican obelisk. Legends apart, the ambitious project for a cathedral in Pisa, the completion of the dome and its decorations, derived from knowledge that must have embraced familiarity with various Mediterranean regions. The layout of the basilica and the use of recovered ancient marbles are proof of the intention to emulate ancient Rome.

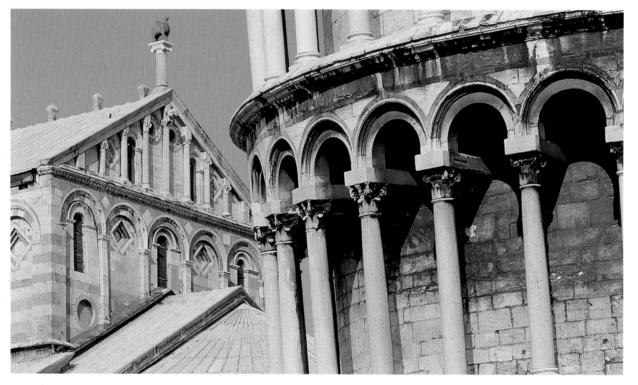

View of Pisa Duomo apse and campanile
end of the eleventh century.

Pisa Cathedral, begun in 1063 following the astounding victory in Palermo against the Saracens, and consecrated in 1118, has virtually no equals in its elevation, in the vastness of its spaces, or the arrangement of its impressive inner colonnade. No other monument in Italy or abroad at that time had been conceived on such a colossal scale (its cupola is 48 m, or 157 feet, high), or with such complex and balanced propor-

tions. Not even Saint Mark's Basilica in Venice, built more or less at the same time, with five cupolas on a Greek cross plan, challenged antiquity so magnificently. Although it was influenced by Islamic monuments and churches of Asia Minor, the Pisan duomo typology, with a nave and four aisles, and an elliptical cupola at the intersection with the transept, which has a nave and two aisles, has independent characteristics, unique in architecture of the time: it was soon to become a prototype for many Romanesque churches on Pisan territory, but also those in Lucca, Pistoia, and as far as Sardinia, at that time ruled by Pisa.

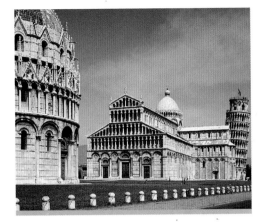

Above:
Pisa, the Duomo and the campanile,
seen from the southwest

Right:
View of the city of Pisa, detail of Saint Nicholas
of Tolentino Protecting the City from the Plague
early fifteenth-century panel.
Pisa, San Nicola.

This painting is one of the first depictions of Pisa,
surrounded by fortifications and tall house towers,
whose rugged walls contrast with the elegant marble
decorations on the duomo and the belfry, the latter
also cadenced by loggettas and arches. The tower
can already be seen to be leaning: Because of con-
structing it on the soft soil, the troublesome building
work extended from 1173 to the first half of the
fourteenth century.

Eulogistic inscription to Rainaldo
early twelfth century, polychrome marble.
Pisa, Duomo, facade.

HOC OPVS ESIMIVM TAM MIRVM TAM
PRETIOSVM RAINALDVS PRVDENS OPERA-
TOR ET IPSE MAGISTER CONSTITVIT MIRE
SOLLERTER ET INGENIOSE: This is the inscrip-
tion on the colored marble intarsia plaque, on the side
of the central portal lunette, praising Rainaldo, "master
and prudent builder who worked admirably, skillfully
and ingeniously." After the death of Buscheto, he con-
tinued the building of the duomo, extending the front
area and defining today's facade (Buscheto's tomb, the
top image on page 24, however, had to be reset into
the new prospect). Under this eulogy to Rainaldo is
another inscription, which rings like an apothropaic
prayer: "Free me, oh Lord, from the lion's jaws and
protect my humility from the unicorn's horn."

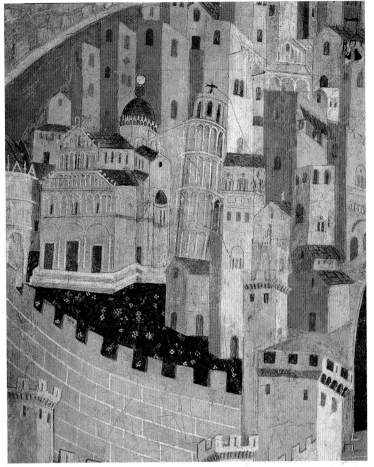

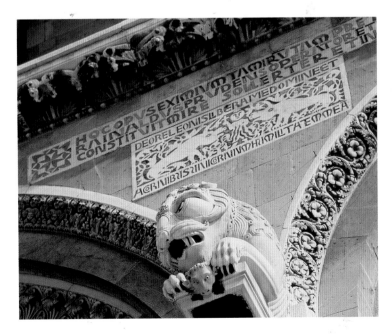

Bernardo Gilduino *Angel's head*
detail from the Saint Saturnine altar, 1096, Saint-Béat marble. Toulouse (Haute-Garonne).

Bernardo Gilduino
(active in Tolosa, c. 1096)

In May 1069, in the presence of fifteen bishops and archbishops, and of Count Raimonda IV di Saint-Giles, Urban II consecrated the eastern part of the Church of Saint Sernin in Tolosa. Even then, the sculptor Bernardo Gilduino was finishing his exacting work on the ornate, sophisticated marble relief altar of the Piranei (in the Saint Béat region). His own signature appears above the cornice: "Bernardus Gilduinus me fecit" (made by Bernardo Gilduino). We cannot be sure whether the entire work came out of his studio, but its seven-layered framework (also of marble, now found in the ambulatory) might have been based on an analogous structure now lost. Thus, Gilguino set up an impressive workshop at the building site of the most majestic French church since that of Cluny. His "humanist" style, while keeping the example of antiquity in mind, signified a turning point at which regional idiom favored works of a character even more monumental than those of the past.

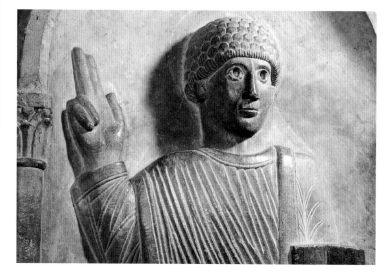

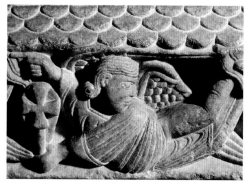

Center, left:
Bernardo Gilduino
Apostle, detail
c. 1096–1100, Saint-Béat marble.
Toulouse, church of Saint-Sernin, ambulatory.

Alongside the figures shown on the other six panels, all now arranged in the church choir ambulatory, this beautiful figure of a blessing apostle, his hair arranged in typical Languedoc curls found in other reliefs and sculptures of the Aquitaine school, is attributed to Gilduino. It is also suggested that for several panels (not this one), the great master may have been helped by an assistant. The style of the reliefs that project from the base of the slabs refers to contemporary sculpture from Jaca (Aragon) and nearby Moissac Abbey.

Bernardo Gilduino
Altar panel
detail of an angel in the frame (top right) and the entire frame (above); signed opus, consecrated in May 1096, Saint-Béat marble. Toulouse, church of Saint Sernin, crypt.

The edge of the altar is decorated with medallions containing images of Christ, angels, the Virgin Mary, and the Apostles. The lobed frame and the cherub shown above, inspired by table-supporting Paleo-christian cupids, are an unusual evocation of the ancient Narbonne sarcophaguses.

26

Romanesque | Bernardo Gilduino

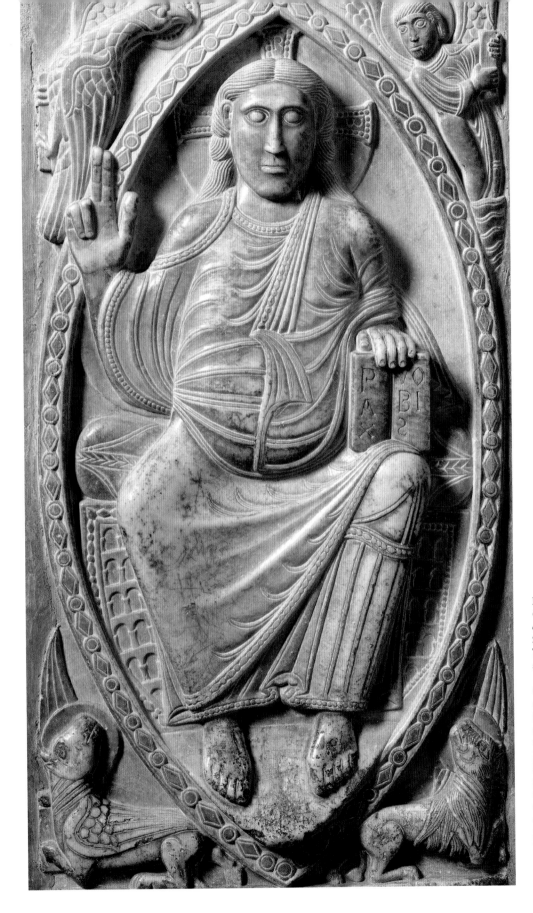

Bernardo Gilduino
Christ in Majesty
c. 1096–1100,
Saint-Béat marble.
Toulouse, Saint-Sernin,
ambulatory.

Gilduino's Christ giving
a blessing is a majestic
figure, shown in a
mandorla surrounded by
the four symbols of the
Evangelists. The strong
hieratic accent, com-
parable with that of many
miniatures and ivories
of that time, does not
diminish the powerful
plasticity of this relief,
which already seems to
offer a shy hint of spatial
depth, underscored by
the mandorla outline.

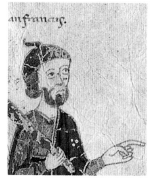

Modenese miniaturist
Lanfranco the architect
early thirteenth century,
detail from the illuminated
page shown below.

Lanfranco
(active in Modena, 1099–c. 1106)

"Famous for his intelligence, learned and skilled, mighty advocate of this opus, rector and teacher" (*Ingenio clarus Lanfrancus doctus et aptus, est operis princeps huius, rectorque magister*). This is the description of the architect Lanfranco, in an inscription found in the apse of Modena Cathedral. Then, in the codex seen here, he is defined as *Mirabilis artifex, mirificus edificator*, considered providential for the people of Modena that such an able architect was found for "such a great work." In 1106, Lanfranco and Bishop Bonsignore of Reggio discovered the urn containing the relics of Saint Geminianus, to be placed in the new crypt. The importance that documentation attributes to him as designer and director of works is a rare acknowledgement for an architect of that period. He was active from 1099, the year the cathedral was founded, to 1106, when the remains of the patron saint were transferred there.

Modenese miniaturist
Lanfranco the Architect Directs Works
on the Duomo of Modena
early thirteenth century, illuminated page from the
Relatio de innovatione ecclesie sancti Geminiani,
ac de translatione eius beatissimi corporis.
Modena, Archivio Capitolare, Ms. O. II. 11, c. 1v.

In the illuminated depiction of workers on the Modena Cathedral site, the figure of Lanfranco is shown larger than the others, better dressed, and wearing different headgear, seen quite clearly in the upper and lower scenes from this page of the codex. Like the Angel of the Apocalypse, using the virga to measure and build celestial Jerusalem, the Modenese architect, holding the virga that here is intended as an instrument of command and measurement, directs the workers and bricklayers (*operarii* and *artifices*). The two scenes show two different periods of construction: The top image is of laborers digging the foundations; below shows the building of the walls, with laborers carrying the blocks of stone.

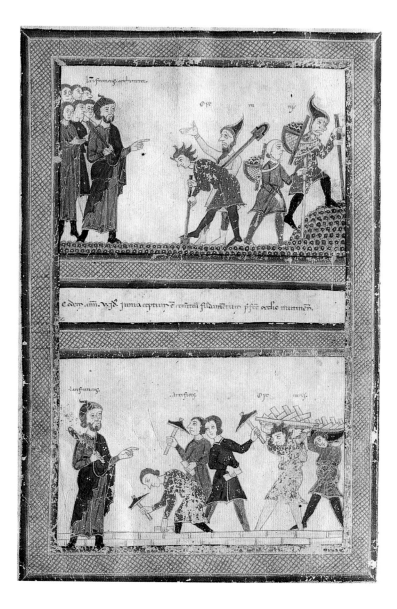

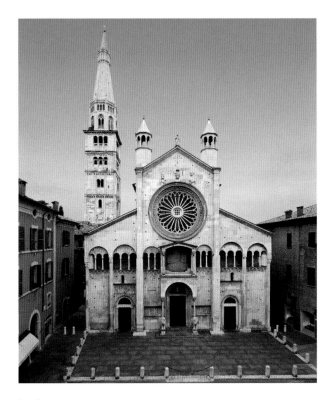

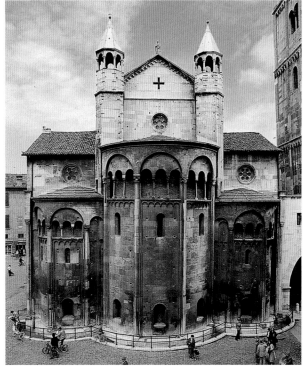

Lanfranco
Modena Cathedral seen from the facade and apse prospect;
building begun on May 23, 1099; the Saint's altar was consecrated on
October 8, 1106.

Appearing without doubt as the most significant example of
European Romanesque architecture, Modena Cathedral symbolized
the civic pride of the citizens. At the end of the eleventh century, this
innovative, marble-faced building appeared to be seeking to create an
opus that would somehow equal the grand (and not so distant) con-
structions of the period, like Pisa's Duomo or Florence's Baptistery.
The building was conceived by the architect Lanfranco at the time of
Canon Aimone, who would also appear to be the author of the origi-
nal apse epigraph (this panel was later replaced by another, ordered
by the "massaro Bozzalino," a figure documented in Modena
Cathedral's early thirteenth-century archives. The monument we see

today is the result of several remodelings that took place after
Lanfranco, in particular of the building's north prospect. Now we
can identify later additions to the facade, dating back to the period of
the aforementioned Bozzalino, and these include the large, high-set
rose window and the side portals. These structural and ornamental
modifications must have been why several reliefs sculpted at the time
of Vuiligelmo were moved higher up from their original position. It
seems clear that Lanfranco, the cathedral's original architect—and
contemporary of Vuiligelmo—must have designed a complex build-
ing, whose interiors and exteriors were closely interconnected.
Cadenced by a system of arches that starts at the apse (the first part
to be built) and continues along the sides and facade, Lanfranco's
church was erected on the site of the archaic cathedral, and modifies
not only the dimensions, elongating them, but also the interiors,
with two aisles rather than four, and gives the square a new impact
within the city plan.

Vuiligelmo

(active in Modena, 1099–c. 1110)

The origins of Vuiligelmo are an enigma even today. The sculptor worked on Modena Cathedral at the end of the eleventh and into the early twelfth centuries. A tribute appears in the closing lines of the facade inscription that states: "The honor to which you are entitled amongst sculptors, Vuiligelmo, is now obvious from your sculpture" (*Inter scultores quanto sis dignus onore claret scultura nunc Vuiligelme tua*). Epigraphists also continue to debate the interpretation of the name inscribed on the plaque: "Vuiligelmo," as he is now known, and not "Wiligelmo," as was suggested for some time, inclining to a presumed but otherwise undocumented Nordic origin for this great *sculptor*. Nevertheless, the issues of his origins and his cultural background are still unresolved. Nor do we know who added the closing lines of tribute, or when, to the plaque supported by the patriarchs

Vuiligelmo
Bearded head
detail from right capital on
the central portal facade, early
twelfth century, Vicenza soft
stone, eyes encrusted with lead.
Modena, duomo.

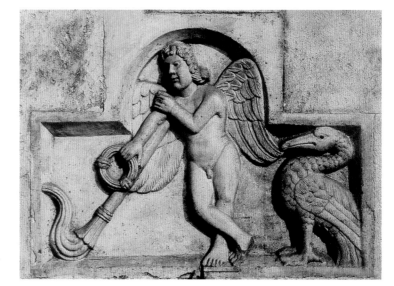

Vuiligelmo
Winged putto resting on an upturned torch, with ibis
c. 1099–1110, Vicenza soft stone.
Modena, Duomo, facade.

A prototype of the image can be found in a number of Roman tomb reliefs, which Vuiligelmo may have seen in the area

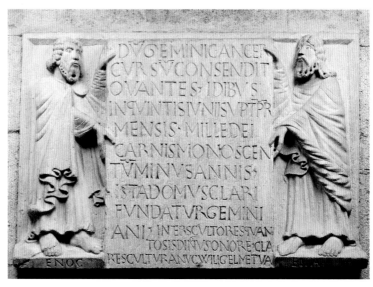

Vuiligelmo
Commemorative epigraph of the foundation of the duomo, supported by Enoch and Elijah
c. 1099–1106, medium-grain marble.
Modena, duomo, facade.

The two patriarchs are taken to Heaven without knowing death, and confer the symbolic value of immortality on the great Modenese building. The figures are by Vuiligelmo, author of the *Genesis* facade reliefs, in a similar style. The scheme is inspired by Roman sarcophaguses with plaque-holding grave cupids, here replaced by the two prophets.

Enoch and Elias commemorati-ng the foundation of the cathedral. It may even be a "personal signature," as was the case with Master Mateo, in Compostela. Certainly, among his contemporaries, Vuiligelmo does fully deserve this rare great praise, including the specific use of the term *sculptor*, which seems to have been used much less frequently than the more generic appellative *artifex*. The most likely theory is that the sculptor Vuiligelmo (or Wiligelmo) prepared the slab and sculpted the figures, whereas other hands indicated the foundation date and, perhaps later, added the eulogy to this great artist. A feature of Vuiligelmo's art is that it is also deeply imbued with the spirit of Christianity and the particular feel for the forms and motifs of antiquity, recovered from the Roman sarcophaguses that abounded in Modena (ancient *Mutina*). In a man-ner of speaking, Vuiligelmo applied an almost philological recovery of antiquity, which was oriented completely to the Christian ethic, for instance, in the facade's winged putti and, above all, in the tablets that depict episodes from the *Book of Genesis*, where the forceful narrative pathos seems to suggest, as Chiara Frugoni (1996) stated, a version of liturgical drama that was very widespread at that time (*Jeu d'Adam*).

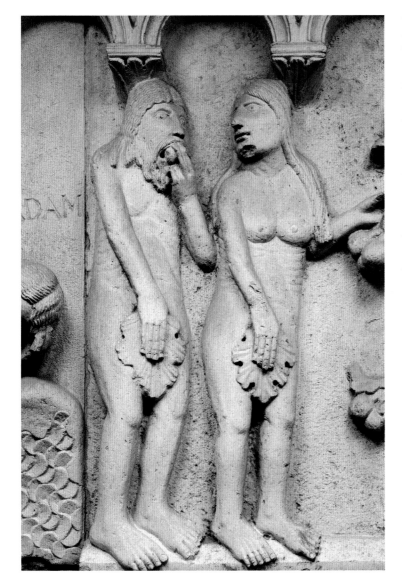

Vuiligelmo
Adam and Eve and the Tree
of the Knowledge of Good and Evil
c. 1099–1110, Vicenza soft stone,
eyes encrusted with lead.
Modena, Duomo, facade.

For his illustration of a biblical episode from *Genesis*, Vuiligelmo was probably inspired by one of the many versions of the *Jeu d'Adam*, a medieval text of a theatrical stamp, or rather the first play of the time in a liturgical key that has reached us. His narration, noteworthy for its sharp immediacy, refers to the fate of our progenitors from the moment of Creation to the curse brought by their sinning; it continues with Abel's fratricide and the death of Cain, up to the Flood and Noah saving humanity thanks to his Ark. To represent the sin, the artist creatively includes several moments in a single scene: Eve takes from the jaws of the evil serpent the forbidden fruit, which a nervous Adam is already eating greedily. At the same time, the progenitors, aware of their sin and of their nakedness, cover themselves with large fig leaves. In the previous scene, Eve showed no trace of sensual-ity, underscoring her primitive innocence, but here she is shown with sumptuous breasts. Her body, and that of Adam, appears shapeless and covered with heavy clothing in the panel depicting them expiating their guilt with hard toil in the fields. As Jacques Le Goff explains (in a refined spoken note), the world of Vuiligelmo is a world of battles and conflict between Humanity and Nature: in other words, the fight against evil, sin, and vice. The duomo portal is the doorway to salvation through human endeavor.

Gislebertus, *Last Judgment* and *Christ in Majesty*, detail of the signature, c. 1130, stone. Autun, Saint Lazare Cathedral, west portal tympanum.

Gislebertus
(active in Autun, 1130s–40s)

The proud author of a masterpiece of medieval sculpture, the western portal tympanum of Autun's Saint Lazare Cathedral, signed his name above the elect in *The Judgment*, right under the large Christ in a mandorla: GISLEBERTVS HOC FECIT. The church is a destination for pilgrims visiting the remains of Saint Lazarus (brother of Martha and Mary) and seems to have been more or less completed c. 1146. It is also quite probable that Gislebertus, aided by his assistants, produced the huge symbolic cycle inspired by the Old and New Testaments, decorating the interior of the building's numerous figured capitals, as well as the reliefs on another portal on the church's northern transept, which was the main entrance and was destroyed in the eighteenth century. Gislebertus's creative imagination and powerful, dynamic expressivity conjure up spiritual drama, addressing joy and terror with equal intensity.

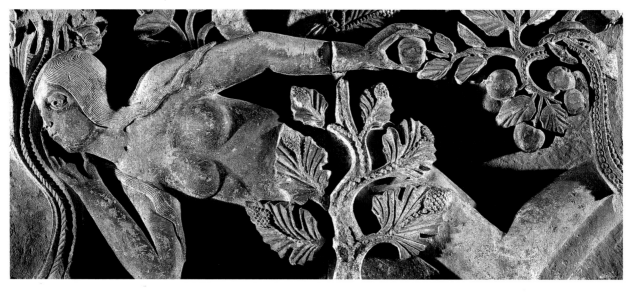

Above:
Gislebertus
Eve
c. 1130, stone. Autun, Musée Rolin, from the right transept arm in Saint-Lazare Cathedral.

The only twelfth-century depiction of Eve to have come down to us: Long hair tumbles over her shoulders and leaves her breasts exposed, while a strategically placed plant covers her private parts. Unusually, Eve is shown lying down as she picks the forbidden fruit, almost crawling, similar to some ancient Indian reliefs. The panel almost certainly comes from the church's destroyed northern transept portal.

Left:
Gislebertus
The Elect, detail of the procession of the elect and the damned from *The Last Judgment*
c. 1130, stone.
Autun, Saint-Lazare, west portal tympanum.

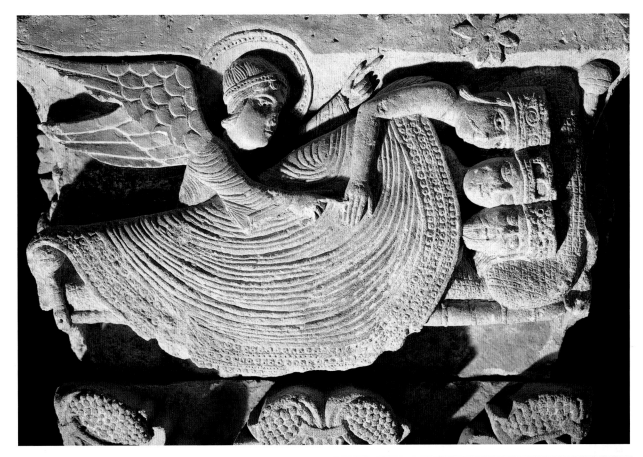

Above:
Gislebertus
Awakening of the Magi
c. 1130, stone.
Autun, Saint-Lazare, Musée Salle Capitulaire,
from a crossing pillar.

Gislebertus's mind, with its endless alternating of good
and evil, created several images that are gentle and
reassuring, like the angel appearing to the Magi as they
sleep under a blanket (clever device), and whose touch
seems already to have awakened the first of the three,
who is opening his eyes.

Right:
Gislebertus
Suicide of Judas
c. 1130, stone.
Autun, Saint-Lazare, Musée Salle Capitulaire, nave.

Pathos, horror, and dramatic scenes: Angels and
demons on the narthex tympanum and the capitals
installed along the nave and aisles, contend with the
damned, while the hanged swings with tongue and
eyes bursting forth. "Gislebertus was no primitive,"
said André Malraux, "but a Roman Cézanne."

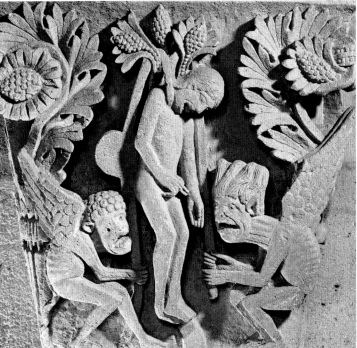

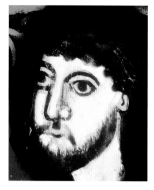

Gerlachus, *Self-portrait*, detail
c. 1150–60, stained glass.
Münster, Westfalisches
Landesmuseum, from
Arnstein-an-der-Lahn Abbey.

Gerlachus
(active in Germany, Arnstein-an-der-Lahn Abbey, Middle Rhine, c. 1150–60)

One of the first self-portraits of the Middle Ages was that of Gerlachus, a master glazier who depicted himself with beard and moustache, a fine sky-blue cloak, a paintbrush in his right hand and a bowl of paint in the left, in one of the five single-light window panels created for the Premonstratensian abbey in Arnstein, Germany, and now found in Münster. The signature is unquestionable, as the artist wrote: REX REGUM CLARE GERLACHO PROPICIARE, wording that rings like a propitiatory invocation uttered by the "famous artist" to the King of Kings. The five panels, together with others that were lost, decorated the abbey's choir windows. Gerlachus, to whom has also been attributed with another stained glass window, *The Crucifixion*, in Berlin's Kaiser Friedrich Cathedral, destroyed in 1945, shows a skilful use of glazing and pictorial techniques, as well as an elegant decorative sense, similar to contemporary miniatures.

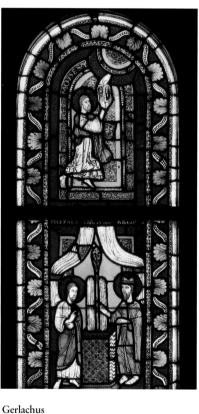

Gerlachus
Moses Receives the Commandments; Aaron's Staff
c. 1150–60, stained glass.
Münster, Westfalisches Landesmuseum, from
Arnstein-an-der-Lahn Abbey.

Playing a dual role as glazier and painter, Gerlachus favored the pictorial aspects of the compositions rather than the sense of monumentality common to stained glass of that period.

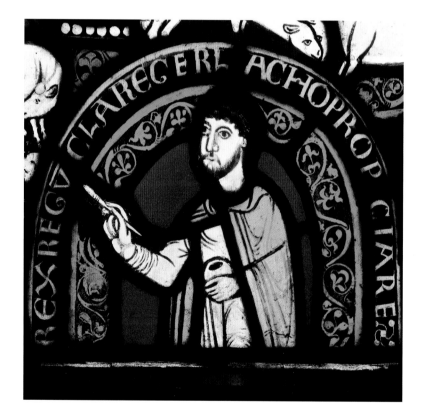

Gerlachus
Self-portrait
c. 1150–60, stained glass.
Münster, Westfalisches Landesmuseum, from Arnstein-an-der-Lahn Abbey.

The self-portrait of the glazier and painter Gerlachus is in a panel that depicts scenes from the life of Moses. A reconstruction offered by Richard Becksmann indicates that the five glass items were originally part of a much bigger cycle. The glazing technique used is complex, as much so as the painting method. Gerlachus was also skilled in the use of halftones and refined nuancing.

Nicodemo, *Bearded figure Stories of Jonah* signed and dated 1159, stone and polychrome stucco. Moscufo (Pescara), church of Santa Maria del Lago.

Roberto and Nicodemo

(active in Abruzzo, c. 1148–66)

Roberto and Nicodemo are not particularly famous or much studied; they worked in a little-frequented area, possessing great appeal, but they boast more than one record on the twelfth-century art horizon. They specialized in pulpits decorated in polychrome stucco, narrating biblical scenes and depicting figures derived from the art of late antiquity, showing transalpine and exotic (especially Moorish) influence, so their training was complex and eclectic; they are two of the few sculptors of that time whose names can be linked to a certain chronology. Roberto and Nicodemo worked in several churches in the Abruzzo countryside, and at least one of the pair continued his father's craft. The ciborium of San Clemente al Vomano (c. 1148) was made by Roberto working with his father Rogerio; in 1150 he worked on the Rosciolo ambo with Nicodemo, whom we know to be the author of the Moscufo (1159) and Cugnoli (1166) pulpits.

Above right:
Nicodemo
Pulpit
detail of a damaged figure of a boy removing a thorn from his foot (called a *Spinarius*) and of the "Islamic" frieze signed and dated 1159, stone and polychrome stucco.
Moscufo (Pescara), church of Santa Maria del Lago.

We know nothing of Nicodemo's origins (although he was said to have been from nearby Guardiagrele) or whether he was actually related to Roberto, with whom he worked at Rosciolo, producing a ciborium dense with refined decorations influenced by Islamic art, as can also be seen in this pulpit.

Above left:
Nicodemo
Pulpit
Detail signed and dated 1159,
stone and polychrome stucco.
Moscufo (Pescara), church of Santa Maria del Lago.

This is the best preserved of the works by Roberto and Nicodemo, and also reveals similarities with another pulpit, a result of teamwork, in the church of Santa Maria in Valle Porclaneta (Rosciolo). Some think that the two craftsmen, skilled in working a blend of plaster, gravel, and lime, came from Sicily or Campania, southern regions where Arab influence was most felt in those days. The Moscufo pulpit, on columns supported by multifoil arches with branching inlay pendentives, at the top shows stories of Jonah, Saint George, and the Evangelists, in the round, but also a bearded man and a youth removing a thorn from his foot, inspired by the ancient *Spinarius* admired by pilgrims in Rome, visiting Piazza del Laterano.

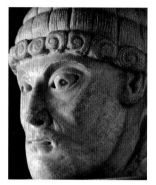

Cabestany Master
Male head
detail, marble c. 1160.
Museo de Castillo de Perelada
(Spain), Mateu collection, from
Sant Pere de Rodes (Spain).

The Cabestany Master
(active in Cataluña, Navarre, Languedoc, and Tuscany after 1165)

The artist known as the Cabestany Master was one of the anonymous itinerant craftsmen who worked in the twelfth century. He was one of the most outstanding (and certainly the most tireless, considering the distances he must have traveled, possibly more than once). Traces of his work (albeit sketchy), and sometimes of some of his assistants, are found many hundreds of kilometers away from one another: Navarre, Cataluña, Roussillon, even Tuscany. The style of this sculptor, who may well have been an architect too, appear original and unique: expressive, often stern, faces; almond-shaped eyes drawn out towards the temples and finished with strong drill strokes; hands and feet with very long digits. Despite his evident creative individuality, the Cabestany Master, of whom neither origin nor real name are known, shows a rare sensitivity to late antiquity. This appears not only in his handling of draping derived from Paleo-Christian sources, as in the

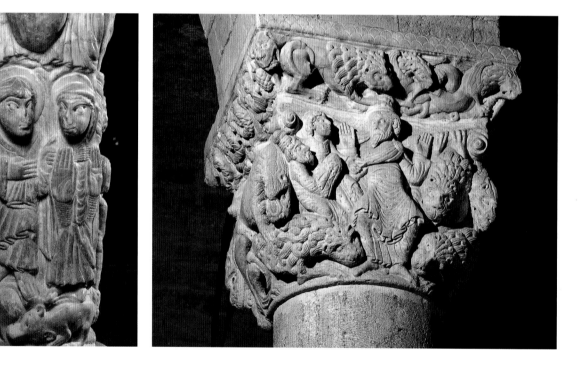

Cabestany Master
Shaft Sculpted with Nativity Cycle
post-1170, calcareous alabaster. San Casciano Val di Pesa (Florence),
Museo di Arte sacra, from a country church oratory, Pieve Vecchia di Sugana.

The original location is unknown, but it is thought that the piece comes from the Benedictine Abbey of Sant'Antimo. The shaft was converted for use as a holy water stoup, and we believe it may have been the base of a baptismal font, with similar iconography to others sculpted in Italy at that time, including one in San Frediano (Lucca) and a less famous artifact now in the Museo di Monte Sant'Angelo (Foggia), brought from the church of Santa Maria di Pulsano, on the pilgrim route.

Cabestany Master
Daniel in the Lion's Den
post-1170, calcareous alabaster.
Abbey of Sant'Antimo (Montalcino, Siena), nave capital.

Further evidence of the work of the Cabestany Master in Tuscany: the only capital of his that remains at Sant'Antimo. We do not know if he sculpted others, nor if he worked at that location.

marble relief of the Martyrdom of Saint Saturnine on a sarcophagus at Saint-Hilaire (Aude, France), but also in the skilled use of different marbles, many recovered, like the slab now in Barcelona's Museu Marès, which came from the church of Sant Pere de Rodes in Cataluña. Other fragments are housed now in various museum collections. Until 1947, the Cabestany Master was unknown, and this fictitious name is attributable to the small town in the Eastern Pyrénées, where an Assumption of the Virgin lunette decoration of his can still be seen. That marble fragment also includes the earliest non-Italian iconographic evidence of worship of the Holy Girdle, a relic brought from Prato in 1141. It comes as no surprise that three capitals, stylistically similar to the Master's French and Spanish reliefs, were found in the Tuscan cathedral (Burrini 1995), given that other traces of the artist were also found in Tuscany, including a capital at Sant'Antimo and a marble shaft, now in the San Casciano museum. His style can also be admired in the tympanums of the church of Errondo (Navarre, now in The Cloisters, New York); in two male heads (Fitzwilliam Museum, Cambridge, and Perelada); and in other reliefs in Boulou, Gerona, Rieux-Minervois and Saint-Papoul.

Cabestany Master
Jesus Appears to His Disciples at Sea
c. 1161, white Carrara marble.
Barcelona, Museo Frederic Marès, from the destroyed portal of the church of Sant Pere de Rodes (Cataluña).

The Apostles show astonishment, carried by their little boat amidst the waves, depicted as overlapping flows where six cheery fish are swimming. Navarro (1998) showed that the rear of the marble slab bears the worn traces of an older work. The panel, sculpted with excellent narrative skill, was one of several decorating the portal of the church of Sant Pere de Rodes, inaugurated in about 1161, after the first church was destroyed. The surviving elements include the splendid head now in the Perelada collections (see top of page 36).

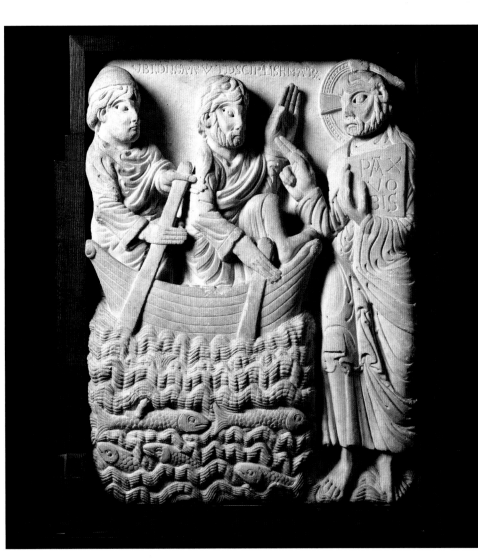

Guglielmo
Lion with Dragon
c. 1159–62, Cagliari, Duomo

Guglielmo
(active in Pisa after 1150)

An inscription now lost—described him as "excellent in the art," and it is no coincidence that Guglielmo is now considered the father of the prestigious Pisan school of sculpture, typified by its particular sensitivity to the ancient style. Like Buscheto and Rainaldo, who designed Pisa Cathedral, Guglielmo is buried in the building's facade and commemorated there. His tombstone says that *magister Guillelmus* was the maker of the cathedral's pulpit. As well as this opus, later taken to Cagliari, he has been credited with several capitals still in this Tuscan duomo, along with a number of panels for the choir enclosure, later dismantled, which were fretted like the most refined embroidery. The *San Ranieri water stoup* (New York, The Cloisters) also resembles the master's style closely, with an idiosyncratic reworking of classical and Middle Eastern references. His talent is clearly seen in round sculpture and stands as a naturalistic antecedent to the Pisano family's work.

Guglielmo
Openwork panel
c. 1159–62.
Pisa, Museo dell'Opera Primaziale,
from Pisa Cathedral choir enclosure.

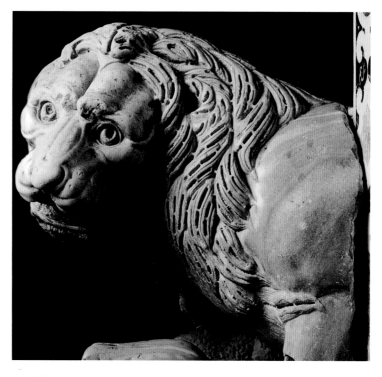

Guglielmo
A Lion Attacking an Ox
c. 1159–62, marble.
Cagliari, Duomo.

In 1312, a Pisan galley brought an ambo, supported by lions, to Cagliari. The ambo was removed from Pisa Cathedral, replaced by Giovanni Pisano's new pulpit, and sent to Santa Maria di Castello, on the rock where the conquerors of Sardinia had erected one of the most striking medieval fortresses of the West. At the time of Guglielmo, Pisa was central to trade with distant worlds and boasted ancient sculptures and oriental artifacts. This opus betrays Syrian influences and a classical tendency in its plastic impact, combined with naturalistic details realized with a drill. In 1670 the lions were taken from the ambo, and were placed at the entrance to the duomo presbytery.

Bonanno Pisano, *Epigraph*
detail of signature, 1185 (signed
and dated 1186, according to
the Pisan calendar) Monreale
(Palermo), Duomo, left leaf of
the main door.

Bonanno Pisano
(Pisa, documented c. 1180–86)

In 1595, a fire in Pisa destroyed the bronze doors of the cathedral's central portal, also obliterating the epigraph, described by Vasari, in which *Bonnanus Pisanus* declared (1180) that he had completed the work in just one year. This was the first evidence of this artist, once incorrectly assumed to be the architect of the Tower of Pisa. In 1185, with manifest civic pride, Bonanno was still signing as a *civis pisanus*, as seen on the bronze door cast in just six months, probably in Pisa, and sent to Palermo for the Cathedral of Monreale, where it remains. The Pisan master was not the only artist casting bronze doors at that time who left his name on his creations: Barisano, for instance, left his signature on the doors of Trani Cathedral (1175), and on those of Ravello Cathedral (1179). Bonanno, however, deserves the credit for reviving the Italian Byzantine tradition in this sector, endowing history-laden panel scenes with narrative unity.

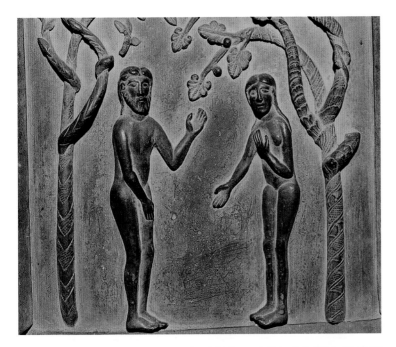

Bonanno Pisano
Adam and Eve in the Earthly Paradise
detail from the main door
1185 (signed and dated 1186, according
to the Pisan calendar), bronze.
Monreale (Palermo), Duomo.

Pisa's "royal" portal perished in the fire, but two more of Bonanno's masterpieces survived: the San Ranieri door, in the transept of that same cathedral, with twenty panels narrating gospel stories, and the main door at Monreale Duomo, with forty Old and New Testament scenes. There is no doubt about the great skill in the cold-casting and reworking techniques evident in the reliefs created by Bonanno, whose workshop may have been near Pisa Cathedral. The doors rest on a wooden base, and the panels, cast singly, have a metal frame attached to the back, nailed to the wood with rosette-tipped nails. Bonanno's innovations were soon acknowledged: In 1329, the Florentine Piero di Iacopo was appointed to copy Pisa's doors as a model for those that Andrea Pisano was making for the baptistery in Florence. The style Bonanno used for composition and handling of figures is often compared to that of an older sculptor and fellow Pisan: Guglielmo.

Bonanno Pisano
Three Prophets Under the Palms
c. 1180–85, bronze.
Pisa, Duomo, San Ranieri door.

Under palms bowed by wind, the prophets talk, depicted with efficacy and understated narrative skill.

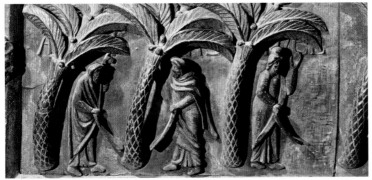

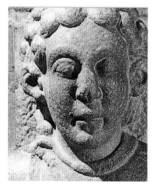

Master Mateo

(Galicia, documented c. 1161–88)

An inscription bears the signature of Mateo, a sculptor and master of works for the impressive Santiago de Compostela Cathedral, in Galicia, the destination for pilgrims from all of western Christendom. The epigraph, indicating the closure of the work on April 1, 1188, can be found in the architrave intrados of the Gloria portico, built "from its foundations" *per magistrum Mateum*. In 1168, Mateo (who had already served as architect for a bridge at Pontevedra, in 1161) was commissioned by Ferdinand II, King of Galicia-León, to manage the concluding phase of the site (he was also to pay his staff from his fee). Chronological facts show this precocious Galician to have developed a style similar to the Ile-de-France "protogothic" sculptures. Using alabastrine marble and painted granite, he achieved intense and unusual expression, thus unfurling one of the largest iconographic cycles of that time.

Master Mateo, *Angel praying towards the church's high altar* an unfounded tradition believes it to be the portrait of Mateo, detail of the back of the central pillar socle, c. 1188, alabastrine marble. Santiago de Compostela, Gloria portico.

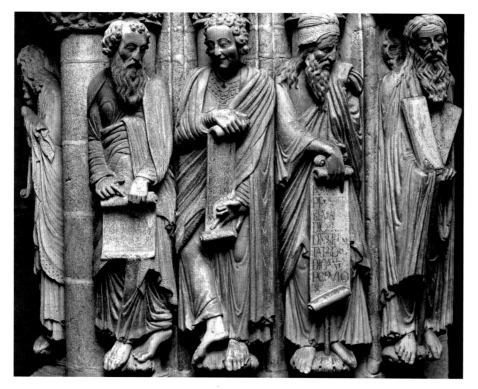

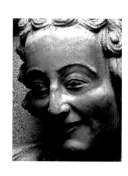

Master Mateo
Prophets Jeremiah, Daniel, Isaiah, and Moses
1188, polychrome red Galicia granite.
Santiago de Compostela, cathedral, Gloria portico, left column of central arch.

Santiago Cathedral, dedicated to the martyr and patron saint of pilgrims, has a long and involved construction history, which began in 1075 and went beyond the thirteenth century, with many modifications even in subsequent centuries. Of the grand Gloria portico, only the inner narthex remains, opening onto the naves and aisles. It was conceived, like much of the building, by Master Mateo, and dates back to the time of a renewed building drive undertaken by a farsighted figure: Gudesteiz, from 1162 archbishop and then administrator of the church. The vast iconographic program seems to have been inspired by the *Ordo Prophetarum*, a musical drama in which numerous characters Foretell the arrival of the Messiah, *Rex Gloriae*.

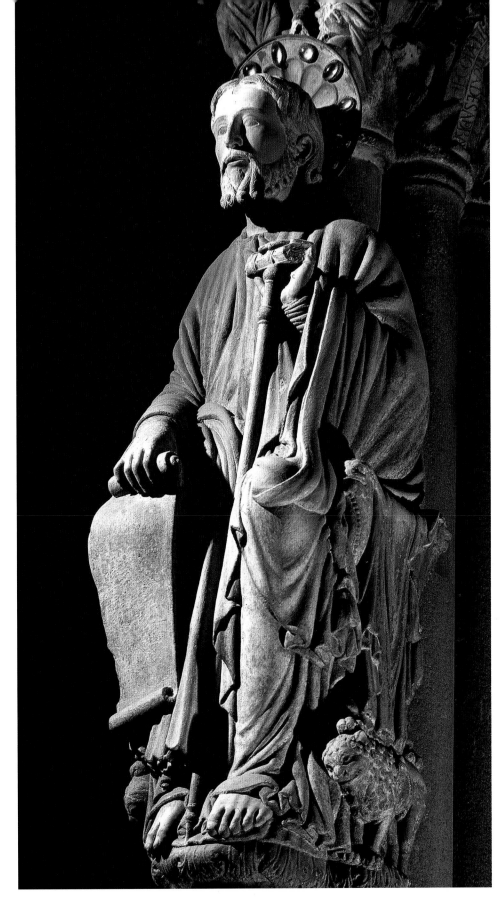

Master Mateo
Saint James
1188, polychrome red
Galicia granite.
Santiago de Compostela,
cathedral, Gloria portico,
central portal column.

Saint James the Great
(Santiago), the first Christian
martyr and brother of Saint
John the Evangelist, was
killed in A.D. 44. It is said
that he appeared to one who
invoked his grace, inciting
him to reach Galicia, where
he would find the remains of
Saint James in a field (*cam-
pus stellae*, Compostela). The
greatest medieval movement
of pilgrims in Christendom
developed around this legend,
with Pilgrims who traveled
the *chemin Français* or the
camino de Santiago reaching
(even today) Galicia to adore
the Saint's remains. At the
center of the narthex, open-
ing onto the nave and aisles
of the western area, the
statue of Saint James appears
enthroned, with the arch-
bishop's staff and a golden
jeweled halo. In this static
pose, his eyes stare fixedly
towards a mystical horizon.
This image, less expressive
than that of the prophets
around it, lingers in the
memory of the millions of
pilgrims who have reached
Galicia.

Romanesque *Master Mateo*

Nicolaus de Verdun and a Rhenish assistant (?), *Otto IV*
detail of the *Reliquary of the Magi*
c. 1200–10, embossed gilt silver,
with enamel and gemstones.
Cologne (Rhineland), cathedral.

Nicolaus de Verdun
(active on the Meuse, in Cologne, and Tournai, 1181–1220)

One of the earliest to deem Nicolaus a great artist, not dissimilar to the "passionate, irresistible personality" of Cimabue, was Roberto Longhi (1939), who wrote that the "deep, blazing might" of the Tuscan painter, found a worthy predecessor only in Nicolaus de Verdun's "vigorous desolation." Longhi admired the "pure violence" seen in the "intense compositions" painted by this great artist (perhaps from Verdun, in Upper Lorraine), to be seen in the enamels of the Klosterneuburg Altar, near Vienna. The altar is Nicolaus's first known work, which was later dismantled and reassembled into a triptych, then restored with various seams; it bears a dedication to the Virgin Mary from Prior Gwernerus, dated 1181, and the name of its maker (*opus quod Nicolaus virdunensis fabricavit*). Nicolaus's name reappears, in 1205 (in an inscription that has been lost but reconstructed in 1890

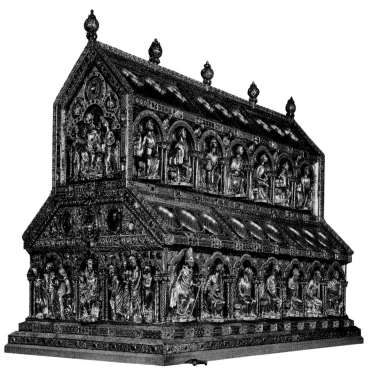

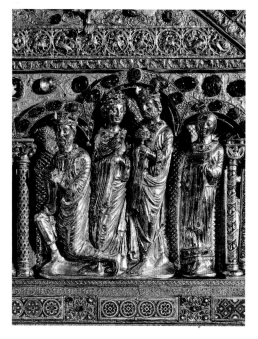

Above left:
Nicolaus de Verdun and a Rhenish assistant (?)
Epiphany, detail of the *Reliquary of the Magi*
c. 1198–1230, embossed gilt silver, with enamel and gemstones.
Cologne (Rhineland), cathedral.

The reliquary casket, considered the most impressive and best-preserved of that period, contains the relics of the Magi and other saints, relics that Reinald of Dassel, Archbishop of Cologne and chancellor of Frederick I Barbarossa, had brought to the German city in 1164, two years after conquering Milan. The item has been tampered with over the centuries and not all the figures can be

attributed with certainty to Nicolaus; several are actually dated after his death. We also know that precious materials, the gold and gems for the reliquary, were provided by Emperor Otto IV of Braunschweig in person, elected in 1198 and shown in the embossed relief following the Magi (far right in this detail). The figures wear typical *des plis creux* (with deep folds), garb, of which Nicolaus was perhaps the greatest master.

Above right:
Nicolaus de Verdun and a Rhenish assistant (?)
detail of the *Reliquary of the Magi*
c. 1198–1230, embossed gilt silver, with
enamels and gemstones.
Cologne (Rhineland), cathedral.

The structure of the reliquary mimics a basilica, with a sloped roof, a nave and two aisles.

thanks to reliable sources), on the *Notre Dame Châsse* in Tournai, a town where he appears to have resided for some time, taking citizenship, and where he may have died. Earlier, the goldsmith must have worked on the lavish *Gold Châsse* or *Three Kings Reliquary* for Cologne Cathedral. In this gold and silver repoussé opus, the pictorial aspects of the enamel decorations certainly prevail over the sculpture. Nicolaus de Verdun lived and worked at the turn of century, at the moment of a Romanesque "transition" to Gothic, a watershed for western art. Much has been written about the clear tendency of his figures to classic plasticity and the vivacity of their expressions, which can be tied in with the artist's extensive knowledge of late antique sources and Byzantine values, well-aligned with the "courtly," imperial premises typical of Meuse goldsmithing from the eleventh century. In his early application of style systems that would later be acquired by Gothic art, Nicolaus seems to have anticipated, or possibly influenced, sculptural vitality and naturalism of the so-called Visitation workshop, which decorated the pilasters of Rheims Cathedral. In this respect, Nicolaus de Verdun can be said to be a forefather of the Gothic style.

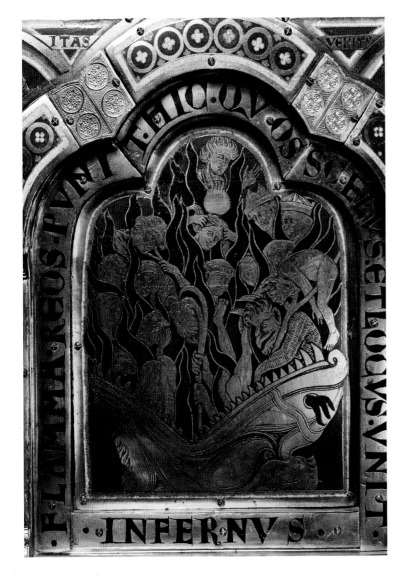

Nicolaus de Verdun
Inferno, signed detail of the altar
1181, gold and enamel.
Klosterneuburg (Vienna), abbey church.

Compared with other works realized by this artist from the Meuse, the altar made for Klosterneuburg Abbey (although we are not certain that Nicolaus actually went there to make the many panels) is dominated by enameled decoration. It is here that the eclectic artist shows his painting skills, but also his talent as a goldsmith and sculptor. He gives great emphasis to narratives with a dramatic accent, figures in exaggerated, almost expressionistic poses, as we quite often notice. Nicolaus has also focused on the rapport between the figures and the frames, highlighted by the contrast between black script on gold, and the enameled backgrounds of the scenes, where shades of azure, blue, and red prevail. This is a sophisticated, clever technique, creating pictorial, dynamic, and spatial effects unknown at that time anywhere in Europe. The figures stand out from the enameled azure background, drawn on strips of gilt metal, engraved and enhanced with tiny inserts of red enamel to underscore the hair, the clothes, and other details, like the flames of Hell on the illustrated panel at left.

Benedetto Antelami

(active in Parma and Northern Italy, 1178–1230)

Antelami worked in Parma and Borgo San Donnino (Fidenza) in the twelfth and thirteenth centuries. His artistic development and cultural makeup are shrouded in mystery and debate: there is even doubt about his origins. Antelamus (or Intelvi) is a medieval place name referring to a valley near Lake Como, which is said to be the homeland of a corporation of master masons who moved to Liguria in the mid-twelfth century. Although various generations of *magistri Antelami* were born in Genoa after 1157, there is nothing to lead us to believe that Benedetto came from that region. There are also doubts about his role as architect as well as sculptor, since in 1178 Benedetto signed himself simply as *sculptor* on the Parma *Deposition*. Restoration of the baptistery nave, however, is convincing in regard to his being the author of the architectural design as well as the reliefs inside and outside of the monument.

Benedetto Antelami,
Deposition, detail with artist's signature
1178, marble.
Parma, Duomo.

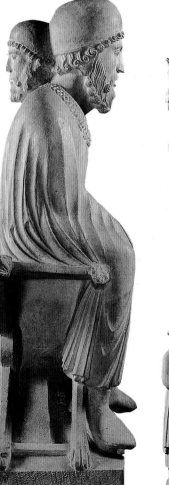

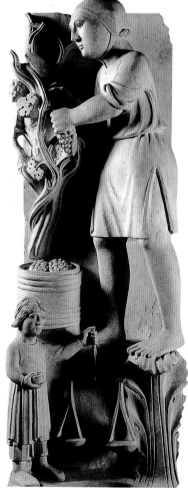

Benedetto Antelami
January
September
early thirteenth century, stone.
Parma, baptistery.

January, symbolized by the figure of two-faced Janus, and *September*, personified by a harvesting farmer and at his feet a figure representing Libra, are part of the cycle of the months, seasons, and the zodiac, originally found inside the baptistery, top, at the cupola springer. The famous sculptures formed a cycle in each of the dome's sixteen sections. A theme runs through the decorations in and out of the building: the believer saw, first of all, the reliefs on the lunettes of the three portals, alluding to the toils of human life; entering the baptistery, they found reassuring images: Risks and troubles, Antelami seems to say with his symbolic works, can be overcome. This was the first time the months and seasons were depicted in such a complex, eye-catching manner, and refer to the facts of human labor, which redeems them from the biblical curse, a concept that had also been expressed by Vuiligelmo, in neighboring Modena. The harmony between sculpture and architecture in the baptistery, which Antelami began to design in 1196, after work on the duomo, was compared with the best of several churches in Provence, a region that the artist may have visited.

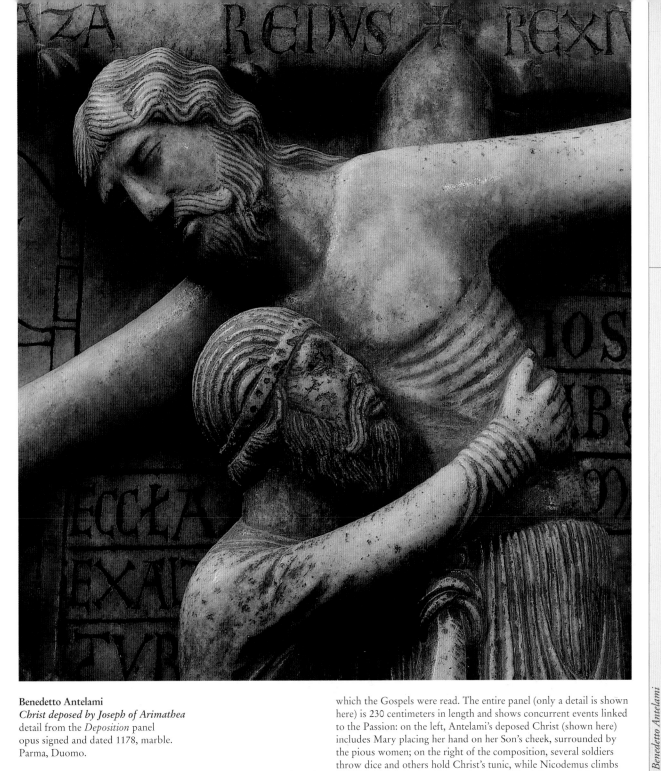

Benedetto Antelami
Christ deposed by Joseph of Arimathea
detail from the *Deposition* panel
opus signed and dated 1178, marble.
Parma, Duomo.

Antelami's *Deposition* for Parma Cathedral, for the harmony achieved
between the spiritual message and dramatic narrative, is considered
one of the greatest works produced in western Christendom in the
last quarter of the twelfth century. The opus was probably part of one
of those pulpits, of which we were speaking earlier in this book, from
which the Gospels were read. The entire panel (only a detail is shown
here) is 230 centimeters in length and shows concurrent events linked
to the Passion: on the left, Antelami's deposed Christ (shown here)
includes Mary placing her hand on her Son's cheek, surrounded by
the pious women; on the right of the composition, several soldiers
throw dice and others hold Christ's tunic, while Nicodemus climbs
a ladder to remove a nail from the Cross. The influence of the
Provencal style seems certain for a number of details, but overall,
this is a masterpiece without precedent, whose original is underpinned
by the captions that can be read in the background, which also appear
to be an expedient to add depth and credibility to the space.

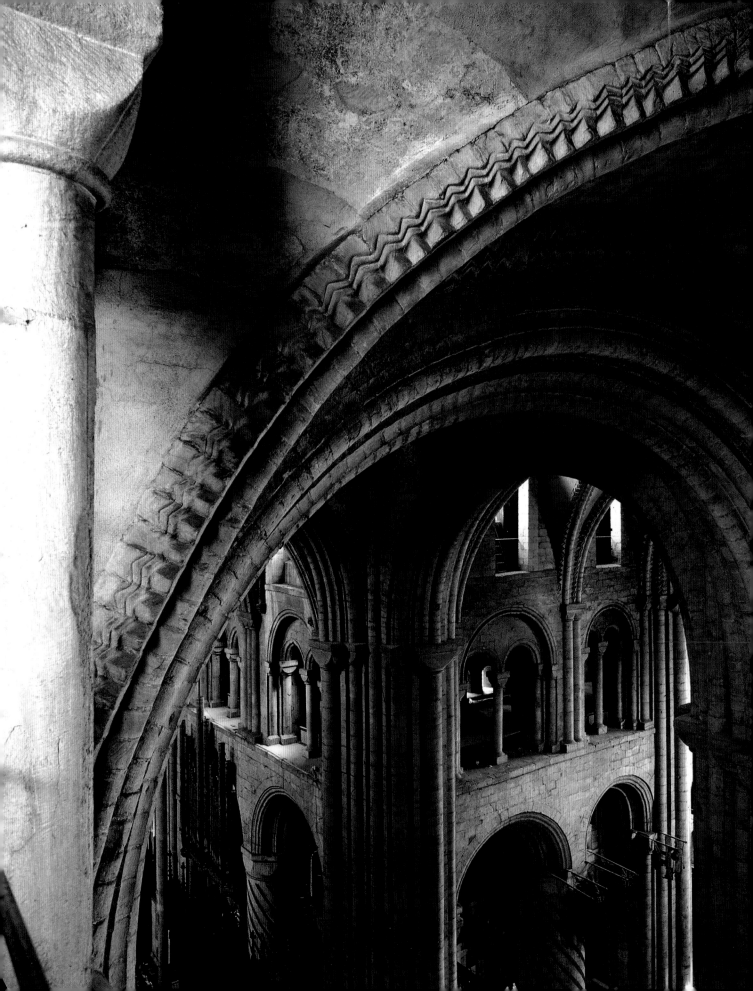

The Romanesque Period:

Styles, Arts, and Techniques

Churches on a Grand Scale for Pilgrims

Peregrinus (from the expression *peragere*, "to cross fields," or *peregere* "a frontier crossing"), for the ancient Romans, was a simple traveler or foreigner. Later the term acquired the meaning of a traveler whose destination was a holy place, reached along a route that was to some extent long and arduous, involving many rites and practices. Pilgrimages have ancient origins, but are not the exclusive prerogative of western culture. Between the eleventh and twelfth centuries, however, they grew to significant proportions in Europe, since they were linked to the concept of redemption through prayer at the sepulchers of Christ (Jerusalem), the Apostles (Rome), the saints, and to the veneration of relics in general. The pilgrimage was a phenomenon associated with exceptional volume of mobility, considered on an equal level with the Crusades, and pioneering research by Frenchman Emile Mâle and American Arthur Kingsley Porter identified it as the keystone of fundamental issues both for social and for art history. In brief, there is still debate on two aspects: the presumed architectural resemblances in churches far apart from one another, but all located on pilgrim routes, and the stylistic and iconographic affinities seen in monumental sculpture separated by thousands of kilometers. For instance, immense sanctuaries like Saint Sernin (Toulouse in Languedoc), Santiago de Compostela (Galicia), or Sainte Foy

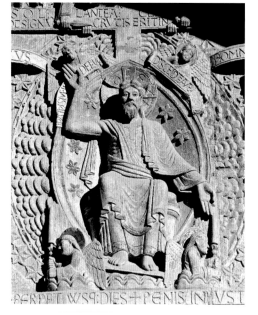

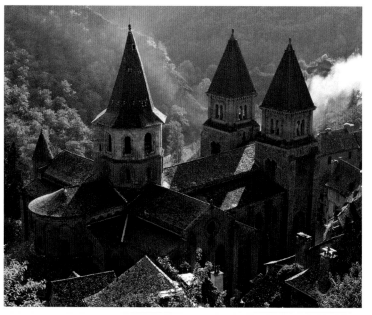

Above:
Christ in Judgment
c. 1140.
Conques-en-Rouergue (Aveyron), central portal tympanum.

At Sainte Foy, the pilgrim encountered Christ in Judgment, promising redemption but also terrible punishment.

Left:
Gislebertus
The pilgrim and the crusader, detail from *The Elect*
c. 1130.
Autun (Sâone-et-Loire), Saint Lazare, central portal tympanum.

A pilgrim with his shoulder sack (decorated with the shell typical of believers on their way to Santiago) and a crusader right behind him, depicted as some of the elect of the *Last Judgment*. They are being rewarded for their tiring journeys and pilgrimages: the crusader to Christ's sepulcher in the Holy Land, the pilgrim to the tomb of Saint James the Great in Compostela.

Above right:
View of the church and monastery of Sainte Foy
c. 1130.
Conques-en-Rouergue (Aveyron).

The sanctuary dedicated to the young martyr, Saint Faith (*Sainte Foy*), ushered the devout into an enchanting landscape.

(Conques in Auvergne), to mention just the three most famous, were all of massive proportions. These buildings were custodians of the most venerated relics and extraordinary treasures of the goldsmith's craft, intended as prestigious gifts for dignitaries and emperors, and were designed to welcome huge numbers of worshippers. It was possible to walk around the altar (where the most important relics were located) using transept aisles to reach the side chapels off the ambulatory (from the verb *deambulare*, to walk). The women's gallery gave access to the upper story, which overlooked the aisles. This layout, also seen in several Italian, English, and German churches, may have been influenced by the design of the Benedictine abbey of Cluny III, in Burgundy (conceived in the period 1088–1113, and then destroyed), and was even more complex because it also had a double transept. The fact remains that if thousands set off from England and Germany for France and Spain, or crossed the Alps to reach Rome and the ports of Bari and Otranto, final destination Jerusalem, it may well be that they carried with them ideas, cultures, lifestyles, and even the artists (the *artifices* sometimes mentioned in the documents of the time).

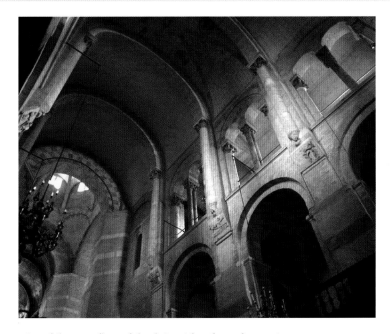

View of the upper floors of the choir, with arches and women's galleries, and crossing with five-story octagonal tower
1080–1150.
Toulouse (Haute-Garonne), cathedral of Saint Sernin.

Toulouse Cathedral is a stunning construction, dedicated to the martyr Saint Saturnine (*Saint Sernin*), and it was the first stop on the so-called *route toulousaine*. Almost every French pilgrim en route for Santiago, in Galicia, stopped here. It is also the only medieval complex to have survived with little modification in this Languedoc city, which boasted many other churches and cloisters, which were destroyed. This cathedral is distinctive for its great height, and was conceived with two floors over the nave and aisles, and a three-story choir. There is a barrel-vault roof with archivolts supported by semicircular piers.

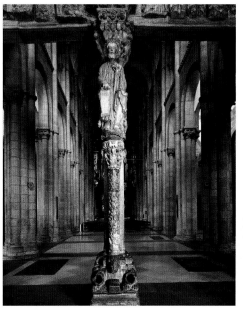

Entrance to the Santiago sanctuary through Master Mateo's Gloria portico, towards the nave
c. 1168–88, building begun in 1075.
Santiago de Compostela (Galicia, Spain).

The Santiago church, one of the most impressive constructions erected between the eleventh and twelfth centuries, underwent many structural modifications over time, above all to its entrances. There is a nave and two-aisle layout, with women's galleries upstairs, a triple transept, an octagonal tower on the crossing, and two towers to the west.

The Road to Santiago and Beyond

The journey undertaken by thousands of pilgrims in the Middle Ages to reach the holy places of Christianity, not only Santiago de Compostela in Galicia, but also Rome and the Holy Land, is documented by a series of extant twelfth-century travel guidebooks. One by Aimery Picaud indicates the stages, marvels, and dangers of the journey to Galicia, whereas the accounts of the Spaniard Benjamin of Tudela, and the English monk Magister Gregorius, describe the Marvels of the City of Rome. The evolution of the Santiago pilgrimage was studied extensively since the time of original suggestions made by Bédier (1908–29), who theorized a link between the *Chanson de Geste* and the Spanish pilgrimage. For Bédier, the *Chanson* was not of the Carolingian period, but actually a series of poems that originated in the eleventh century to validate the ideology of the vast political operation to *liberate* (reconquer) Spanish territory occupied by the Moors, and to support the ever-increasing flux of pilgrims. However likely this fascinating hypothesis may be, the fact remains that after the ninth century, Christian kings in Northern Spain flourished their "patronage of the apostle in the battle against the Muslims" (Oursel 1979), while Cluny Abbey assured the pilgrimage the support of its influence and immense resources. Thus, between

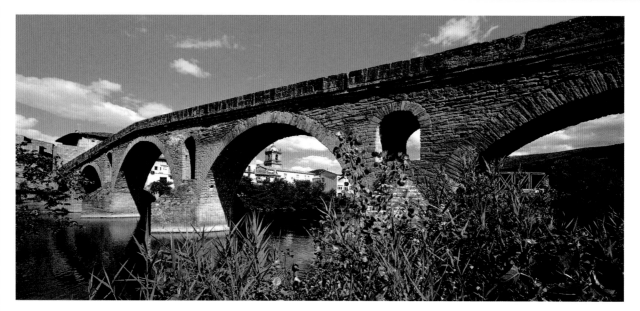

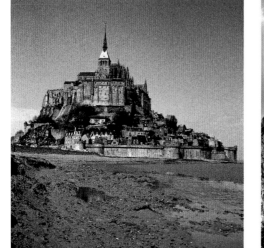

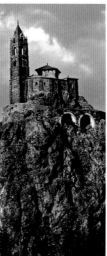

Far left:
View of the abbey begun in 1035. Mont Saint Michel (Manche, Normandy).

Left:
Saint-Miguel de l'Aguilhe Le Puy-en-Velay (Haute-Loire).

These sanctuaries dedicated to Saint Michael the Archangel, protector of Christian soldiers, are built on high ground, in keeping with the cult of the Saint's apparition from the height of a vast cavern.

Above:
Bridge over the River Arga End of the eleventh century. Puente la Reina (Navarra).

On the Navarre route to Compostela, pilgrims would find the bridge, traditionally said to have been commissioned by Queen Doña Mayor. Between the eleventh and twelfth centuries, bridges like this one became widespread, making journeys easier by avoiding dangerous fordings.

the eleventh and twelfth centuries, Saint James the Great (*Santiago*) became the symbol of the crusade against the Moors. This martyr, killed in Jerusalem in AD 44, after evangelizing Spanish territory, was said to have appeared at Clavijo in 844, during the Battle of Ramire, putting to flight the Arabs (hence his appellative *Santiago Matamoros*, Saint James the Moor Slayer). Moreover, he was the brother of Saint John, witness of the transfiguration of Christ and the only Apostle whose body was never moved from where it came to rest after transportation from the Holy Land—Compostela, of course. Visiting the tomb meant venerating one of Christ's closest companions, *primus ex apostolis*, as the Ultreia march declared. Aimery Picaud's guide-book (c. 1135) describes four routes for reaching Santiago, and each begins with a visit to a sanctuary: Sante Foy at Conques, Saint Martin in Tours, Madeleine in Vézelay, and Saint Gilles in Le Puy, splendid monuments and rich with relics. Others were indicated by the Cluny Order, and many constituted the stopovers for those who crossed the Alps and reached Rome along Via Francigena. From the end of the eleventh century, the pilgrims going to Rome were joined by the crusaders, and from 1300, at regular intervals by the Jubilee pilgrims.

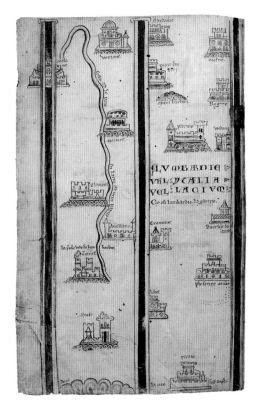

Itinerary from Susa to Sarzana,
from Matthew Paris, *Chronica Maiora*
1250–59.
Cambridge, Corpus Christi College, ms. 26, c. 2v.

The itinerary drawn up by the monk Matthew Paris, of Saint Albans monastery north of London, is handed down in four manuscripts kept in London and Cambridge. The work illustrates the stopovers on the way to Rome, with a sequence of miniatures showing single towns or settlements.

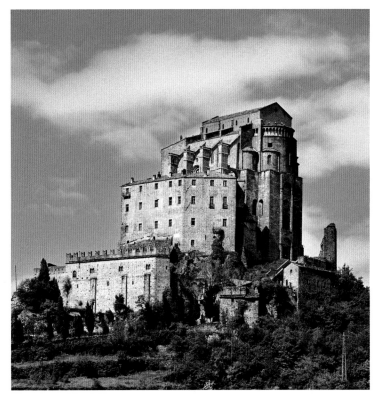

Sacra di San Michele
twelfth century.
Val di Susa (Piedmont).

This abbey on Mount Pirchiriano was erected on a rock spur, just like all the other medieval hermitages linked to the worship of Saint Michael the Archangel. It stood at the crossroads with the section of Via Francigena in the direction of Sarzana, so it was the first stop for pilgrims who had crossed the Alps on their way to Rome. Here they could pray and meditate in the abbey church, enhanced with splendid reliefs, and also rest in the guest quarters set aside for them. Almost all the sanctuaries along pilgrimage routes, both in France and in Italy, offered similar hospitality.

The Roads to Saint Michael the Archangel

A young Greek pilgrim, Nicholas, came ashore at the port of Otranto, in 1094, bound for the Mount Sant' Angelo sanctuary, on the Gargano promontory, where Saint Michael the Archangel had long been venerated. Exhausted by his journey, Nicholas then reached Trani, where he fell on the steps of what was the cathedral in those days, dedicated to Our Lady. In just a few days he died of privation. This legend is at the root of the foundation of Trani's new cathedral, one of the most suggestive of Apulian Romanesque, dedicated to the pilgrim saint later buried there. The pilgrims traveling to the Gargano hilltop sanctuary arrived along the roads of Apulia and the sheep tracks originating in Abruzzo. This is precisely where the custom arose of dedicating to the dragon-slaying archangel and *custos ecclesiae* the highest parts of a building, often—in its turn—set *in summitate*. The *culte aérien* or angel cult, believes that Saint Michael appeared on the Gargano on May 8, 492. Mount Sant'Angelo is in the area known as Capitanata and stands at the confluence of the roads that connected the Bari lands with the rest of the peninsula. The roads were used not only by pilgrims, but also by merchants and crusaders who sailed for the Orient from the more southern Adriatic ports of Bari, Otranto, and Brindisi, mentioned by the geographer al-Idris in the twelfth century, and also Vieste and Manfredonia, near

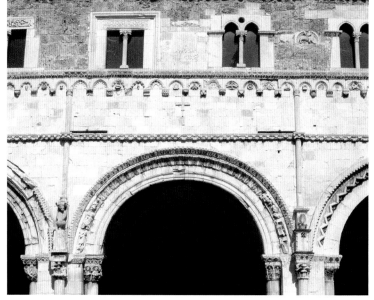

Left:
Rainaldo
Saint Michael the Archangel
c. 1160, sculpted and openwork marble.
Pisa, Museo dell'Opera Primaziale.

The worship of Saint Michael the Archangel was widespread in western Christendom, as we can see from the extensive iconography showing him with a drawn sword, triumphing over the dragon, or in a blessing pose.

Above left:
Saint Nicholas Pilgrim
c. 1089–1185
(thirteenth-century campanile).
Trani (Bari).

On the sea, in a stunning location, this building comprises three churches built one over the other: the underground church of San Leucio (eighth century), two crypts, and the cathedral with a nave and two-aisle basilica layout, renovated from 1159 to 1185.

Above right:
Atrium of the Benedictine abbey, detail
c. 1176.
San Clemente a Casauria (Pescara, Abruzzo).

In about 1176, above the triple-arch atrium, Abbot Leonate ordered the addition of an oratory overlooking the interior of the nave, dedicating it to Saint Michael and to Saint Thomas Becket.

Siponto. Moreover, Apulia's rural production played a leading role in trade with the North at that time, especially with Venice. From the *Chronicon Casauriense* documents (late twelfth century, Paris, Bibliothèque Nationale), we know that around 1165 Abbot Leonate of Abruzzo's influential San Clemente a Casauria monastery, following a donation from the Norman Count Goffredo, had sent to Capitanata's Lake Lesina, along the transhumance sheep tracks, *artifices cum expensis et operarios, equos et animalia*, in other words artists with much money, workers, and horses and other animals, in order to build a church and a monastery (Fossi 1981 and 1984). It is now proven that subsequent to this event, these same artists, also active in the Abruzzo monastery, spread a style on the Gargano (or vice versa, imported from there to Abruzzo) that seemed to derive from western French reliefs. Angoulême would appear to have been the source of an "aesthetic taste" that can be identified at Casauria, Pulsano on Mount Gargano, and San Leonardo at Siponto, a church with its own hospital and guest quarters: an exemplary confirmation that pilgrimages also played a crucial role in the diffusion of decorative themes.

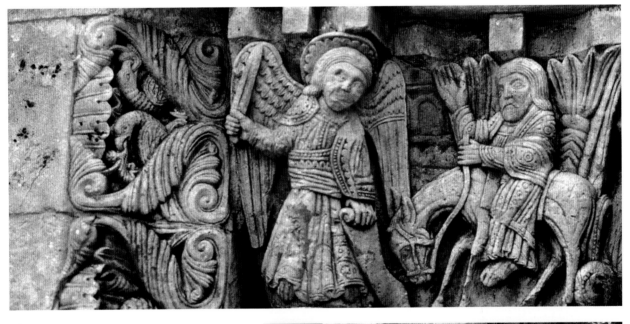

Above:
Balaam's Donkey or *The angel Guiding the Pilgrim to Mount Sant'Angelo*
post-1175, stone.
San Leonardo di Siponto (Foggia).

Right:
Capital
post-1175.
San Clemente a Casauria (Pescara).

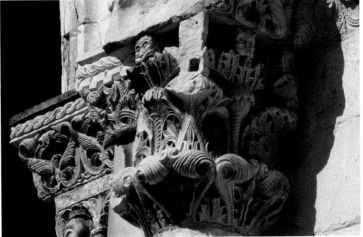

The Siponto reliefs show such a similarity to the Casauria atrium and portal decorations that we can well believe they were by the same masters active in Apulia and Abruzzo, confirmed by chronicles of the era. In their turn, these decorations seem to derive from a very distant church: Saint-Pierre Cathedral, at Angoulême, in France.

The Marvels of the City of Rome

In about 1148, one *Guillelmus David* stated in a letter-book entry at the French abbey of Saintes, that he wanted to be buried *sub Costantino de Roma qui locus est ad dexteram partem ecclesiae*, in other words under "Roman Constantine," a relief figure that prior to the French Revolution demolitions was under the first-floor arch in the French church. The *Costantino de Roma* was none other than the ancient bronze statue of Marcus Aurelius, installed in Rome's Piazza del Campidoglio in 1538, but from the tenth century until its transfer, was located opposite the Pope's palace in Piazza del Laterano. In medieval credence, the statue, which originally had a figure of a sub-jugated barbarian between the horse's legs, was an effigy of Constantine, the first Christian emperor. Stone homages to the impressive imperial bronze, "Christianized" and transformed according to the most typical canons of Romanesque sculpture, are quite frequent on church portals in western France, although they are now so deteriorated that they pass almost unnoticed. We do not know if the French expression of the ancient model derives from direct knowledge of the prototype, or if it became popular simply thanks to the descriptions in the *Mirabilia urbis Romae*, guides popular in the

Filippino Lippi
Marcus Aurelius, detail from frescoes
in the Carafa chapel
1488-93.
Rome, Santa Maria sopra Minerva.

The famous fresco by Filippino Lippi illustrates the original location of the colossal bronze statue of Marcus Aurelius, set opposite the loggia of the Papal Palace in Piazza del Laterano, from where it was moved to the Campidoglio in the sixteenth century.

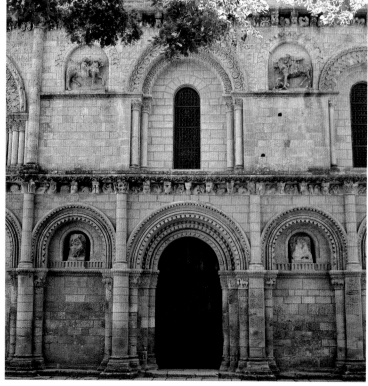

French stonework
Constantine Knight
end of the twelfth century.
Notre-Dame de Surgères (Aunis, Saintonge), upper section of the west facade.

The Knight of Surgères, an evocation of the Roman Marcus Aurelius statue, is one of the best preserved of those found in Romanesque Saintonge.

twelfth and thirteenth centuries, in various editions (two of the most renowned, as already mentioned, were those of Magister Gregorius and Benjamin of Tudela). A version dating to the mid-twelfth century, later repeated with few variations, says that in the Lateran there was a *caballus aereus qui dicit Constantini, sed non ita est.* In other words, it was a case of "mistaken identity," but not really in error, and in the Middle Ages, the equestrian statue had assumed a new ethical and political significance, as had other ancient sculptures (the Dioscuri and the She Wolf). It certainly does not appear to be mere coincidence that in the same French churches adorned with the "Constantine on horseback," shown with a flowing cloak and a figure at his feet, there is often, especially on capitals, the so-called *Spinarius*, the image of a boy removing a thorn from his foot, a clear reference to a sculpture of Hellenistic origin, which was also in Piazza del Laterano at that time. The *Spinarius*, transfigured in accordance with Christian ethics, into the symbol of March or of one of the "ages of man," is actually one of the most widespread and differentiated Medieval references to the ancient world, not only in Saintonge, but throughout Europe: from Switzerland to Germany, Italy to France, in stuccoes, bronzes, frescoes, and capitals.

Brother Pantaleone
The Month of March, detail of the mosaic depicting the months
1163–65.
Otranto, cathedral, nave.

This vast mosaic was commissioned by the Archbishop Gionata and laid by the monk Pantaleone, confirmed by the floor inscriptions. The mosaic covers the nave and two aisles of the church, unfolding a complex iconographic cycle, including tondi with months and signs of the zodiac. In Medieval iconography, each month represents a trade, or human labor, in expiation of original sin. The month of March, as seen in other depictions of the time, including miniatures, is symbolized by the *Spinarius* (or "thorn remover"), here seated naked on a bench, removing the thorn with a twig. There is clearly an enormous difference between the Roman and the Romanesque models.

Top right:
Spinarius
early twelfth century, stone.
Le Puy-en-Velay, Musée Crozatier.

One of the oldest Romanesque depictions of a youth removing a thorn from his foot.

Roman art
Spinarius
first century AD, bronze.
Rome, Musei Capitolini.

This ancient sculpture was admired by medieval pilgrims in Piazza del Laterano.

The Sumptuary Arts

At the end of the journey pilgrims hoped to admire, venerate, and possibly even touch an image, a statue, a sepulcher, a relic "to encounter a transcendent reality in Faith" (Sot 2004). In this way, the good Christian would somehow bring his soul closer to that of the venerated saint and consequently come closer to Christ himself. To use a modern-day expression, this phenomenon was a kind of "existential" experience, and had two consequences of extraordinary scale, as we have seen, in the field of architecture and figurative arts, as well as having an enormous influence on the diffusion and realization of precious objects, reliquaries, ivories, bronzes, enamels, and in general works of the goldsmiths' art, intended for liturgy and pomp (for instance, pastoral staffs that culminated in often quite elaborate "crooks"). This shimmering sphere of gold and precious stones is now described with the expression "sumptuary arts" (from the *Latin sumptuarius*, "expense"). The artworks were extremely costly because of the materials used and the elaborate techniques required for their completion. The crafting of gold, bronze, and ivory had already developed enormously during the times of Charlemagne and Otto, also for reasons linked to imperial celebrations, but as pilgrimages and the veneration of relics increased, the art reached its peak in the Romanesque and Gothic period. Gold crafting played an

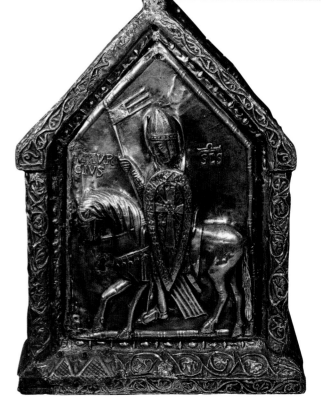

Castilian artist (?)
Crozier crook of Saint Julian de Cuenca
twelfth century, gold and enamel.
Cuenca (Castile-La Mancha), Museo Diocesano Catedralicio.

Saint Michael the Archangel is the key figure in this crozier crook (see enlargement on page 15), whose curve is exploited to depict the dragon, in the guise of a serpent, vanquished by the warrior saint.

Nordic master
Reliquary of Saint Maurice
twelfth century, silver and gold.
Saint Maurice d'Augune Abbey (Valais, Switzerland).

The martyr saint—killed in the third century on the spot where the abbey in his honor was later built—is shown here garbed as a crusader.

important role in monastic workshops, and also in those of courts and towns. A lively iconography, linked to the lives of saints, their miracles, and their martyrdom, was applied to objects of the most disparate forms, where presumed relics of figures who had become legendary were incorporated or set. The phenomenon proceeded at the same pace as the increasingly fervid quest for "bodily evidence," which often led to rivalry among sanctuaries, contending holy relics to parade before the devout for worship. One quintessential example is that of the theft of the remains of the bishop and saint, Nicholas of Myra, which at the end of the eleventh century were crucial in ensuring trade and other success for Bari, where they were taken.

The Apulian port then dedicated a cathedral to the ancient Byzantine patron of sailors (not to be confused with the pilgrim, Nicholas, later worshipped in Trani) and became the European capital of the worship of Saint Nicholas. As the eleventh century came to an end, concurrently with Pope Urban II's First Crusade (1095), the iconography of saints was enhanced with a new element: the holy soldier, fully armed, bearing the typical crusader shield (as can be seen in the reliquary of Saint Maurice, who really had been a soldier, the commander of Thebes' legendary Roman legion).

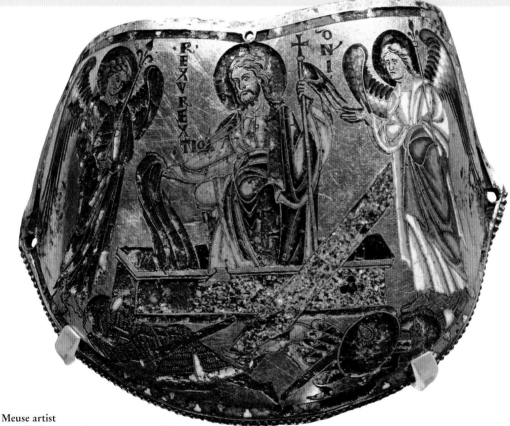

Meuse artist
Armilla depicting the Resurrection of Christ
c. 1170, gilt copper and champlevé.
Paris, Louvre.

For some time this was thought to be a shoulder-plate from a suit of armor, but like the *Pendant with Crucifixion* (now in the Nuremberg Museum), it was actually an *armilla*, in other words a decoration to wear on the upper arm. Mystery surrounds this extraordinary artifact and its twin, made by one or two different artists, whose talent produced the refined painting of the figures and who were master craftsmen of the champlevé enameling technique. This is thought to be a gift from Frederick Barbarossa to the Russian Prince Andrea Bogoljubskij, in whose tomb the two armillas are said to have been found.

Forms and Techniques

From the time of Desiderius of Montecassino and Suger of Saint Denis, upholders of ecclesiastical splendor, many monasteries were large goldsmith's shops. We find confirmation in the treatise *De diversis artibus*, penned by a German monk, who went by the pseudonym of Theophilus (early twelfth century), and who may have been the goldsmith Roger, of the Benedictine Abbey of Helmarshausen, in Rheinland. The essay was in three sections, each dedicated to an art, like a manual for painting on walls, on panels, on parchment, one for stained glass, one for goldsmithing, showing us how much prestige was attached to the crafting of gold. A monastery, says Theophilus,

must have kilns, tubs, an *organarium* for drawing the gold, and all the tools required by the *aurifices*, *inclusores*, *seu vitrei magistri* (goldsmiths, gem setters, master enamelers, and glaziers). There were also workshops run by laymen, like that of Grand Pont, in Paris, where nonreligious items were made *à l'usage des barons et des nobles dames*. Now we should consider techniques, as they were used to create the most disparate forms in Spain, as in France, Italy, Germany, and England. The goldsmith cut and engraved. Theophilus writes that the intaglio was done using "designs," and could be concave or relief; it was also common to find embossing and chasing, which allowed a plate to be embossed on the back and

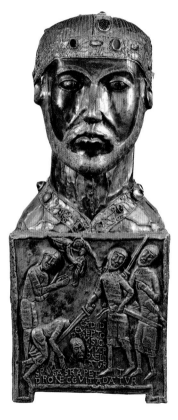

Reliquary bust of Saint Candide, whole and details
1165, silver, gold leaf, gemstones, walnut.
Saint Maurice d'Augune (Valais, Switzerland).

The head-shaped reliquary, with a cranium included in the carved wood, contains the remains of Saint Candide, the legendary companion of Saint Maurice in the Roman legion at Thebes. The events of his martyrdom are forcefully embossed onto the base, in a simultaneous narrative from his decapitation to the ascent of his soul to Heaven.

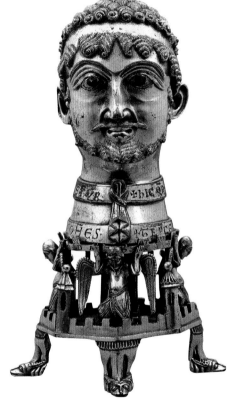

Aachen school
Reliquary bust of Frederick I
c. 1155, gilt bronze, with partial silver coating.
Cappenberg, Stiftskirche.

This portrait of Frederick Barbarossa (1123–90) conceals relics of Saint John, and seems to have been donated to the Emperor by his godfather, Otto of Cappenberg.

chased on the front, creating objects in the round. Copper and less noble metals might be gold-plated to make them look more valuable, while for silver it was customary only to gild in part. Reliquary busts, for example, are particularly striking, for the contrast between golden hair and beard, and silver skin. Objects like the *Bust of Saint Candide*, illustrated here, constituted "a fundamental step in the development that brought about the bust portrait of the modern day" (Collareta 2003). Lastly, there was *clusoria*, that is to say, the art of gem setting, which developed during the "barbarian" period, using the *cabochon* cut, which allowed for various plays of color and brightness. The geometrical interplay of the differently shaped stones was also exploited, set with gold leaf and refined filigree. Nor should we overlook enamel, which in Byzantium was made using the *cloisonné* method on gold, whereas in the West the *champlevé* technique was set on copper. The figures were enameled onto gilt backgrounds, or gilded onto enameled backgrounds. The great Meuse and Rhine schools (whose famous exponent in the twelfth and thirteenth centuries was Nicolaus de Verdun), as well as those of Limoges and, as is now confirmed, above all those of Conques, produced a huge volume of enameled objects for any number of applications.

Above:
Limoges school
Wise Virgin
c. 1180, gilt copper, engraved champlevé.
Florence, Museo Nazionale del Bargello.

One of ten altar panels.

Conques school
Medallions
1110–30, gilt copper, champlevé.
New York, Metropolitan Museum of Art.

The two medallions are part of Abbot Boniface's famous casket, of which several pieces still belong to the treasure of Conques Abbey; others are in Florence's Museo del Bargello. The decoration comprises stylized illustrations of fantastic birds and animals, possibly inspired by the iconography of oriental fabrics.

French school
Crozier crook
end of tenth–early eleventh century, gilt bronze.
Rheims, Palais du Tau.

Tradition decrees that this crozier crook belonged to the Archbishop Odalricus (governing in Rheims in about 969). The object's minimal appearance confirms its antiquity, with a focus on the monkey's head, realized in the round in the closing part of the curve.

The Romanesque Period | *Forms and Techniques*

Ivories

The production of ivories was noteworthy for its variety, quality, and the number of subjects that have survived. This can be chiefly attributable to a tradition that continued without interruption from the Carolingian age, in its own turn the legacy of consolidated late antique and Byzantine practices. From the eleventh to the twelfth centuries, refined ivories were carved in Scandinavia, in Anglo-Saxon countries, and in almost all areas of continental Europe. Ivory was already difficult to acquire and very costly: it was produced from the bones of walruses, narwhals, and other cetaceans (in Nordic countries), or from the bones of large mammals (less prized), and most often was made from African and Indian elephant tusks. These tusks had to be well-aged before carving, to avoid any risk of shrinkage, and much of the tusk was discarded because the material was unsuitable for crafting. Apart from a few mentions in Theophilus's treatise, no indications have come down to us on crafting techniques, although there is no doubt that the fine carving required great dexterity, on a par with that of a miniaturist. It would seem that ivory was often carved by the same craftsmen who worked with wood. Ivories were intended for a very small circle of patrons, and apart from their unique elegance, they also have a complex iconography. Outstanding in its production was Spain, heir of those

Sicilian school
Crozier crook with gazelle's head
second half of the twelfth century,
ivory with polychrome traces.
Paris, Louvre.

Beauvais school (?)
Crozier said to belong to Bishop Yves of Chartres
end of the eleventh century (base not relevant), elephant ivory.
Florence, Museo Nazionale del Bargello.

We know little of ivory production in northwest France, and this is a rare surviving artifact, stylistically similar to a number of Anglo-Saxon crozier crooks. The bishop shown in the center of the crook is surrounded by deacons and figures in veneration, surmounted by a typical arched structure with belfries: a common feature in contemporary miniatures and monumental sculpture. The crozier crook, however, which ends in a dragon's head, is decorated with fantastical animals and nude figures in twisting branches. The object is of exquisite taste and remains, rightly, one of the most famous ivories of the era.

Mozarabic ivories influenced by Islamic art, which flourished on the Iberian peninsula at the time of Arab domination. In about the mid-eleventh century, a variety of influences were already converging in the wonderful carvings, with their imperial connotations, of the Leon reign. In about 1060, at San Millan de la Cogolla, a German master, Engelram, carved his name on an ivory and gold reliquary. One of the great masterpieces of this period was the large *Crucifix* donated in 1063 by Ferdinand I and Queen Sancha to their Palatine chapel at San Isidoro de León; another is the whalebone ivory depicting the *Adoration of the Magi* (twelfth century, Victoria & Albert Museum). If Spain's imperial patrons also influenced iconography and objects,

in other regions there was an equally varied production of ivory, ranging from caskets, reliquaries, and pastoral items to secular objects like combs, chess pieces, and chessboards. The Norman conquest (1066) then intensified trade between England and the North French coast, so it is now difficult for us to distinguish which items came from which country. From at least the late eleventh century, there was certainly a proliferation of shops in Sicily (Palermo), and in Campania, at Amalfi and Salerno, the city that produced one of the most complete surviving chess sets.

Scandinavian art (Norwegian?)
Chess piece
end of the twelfth–early thirteenth century, walrus bone.
Paris, Louvre.

French or Anglo-Saxon art
Chess piece
twelfth century, ivory.
Florence, Bargello.

The most numerous secular ivory objects that have come down to us from the Middle Ages are the chess pieces, confirming they were widespread throughout Europe. They are found in many museums worldwide and have a noteworthy liveliness of expression.

León reign workshop
Cross of King Ferdinand and Queen Sancha
1063, ivory.
Madrid, Museo Arqueológico Nacional, from the Palatine Chapel at San Isidoro de León.

A masterpiece of Spanish ivory crafting, this large crucifix is 52 centimeters high and was commissioned by the progressive sovereigns, Ferdinand and Sancha, whose names are on the base of the opus. The carvings at Christ's sides are very complex and original, with countless figurines filling out the rinceaus.

The Art of Bronze Craft

"Chalices, chandeliers, thuribles, ampollas, vases, reliquaries, cruci-
fixes, Gospel cases" are the liturgical items "without which the divine
mysteries cannot continue," said Theophilus in the twelfth century,
teaching craftsmen who worked metals, especially bronze and
copper. Although little of it has survived, metalworking was one of
the Romanesque era's most important crafts, practiced mainly in
Germany, between the Rhine and the Meuse, and in Lower Saxony:
small liturgical objects, caskets finished in the round, but also
majestic works, like the Lièges font cast by Renier de Huy (c. 1107).

The technique of melting bronze in wide casts, widespread in the
Christian West between the eleventh and twelfth centuries, has
Byzantine roots. Works brought from the Orient were held in great
esteem: one perfect example is the episode of the huge Islamic
gryphon (eleventh century), which the Pisans considered such a rarity
that they installed it on the roof of their duomo. In southern Italy,
outstanding for having the largest number of bronze doors of that
era, the doors of Amalfi Cathedral had been brought from
Constantinople in 1062, then Desiderius of Montecassino ordered
those for his abbey (1066), not to mention those intended for the

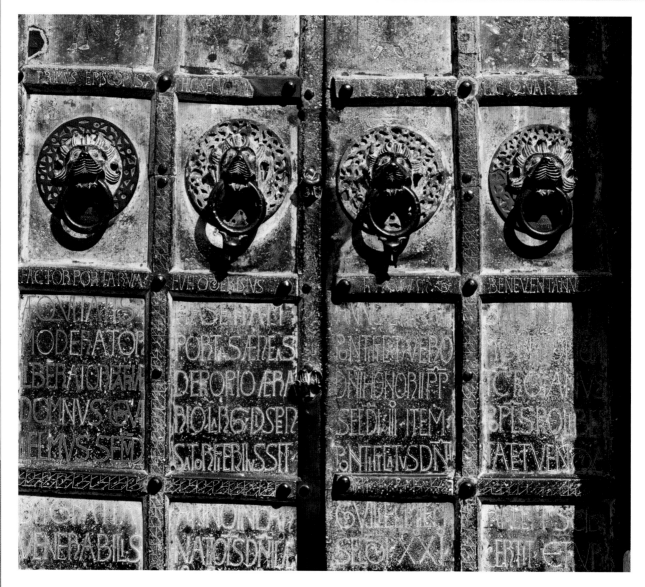

Mount Sant'Angelo sanctuary on the Gargano, commissioned in 1067 by two Amalfi merchants, Mauro and Pantaleone. The technique combined niello and damask work (nielloing is the method used to fill in grooves with colored material; damask work is the ingraining of gold, silver, pearls, gems, and enamels). Scenes were emphasized by filling in the chased incisions with red or two shades of green mastic. On the Gargano doors, both the silver and the copper are ingrained in the figure outlines. This typology, like that of other Byzantine doors featuring framed figured panels and relief busts of lions serving as handles, must have inspired those produced locally, for instance: the door for Bohemond's mausoleum at Canosa, cast in part by Roger of Melfi (c. 1180), and Abbot Joele's door for San Clemente a Casauria (c. 1182). Nevertheless, the autonomous and rather early masterpiece is by Oderisius of Benevento (1119), whose signature is on the doors of Troia cathedral. For the first time "a church exploited the full expressive potential of bronze," multiplying the knockers to two registers of four panels, as well as adding two with monstrous winged creatures, springing unshackled from below" (Pace 2003). Moreover, we should not forget the Barisano series (1175–1200) at Trani, Ravello, and Monreale, where Bonanno had also worked.

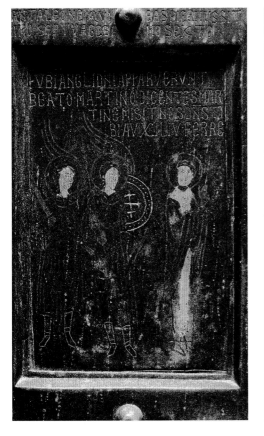

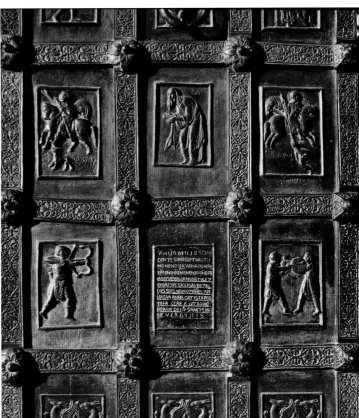

Facing page:
Oderisio da Benevento
Door panels and leafs
1119, bronze.
Troia (Foggia), cathedral.

Above left:
Byzantine art
The Angels Appear to Saint Martin of Tours,
panel detail
c. 1076, bronze. Mount Sant'Angelo (Foggia).

The panels from the bronze door at Mount Sant'Angelo, made specially at Byzantium, are some of the most refined for their use of niello and damask technique.

Above right:
Barisano da Trani
Door panel
c. 1175, detail of bronze.
Ravello (Salerno), cathedral.

Barisano places his figures in small frames, so they stand out from the door background, which is divided into squares decorated with studs.

Wood Sculpture

Despite the relative perishability of painted wood, there are dozens of in-the-round sculptures made from this material throughout Europe. Theophilus wrote that woodworking shops in the twelfth century were separate from those of other crafts, and the *carpentari*, or master woodworkers, were often members of the Masonic corporations. In England, the term also denoted those who repaired buildings. In any case, wood was used extensively for buildings, for decorated doors (like those of Le Puy and Corneilla de Conflent), for altar furnishings, and, of course, for furniture, of which very little has survived. The

most common types to have come down to us, simply because they are linked to popular devotion, are the *Madonna and Child*, crucifixes, and a few *Depositions*. Usually the wood was carved in one piece; in effigies of the Madonna holding Jesus in her lap, the Child might be carved as a separate piece. Another method was that of fitting together several pieces of wood, each carved separately. These statues were of various sizes and contained relics, which may well be one reason why they have survived in large numbers. Bright colors were used to paint the statues, and gold was sometimes used for the skin, imitating the more precious objects made by goldsmiths. There

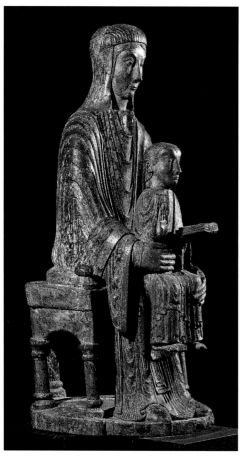

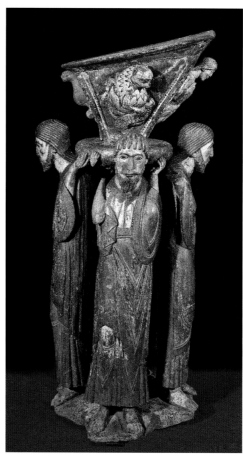

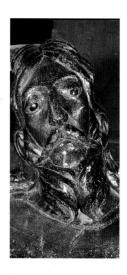

Auvergne art
Enthroned Virgin
mid-twelfth century, polychrome wood.
Forse da Vauclair, Molompize (France).
German art

Lectern with symbols of the four Evangelists
mid-twelfth century, polychrome wood.
Freudenstadt (Baden-Württemberg), Stadtkirche, brought from the abbey church of Alpirsbach Monastery.

Tuscan art
Holy Face, detail
twelfth century (?).
Lucca, Duomo of San Martino.

are also some famous statues with black faces, and this unique iconography is now explained as the result of Byzantine influences (from icons), from verses in the *Song of Songs*, or deriving from the Muslim world. Cataluña, the Auvergne, and more sporadically, Italy, are the areas where the theme of the *Mother of God*, or the *Sedes Sapientiae*, seated on a throne with her Son in an axial position, seems to have been most widespread; in the thirteenth century this model evolved into ever less static and more expressive positions. In this period there were also versions of *Christ in Glory*, wearing a crown decorated with huge flowers, and of *Christus patiens*, His

expression twisted in pain. There are also variants of Christ without garb and those where He wears a long pleated tunic, brightly colored and decorated, emulating precious fabrics: this is the case of the so-called *Majestat Battló*, in Cataluña, which is one of a significant group of crucifixes, some German, whose prototype is traditionally identified as the *Holy Face of Lucca* (possibly twelfth century), an object of deep veneration and thus often visited by pilgrimages. In actual fact, the real model for these works was probably lost.

Above and right:
German art
Cross of Imervard
mid-twelfth century.
Brunswick (Lower Saxony), Sankt Blasius Cathedral.
Catalan art

Christ crucified (Majestat Battló)
mid-twelfth century, painted wood.
Barcelona, Museu d'Art de Catalunya.

German and Catalan crucifixes of the twelfth century, like the two illustrated here, show a common iconographic reference to the greatly venerated *Holy Face* of Lucca, shown on the right, opposite page, which legend says was sculpted in cedar of Lebanon by Nicodemus, a follower of Jesus.

Mosaics

In the early twelfth century, Baldric, Abbot of Saint Pierre at Bourgueil, in France (Indre-et-Loire), described a mosaic floor that he had seen in the apartments of Adele, Countess of Blois. For the time, it is a rare description of a secular figurative work and so charming that some have suggested it was an invention. In reality, the description of this stunning atlas of the world, as it was known in those days, was quite likely, and when we read of the sea that seemed to be moving, similar mosaic illustrations come to mind, like that of the duomo of Monreale. Baldric describes the floor in the countess's chamber as depicting "the shape of the world": "One could see the monsters of the Earth and the Sea, with their names; all surrounded by a flowing green color, which was the sea that seemed to be moving; there was the island too, and one could see creatures of the sea like whales, cachalots, and other such marine monsters [...]. The entire Earth was surrounded so that the rivers entered the ocean; it was round in shape and the order was absolutely divine, contributing to its complexity, but the craftsman's skill had also contributed greatly." The art of mosaic was inherited from Roman and late antique times, and in the twelfth century was applied to flooring in many countries: France,

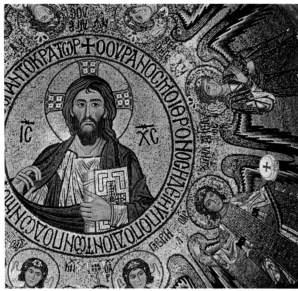

Left:
Brother Albericus
floor mosaic detail
c. 1150.
Saint Denis
(Ile-de-France),
abbey church.

Far left:
Christ Pantocrator
c. 1150, mosaic.
Palermo, Palatina chapel
cupola.

Above:
Town of Bethlehem
twelfth century, mosaic.
Rome, San Clemente.

England, Germany, Spain, and also in Italy (although few examples have survived). Iconography was inspired by subjects similar to those described by Baldric, or by the months, the zodiac, and scenes from the Old Testament. Mosaics could cover vast areas of churches, as can be seen in the huge Otranto floor, shown on page 55. Nor is it surprising that severe Bernard of Clairvaux condemned mosaic floors, since in his opinion the "fine holy illustrations" depicted by this art were destined to be covered in dust and spit: "Why not respect at least the images of the saints, instead of laying them on the floor and walking on them? Often the image of an angel is spat upon and the head of a saint is trodden on." There were various techniques: Some copied the Hellenistic examples of the *opus alexandrinum* (intarsia of precious marble), some the Roman *opus tessellatum* (small tesserae) and *opus sectile*, use of pebbles. In Italy the wall mosaics of Byzantine tradition were also continued, and mosaicists from the Orient, possible itinerant artists, worked in Venice and Palermo. It was their teaching that allowed local craftsmen to continue, producing works like the vast cycle in the Florentine baptistery, and also influenced panel painting.

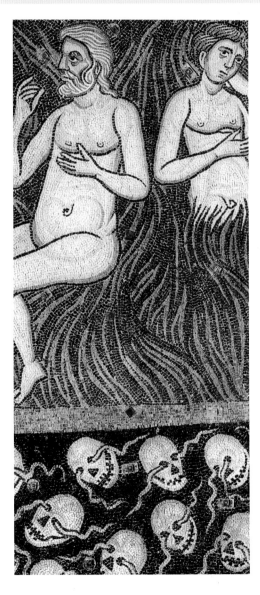

Left:
The Damned in Hell
detail from the *Last Judgment*,
twelfth century, mosaic.
Torcello (Venice), cathedral counterfacade.

A powerful evocation of divine justice, with the crude depiction of those condemned to suffer in Hell, thus shown naked, and also a *memento mori*, with horrible skulls crawling with worms.

Above:
A Drowning Man in the Great Flood,
detail, *Old Testament Stories*
c. 1180–85, mosaic.

Monreale (Palermo), Duomo,
left nave wall.

67

The Romanesque Period | *Mosaics*

Wooden Ceilings and Panel Paintings

In Switzerland's ancient Raetia area, in a small church in Zillis, near Coira, there is one of the earliest vast pictorial cycles of Romanesque culture, with religious and secular figures, and the only known painted wooden ceiling of the twelfth century. The art history of this period must, in point of fact, take into account some serious gaps and the fact that many works have not survived. Today we are unable to establish whether this extraordinary figurative document of 153 framed panels, each with a tale linked to the Old and New Testaments, with personifications of the forebears of Christ, and with a series of imaginary sea animals, is an isolated case in the Romanesque painting scenario. Only one other wooden ceiling has survived, in the church of St. Michaelis, in Hildesheim, but this is dated the first half of the following century. Panel paintings would appear not to have been so rare, at least in some regions, like Cataluña and Italy. In fact, there are several Catalan altar fronts, called *paliottos* (now found in museums at Barcelona and Vic), which confirm a rich, varied production in that area, following a parallel development with Catalan frescoes. There is evidence of various style phases: one influenced also by Lombard frescoes, and another

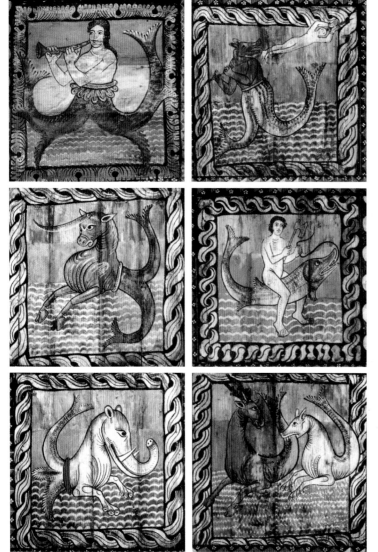

Left:
Coira Master
Fantastic sea animals, detail of ceiling panels c. 1140, painted wood.
church of Saint Martin in Zillis (Switzerland).

Nereids playing music, wolves and elephants with fish tails: This is the fantastic bestiary on several of the 153 panels of the Zillis wooden ceiling, "the mirror of the Medieval universe."

Above:
Catalan school
Saint Paul Apostle surrounded by angels, end of the twelfth–early thirteenth century, tempera on wood.
Barcelona, Museu d'Art de Catalunya.

This is a side fragment of an altar front from Auros (Pallars Sobirà), distinctive for its lively color contrasts.

bridging the twelfth and thirteenth centuries, characterized by a neo-Byzantine current, also defined as "Italo-Byzantine" for its affinity with oriental, Arab, and Byzantine trends in contemporary Italian painting. Typically Italian are the crucifixes painted on panels, found mainly in Tuscany and Liguria (Sarzana, Pisa, Lucca, Florence), and in Umbria (Spoleto), which represented the first step towards the Gothic era's large-scale production. Theories regarding what little remains (about ten pieces) evolve continuously, especially with regard to the paternity of the works, almost all anonymous, except for the crucifix signed by a Master Guglielmo (Sarzana, 1138) and one by Alberto Sotio (Spoleto,

1178). The figures were painted on wood or on sheets of leather or parchment, then glued to the cross-shaped wooden support. These huge panels hung above the high altar, where all the worshippers could see them, or above the iconostasis, which separated the aisles from the presbytery. *Christ on the Cross* is not yet depicted as the suffering *Christus patiens* of the Gothic period, surrounded by episodes from the Passion, by the mourners, and by the Evangelists' symbols. Some works have "Christ in Majesty" painted on the upper arm.

Florentine master
Painted crucifix
c. 1180, tempera on wood.
Florence, Uffizi Gallery.

This large painted cross, also known by the museum inventory number (*Croce 432*) until very recently attributed to an anonymous Pisan master, but is now said to be the work of an anonymous Florentine master, probably briefed on mosaics by the Byzantine and Arab craftsmen working in Palermo's Palatine chapel. It is likely that these same craftsmen later influenced the first great mosaic works in Florence's Baptistery cupola. On the board, Christ is shown in a stiff frontal position, his gaze fixed like in a Byzantine icon, and at each side we see the Passion narrated with unusual expressiveness and energy.

Wall Paintings

Our concept of the Romanesque church makes us think of austere interiors, perhaps rich in sculpted decorations on column or pillar capitals, enhanced by an altar with relief ornamentation or a pulpit, but nothing more. We think of these churches as plain, with simple plaster or stark exposed stone blocks. Yet precisely these stone blocks, so beautifully hewn, were covered with frescoes after they had been plastered. This is explained by the Medieval mind's *horror vacui* and by a strong decorative creativity, which also led to the adornment of floors, portals, and facades. Only a tiny percentage of

wall paintings have survived, not least of all because in the nineteenth century many frescoes were whitewashed or destroyed, so that the original stone blocks were exposed, impusing on them a "purist" but mistaken concept of Romanesque architecture. For years, this same theory rejected a reality that can no longer be disputed—that of a far more colorful style than is imagined, even in sculpted decoration. On the other hand, we should consider the sheer size of the Romanesque interiors, with apertures that were relatively small, windows that were little more than slits with rare glass panels and at most a wheel-window in the counter-facade, allowing paintings to

Left:
Poitiers school
Noah's ark, detail of *Stories from Genesis and Exodus*
end of the eleventh century, fresco.
Saint-Savin-sur-Gartempe (Vienne).

The cycle extends from the crypt to the gallery, to the nave vault.

Above:
León school
God's hand between the prophets Enoch and Elijah
vault detail post-1150, fresco.
Sant'Isidoro de León (Castile y León), Panteon de los Reyes.

This lovely fresco cycle, lavish with appealing connotations, features an accentuated outline linearity and figures with elongated limbs. The work dates to the time of Ferdinand II, King of León (1157–88), who also appears among the illustrated figures, with his wife Urraca.

occupy vast surfaces, both on the walls and on the barrel vaults. This was not the case with Gothic architecture, where the smaller spaces available to frescoists, especially in Italy, were found in chapels set aside for the purpose, or around large windows. Fresco techniques were used for wall-painting at that time, sometimes combined with tempera or paint spread on dry rather than on wet plaster. The inevitable deterioration meant that extensive repainting occurred over the years, and despite increasingly effective restoration techniques, some applying the detachment method, removing the frescoes from the walls, mere snippets were recovered of huge painted surfaces.

Some of the best-preserved cycles are in Spain, many now separated from the original context, however, like those in the splendid Museu Nacional d'Art de Catalunya, in Barcelona (in particular, wall decorations from Tahull). At Saint Savin sur Gartempe, in France, it is still possible to see the largest, liveliest Old Testament cycle, although it is not very legible; the small Burgundian church of Berzé-la-Ville, however, has retained mere fragments that nonetheless suggest the quality of the far greater frescoes of the Cluny mother house.

Catalan School
Bartholomew, detail of *Christ in glory with Mary and Apostles*
c. 1123, fresco.
Barcelona, Museu d'Art de Catalunya, from the apse of San Clemente de Tahull.

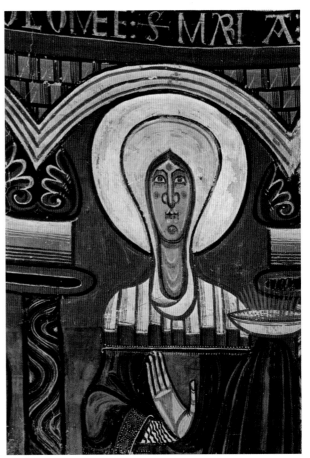

Catalan School
Mary, detail of *Christ in glory with Mary and Apostles*
c. 1123, fresco.
Barcelona, Museu d'Art de Catalunya, from the apse of San Clemente de Tahull (Cataluña).

For further details, see the illustration on page 22.

The Painter and the Miniaturist

The style of the Romanesque fresco, so lively from the narrative standpoint, on one hand seems to have been influenced by Byzantine art, probably filtered through illuminated codices, mosaics, and other creations, but on the other (as in the case of the Tahull frescoes in Cataluña) is expressed in a new, independent language. In the first instance, the painters show their preference for draping that tends to underscore the human form, aiming to come closer to a naturalistic depiction of the subject; in the second case, we note an inclination towards simplification of forms and emphasis of two-dimensionality and linearity, also playing on skillful color contrasts that achieve a very successful disruptive effect, so admired by artists like Picasso. Nevertheless, it is felt that the lead role in painting was played by the miniaturists and not by the frescoists. Perhaps it is no coincidence that the names of the fresco painters have not come down to us, though we must consider how little has survived, perhaps just one percent of all wall paintings. On the other hand, we do know the names of several miniaturists and there are even cases of self-portraits. For instance, there was a Norman, *Hugo pictor*, who signed his name and depicted himself in the late eleventh century, at the end of the manuscript with Saint Jerome's comment on Isaiah (Oxford,

Master Hugo (?)
Saint Paul and the Viper at Melita
early mid-twelfth century, fresco.
Canterbury (England), cathedral, Saint Anselm's chapel.

This is one of the few surviving Anglo-Saxon frescoes, and despite its incomplete state, it still betrays a significant harmony in the composition. The work is attributed to Master Hugo, who worked in the retinue of the erudite Abbot Anselmo, who had spent time in Rome before going on to Canterbury, and in Rome was certainly influenced by the local artistic culture.

Master Hugo
Christ in Majesty
c. 1135, miniature from the *Bury St. Edmunds Bible*.
Cambridge, Corpus Christi College, ms 2.

The miniatures in this manuscript, probably the work of Master Hugo, have a smooth, elegant style and very appealing color contrasts.

Bodleian Library, ms Bodley 717, c. 278v). Alongside his image, Hugo declares himself to be a painter and miniaturist (*imago pictoris et illuminatoris huius operis*), although in this case it is not clear what the difference is between the two terms, nor can we declare with any certainty that he worked both as an illuminator and as a frescoist. Forty years later, we find another Hugo working in England, with Abbot Anselmo (1121–48), who came from Piedmont. Anselmo is said to have been the driving force behind the Italo-Byzantine renewal in English painting. In the *Gesta sacristarum monasteri sancti Edmundi*, "Hugo magister" is defined as an artist of many skills, author of an illuminated Bible that has

been identified as that of Bury St. Edmunds. The stylistic affinities with those miniaturists have led to Hugo being credited as artist of fragments of the intense fresco in the Saint Anselm's Chapel, Canterbury. We also know that he sculpted several bronze doors and a crucifix with statues of the Virgin Mary and Saint John. Similarly, other miniaturists must have been painters, and Gerlachus, the master glazier (whose biography is included on page 34, is another significant example of the close ties linking the various figurative techniques.

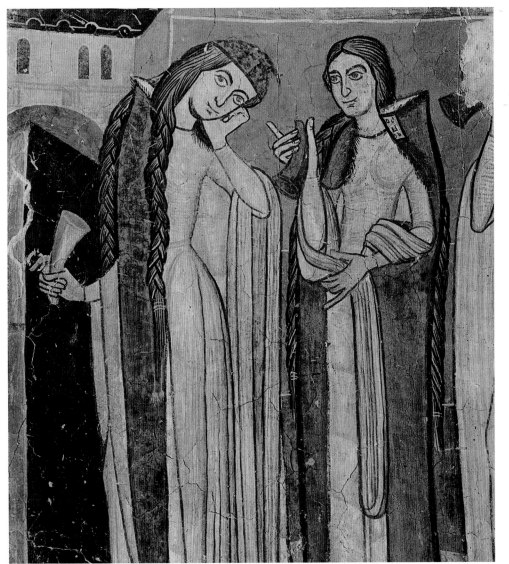

Alto Adige master
Foolish virgins,
detail of the partially preserved cycle, depicting the *Parable of the wise virgins and the foolish virgins*, end of the twelfth century, fresco. Castellappiano (Bolzano), castle chapel.

These frescoes are one of the few surviving Italian cycles (many of them in very poor condition, in Lombardy and central Italy) and despite the biblical subject matter, seem to overflow into an independent worldly depiction. Their unknown author imagined the silly girls "concerned only with their dresses and long plaits, careless of the fate of the spent lamps; nor does his depiction resemble a parable from the Gospels, only a lively scene from village life." (Segre Montel 1966).

A World in Miniature

Religious texts and scientific, arithmetic, and medical treatises, philosophical essays, and Ancient and late antique literature (Hippocrates, Terence, Aesop, Pliny, Virgil, Boethius and many others) are the contents of illuminated codices that can now be admired only from photographs, because the originals are kept in libraries and archives. The manuscripts were illustrated in order to transmit knowledge to a small circle of theologians and scholars or were used for liturgical purposes. Sometimes these books, with sumptuous jeweled covers and quite large in size, were offered as prestigious diplomatic gifts. The codices were created pursuing a tradition that had not faltered, even during centuries of barbarian invasion, and ensured that an immense scientific and literary heritage that would otherwise have been lost was preserved, by copying a myriad of ancient texts in various versions. Initially, the manuscript art was entrusted to the *scriba* (the copyist, a patient craftsman of calligraphic skills) and no decorative function was involved. The art of miniatures flourished under Charlemagne and Otto (Reichenau Abbey was an important center for its development from the mid-tenth century onwards), and later spread to Spain, between tenth and eleventh centuries. The highly colored and stylized works, distinctive for their Mozarabic style (produced by Christians during Arab

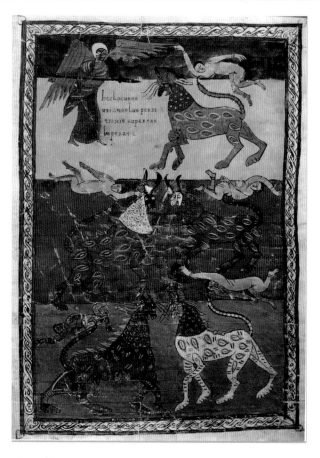

Mozarabic art
The Plague of Locusts
970, miniature from Beatus's codex,
In Apocalypsin, 433, c. 120.
Valladolid, Biblioteca Universitaria.

The apocalyptic plague of locusts is brought to life, dividing the world into four colored strips, to symbolize the destruction of Creation.

Mozarabic art
Opening of the fifth seal. The souls of the martyrs under the altar
tenth century, miniature from Beatus's codex, *In Apocalypsin*,
Hieronymus, *In Danielem*, c. 106
Seu d'Urgell (Cataluña), Museo diocesano, no. 26, c. 106.

The sense of space is all entrusted to the various bands of color, neglecting any perspective for the two overlapping scenes.

domination), caught the imagination of artists like Picasso and Miró. Whether they be Anglo-Saxon, French, Italian, German, or Mozarabic, medieval miniatures offer us memorable images, rife with symbolism and the most disparate and fantastic decorations: angels, demons, serpents, saints (sometimes wearing the fashions of the day), and winged monsters, imaginary beasts, flowers, signs of the zodiac, and musical images: in other words, a world in miniature. Although they were intended for a select few, between the eleventh and twelfth centuries, codex illustrations must also have had didactic functions, to some extent comparable to those of the ample sculpture sequences and fresco cycles created for churches. Some manu-

scripts were eulogies of erudite abbots, committed to promulgating Classical and Christian knowledge, for political reasons also. To mention just two Italian examples, there was Desiderius of Monte-cassino, under whose direction important codices were produced, and Leonate of Casauria, who ensured a detailed chronicle of his monastery's numerous activities, from its origins to the end of the twelfth century, which has allowed reconstruction of the entire history of this influential abbey, from its early Medieval foundation to the Romanesque period.

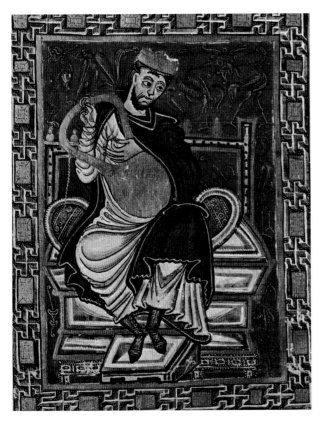

Scriptorium
David playing the lyre
Reichenau (Germany), tenth century, miniature
from the *Reichenau Psalter.*
Cividale del Friuli, Museo Archeologico Nazionale, ms. s. s. , c. 20v.

This Ottonian miniature, whose solemn mood seems linked to Byzantine art, is enriched with extensive flights of imagination, in this case underscored by the precious backdrop decorated with animals to mimic a fabric or a fresco.

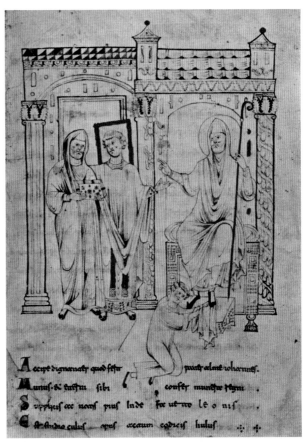

Cassino school
Desiderius Presents Brother Leone to Saint Benedict
eleventh century miniature from a Cassino *Homiliary.*
Archivio della Badia, Montecassino (Frosinone), ms. 99.

Leone, shown here, was the scribe and possibly also the author of the codex's pen drawings.

Typologies and Techniques

As we have just seen, the *scriptoria* that flourished in monasteries made it possible to hand down ancient knowledge using illustrations, making it easier to understand and more palatable. Miniaturist workshops also began to spring up in the towns, from at least the mid-twelfth century, near the theological workshops that had opened, thanks to renewed interest in antiquity, which we now call "proto-Renaissance," or the "twelfth-century rebirth." As far as materials are concerned, Theophilus mentions the use of Greek parchment (although this was really of Chinese origin and had already been used in the Middle East and in Byzantium) and of

vellum. The most popular religious texts to be illustrated were the Bible, the Gospels, exultets, psalters, and rolls (the latter are long rolled-up strips that were used mainly in southern Italy at that time). In England, codices were playing a leading role in this field in the Romanesque period, renowned for their splendid decorated initials. Throughout the West, initials became increasingly elaborate, sometimes filling the entire page, with ornate detail and close rapport between the illustration and the letter. The large miniaturized block initial is a genre typical of the Atlantic Bibles, which spread beyond the Alps but were mainly a creation of Central Italy (the first examples appeared in the late eleventh century). The

Above left:
Saint-Sever school (France)
The angel gives John a message from the church of Tiatira
twelfth century, miniature from Beatus's codex *In Apocalypsin.*
Paris, Bibliothèque Nationale, ms. lat. 8878, c. 69v.

Beneath the porch of a church with cupola loggetta and belfries, the angel with multicolored wings asks John to transcribe the message of the church of Tiatira, dividing the world into four colored strips, to symbolize the destruction of Creation.

Above center and right:
Anglo-Norman school
Illuminated initial
c. 1130, miniature from a codex of Flavius Josephus's *Jewish Antiquities.*
Canterbury, Cambridge University Library, Christ Church, ms. Dd. I. 4.

The lavishly decorated initial is from a manuscript of Greek origin, frequently copied into Latin in the Middle Ages, and refers to the *incipit* of the fourth chapter of the book. The text narrates Jewish history and had been written by the celebrated historian, Flavius Josephus (AD 37–95). The manuscript, shown here in detail, is in Canterbury, and does not have many miniatures, but is outstanding for its initials, which are rightly considered to be masterpieces of illumination—not only Anglo-Norman—from this period.

Atlantic Bible usually comprised two volumes and takes its name from its large size, which can vary between 50 x 34 cm (20 x 14 inches) and 66 x 41 cm (26 x 16 inches). The extravagant capital is the anchor for the entire page, and is usually organized in geometric sections decorated with naturalistic or abstract elements. In English miniatures of the Anglo-Norman period (1066–1200), illustrating herbals and bestiaries, usually of Greek origin, the image is closely connected to the written text. In miniature psalters (the biblical *Book of Psalms*), Anglo-Norman illuminators usually preceded the written text with large, full-page illustrations, even depicting episodes from the Gospels, although there might have been no connection with the actual text. The Psalter, conceived to be read during religious functions, and entrusted to the members of the choir, then developed into the "*Book of Hours*," typical of the Gothic period, and for secular use. Illustrations of the Apocalypse also played an important role, as it is one of the most powerful and visionary texts known. The oldest surviving miniatures are Mozarabic, included in the comment to the Apocalypse written by Beatus of Liébana in about 784, sometimes known simply as "Beatus."

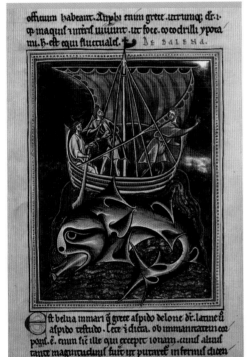

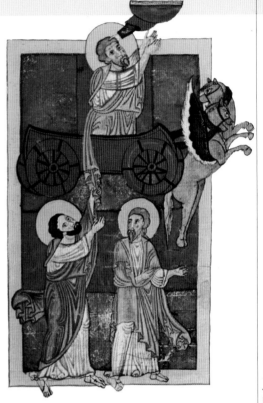

Above left and center:
Anglo-Norman school
De balena
end of the twelfth century, miniature from a *Bestiary*.
Oxford, Bodleian Library, ms Ashmole 1511, c. 86v.

Medieval bestiaries are a direct legacy of the Greek *Physiologus*, a compilation of texts that describe real and imaginary animals, with an allegorical and moralizing function. The original texts were transcribed into Latin time and again, perhaps even as early as the fifth century, although the first known copies are from the eighth century. The most ancient illuminated manuscript produced in the British Isles is dated 1120. The page shown here depicts a quite realistic whale, as it devours two large tuna, very near to the boat where three fishermen are hoisting their sails to the wind.

Above right:
Tuscan school
Elias on His Chariot of Fire
twelfth century, miniature in an Atlantic bible.
Florence, Biblioteca Medicea Laurenziana, Ms. Edili 125, c. 150 r.

The multicolored background, with intense contrasting shades, draws the figures into the foreground with unexpected energy. The unknown artist has not only wagered on these lovely colors—which fortunately are well-preserved—but also on very effective drawing concepts, including the two rearing horses.

The World in Sculpture

The creative momentum of Romanesque sculptors was expressed in various ways: they used stone, marble, and sometimes stucco or alabaster, working in bas-relief and in the round, even sculpting rock. These artists used their imagination and their skills even in complex monumental installations. One of the most original and least known aspects can be encountered in northern Rhineland, in a version of the *Deposition From the Cross*, now lacking several parts, sculpted from rock. Despite its current incompleteness, the evocation of this sacred event seems to rely on few elements, arranged according to a powerful sense of symmetry in the space enclosed by the arms of the cross. The great eloquence of the figures conjures up a scenario of religious enactments and, in point of fact, the relief (over five meters in length and almost four meters wide—16 x 13 feet) is thought to have been used as the stage for Easter celebrations. It is also the entrance to a chapel, similar to a cave, on what was originally the site of a pagan place of worship. The chapel was recovered under the Bishop of Paderborn, Heinrich von Werl, and consecrated in 1115, to represent the holy places of Jerusalem. In England, at more or less the same time,

Westphalia school
Deposition
c. 1115–25, relief sculpted into rock.
"Externsteine," Holy Sepulcher, Horn (Detmold, North Rhine-Westphalia).

This is a very large opus, and totally unique in the Romanesque sculpture scenario, carved from rock as a symbol of a long pilgrimage.

German school
Matthew the Evangelist
c. 1200, detail from the choir enclosure,
polychrome stucco.
Halberstadt (Sachsen-Anhalt), Liebfrauenkirche.

Alongside several stuccoes in Hildesheim, the Halberstadt artifact represents a rarity in polychrome stucco ecclesiastical furnishings, since it has survived intact.

another nameless sculptor was working on a series of screens (possibly for the choir) for Chichester Cathedral, in Sussex. Only two have survived, one of *Meeting at Bethany*, the other of the *Resurrection of Lazarus*. In these two, closely connected, episodes, the artist has wagered on a well thought out distribution of the figures in the square space, and here as in Germany, the austere faces express intense suffering. Another example of the period refers to bas-relief panels that can still be observed on the column corners of the cloister in the Santo Domingo de Silos monastery, in old Castile. Here a talented but anonymous sculptor

depicted scenes from the Death and Resurrection of Christ, and gave a unique interpretation by rendering the panels in a vertical direction. The series is acknowledged as one of the great sculptural masterpieces of all time, showing stylistic affinities with the famous French reliefs at Moissac (shown on the next page), but "unlike the inimitable unrestrained visionary expressionistic accentuation" of the Moissac master, the Silos artist "has inflections that are more humanly gentle, delicately narrative, whose vocation could be lyrical or tragic but nonetheless earthly, and become a constant in the Spanish artistic vision" (Rosci 1967).

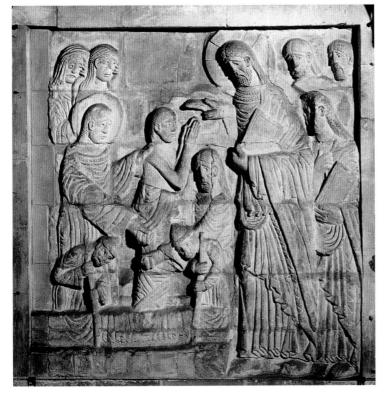

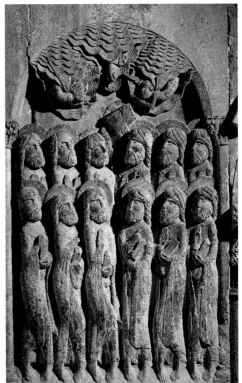

Anglo-Westphalia school (?)
Resurrection of Lazarus
c. 1125, stone.
Chichester (Sussex), cathedral choir screen.

German style influences are evident in this bas-relief slab sculpted in stone and another that pairs with it, sadly both in very poor condition. It is likely that they were commissioned by Bishop Ralph de Luffa, who died in 1123, and who was almost certainly of German origin, leading us to think that his native culture influenced the author of this opus.

Castilian Master
Pentecost, detail of bas-reliefs
early twelfth century, stone.
Santo Domingo, Silos (Castile y León), church cloister.

We know that the Santo Domingo church in Silos was consecrated in 1088. The cloister, which houses these lovely bas-reliefs, is thought to be from a century later.

Sculpture in the Service of the Faith: The Great Masterpieces

Even a much bigger book than this would be insufficient to provide a complete overview of the immense legacy of Romanesque sculptures that is still found in Europe, mainly *in situ*, and some in museums. In this respect, we might well remember that overseas institutions and museums, especially in the United States, also have important collections of Romanesque sculpture. One example is the Isabella Stewart Gardner Museum in Boston, and then there is The Cloisters, the New York Metropolitan Museum's annex

dedicated solely to medieval art, where entire monumental complexes have actually been reconstructed. In these two pages, we have simply shown four examples considered among the greatest masterpieces in this field, and of primary importance in the stylistic and iconographic evolution of Romanesque art. First, one of the eight surviving capitals of the Cluny Abbey church, destroyed sometime between 1810 and 1823. This must have been an enormous iconographic cycle, with symbolic depictions of rivers and trees in Paradise, the winds, the seasons, the liberal arts, and the eight tones of Gregorian chant. The series must

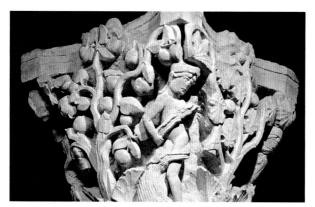

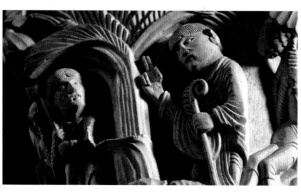

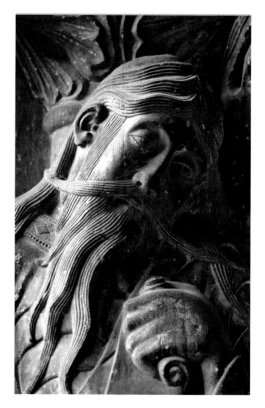

Top:
Capital With Rivers and Trees of Paradise, detail
end of the eleventh–early twelfth centuries (before 1120), stone.
Cluny, Musée Lapidaire, church choir.

Above left:
Miracle of Saint Martin
post-1120, stone. Vézelay (Yonne), Madeleine church.

The stylistically similar capitals that survive from the abbey church of Cluny (destroyed), and those still *in situ* in the Vézelay church, are typified by the feel of essential, yet extremely plastic, volume.

Right:
The Prophet Jeremiah
c. 1120–35, central column from the south portal, stone.
Moissac (Tarne-et-Garonne), former abbey church of Saint-Pierre.

Facing page:
Nicolaus
The Creation of the Animals
1138, stone.
Verona, San Zeno, facade.

therefore have referred to the complex medieval system of cosmo-
logical and virtue symbols. Stylistically speaking, the reliefs appear
to be by one artist, who "is in perfect command of the nude and
confers complete vitality and natural movement on the bodies"
(Xavier Barral i Altet 1983). There is some debate about the dates
of these works, also because the style of the Cluny Master, or
of his assistant, seems to emerge in the nave capitals at the
Madeleine church in Vézelay, rebuilt after a fire in 1120. Soon after,
in Autun, also in Burgundy, the great sculptor Gislebertus set to
work (see his biography on page 32), but this was the same period

in which at Moissac, in Aquitaine, a majestic portal was sculpted
with a lunette containing a Christ above twenty-four elders. The
lunette is supported by several pillars with unusual undulated
incisions and, on the *trumeau*, the elongated figure of the prophet
Jeremiah, deep in thought, is considered the vertex of the Moissac
sculpture's composition. Lastly, in Italy, a master of some stature was
working on the Ferrara Duomo and at Verona, proudly signing as
"Nicholaus" some of his work of the time: works whose sturdy
feel for relief betray his allegiance to that Medieval culture so typi-
cal of Emilia Romagna, and whose forefather was Vuiligelmo.

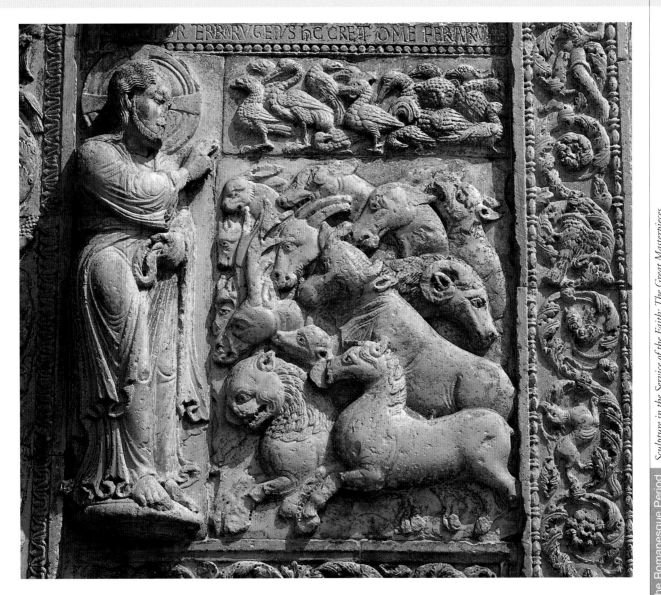

Ornamental Sculpture

The interior of Romanesque churches, especially the more influential, were fitted with furnishings essential for liturgical services. Perhaps it was precisely because of their function that these works were often realized with particular care and refinement, almost as if their makers, again mainly anonymous, were well aware of their religious importance. Apart from holy-water fonts, installed at the entrance, these items would be located in the areas set aside for the liturgy, towards the back of the church. Often the altars were also decorated, and here we include a fine Toulouse example, sculpted in marble by Bernardo Gilduino, as were the baptismal fonts (an item that was mentioned with reference to the Cabestany Master). On the other hand, slabs and *pluteuses* (a Latin word meaning "backrest") were sculpted in low relief or openwork, and had developed during the Dark Ages, in presbytery compounds and piers located at the end of the nave, towards the presbytery, an area of the church set aside for the bishop and the clergy. These large, complex furnishings, connected to the architectural structures and composed mainly of sculpted screens, now survive only in fragments. For instance, Antelami's famous *Deposition* for the Parma Cathedral (discussed in the sculptor's biography on page 44), was probably part of a pier. Another significant example

Pulpit with lions, telamons, and eagles, detail
c. 1110, stone.
Milano, basilica of Sant'Ambrogio.

In about 1200, the pulpit was poorly refurbished following the collapse of the vault in the third bay of the church. The arms of the telamon, suffering the weight they were supporting, twisted into an improbable pose.

Lectern deacons
c. 1180, detail of the pulpit, marble and mosaic.
Salerno, cathedral.

The mock-classical look of this splendid item is often explained by suggesting the influence of Provencal sculpture. Nonetheless, it must be said that this style could also be independent, since Campania's culture was swept up, in the eleventh century, by a protohumanistic current, thanks to a renewed study of the classics, fostered by Abbot Desiderius of Montecassino and in Salerno, by Bishop Alfano.

of this type of polychrome stucco is the enclosure at Halberstadt, in Germany, illustrated on page 78. Another feature that became popular in the Dark Ages was the ciborium (from the Greek *kiborion*, cup), taking the form of a temple with cupola, set at the center of the altar. A special role was then played by furnishings for hosting the bishop or anyone appointed to read the Scriptures. In this context, the most outstanding for quality and quantity are above all the bishop's thrones made in Apulia and the pulpits from various Italian regions. In the twelfth century, the throne, which had been in use since Byzantine times, became extremely popular in southern Italy in a specific form, decorated with elephants

(Canosa), or with telamons that support the bishop's seat. Also prominent were the pulpits (in Latin *pulpitum*, a stage) or ambos (in Latin *ambo-ambonis*, both made from two separate elements, facing each other, either a *cornu epistolae* or a *cornu evangelii*, so readings of the Letters and the Gospels could alternate). These pieces were more or less set against the wall and comprised an elongated quadrilateral base, supported by columns with varying degrees of decoration, and included a set of steps for access.

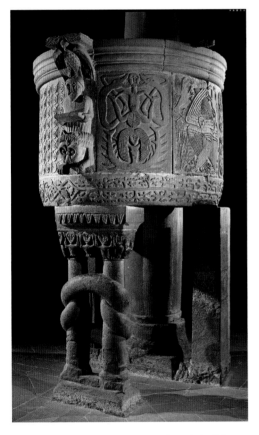

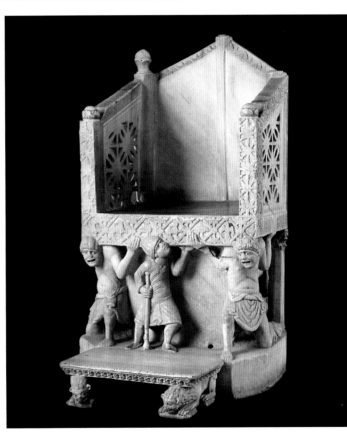

Pulpit with fantastic figurations and symbols of the Evangelists, in the round
end of the twelfth century, sandstone.
Gropina (Arezzo), Pieve di San Pietro.

The pulpit, supported by two small columns with a Solomon's knot motif, is decorated with human figures, sirens, and fantastic animals, in a style that leans towards simplicity and geometry.

Chair of Bishop Elia
c. 1103–05, marble.
Bari, cathedral of San Nicola.

This marble seat is one of the most refined Romanesque sculptures, also known as *Elia's Throne*, taking its name from the Bishop of Canosa di Puglia (from 1089 to 1105). The item is in openwork with ornamental motifs that are probably of Islamic origin, and is supported by three atlases, their faces grimacing at the effort. The throne, moreover, has a footrest, also in marble, set on two small lions.

Precious Facades

The main front of a building, the facade (from the Latin *facies*, face or aspect), is what strikes us first and, like a person's face, it is also the image that stays in our minds as time passes. As early as the Greek temple, the fronts had a decorated tympanum where the religious significance was expressed, through lavish sculpted decoration. In Romanesque architecture it was common to adopt a basilica floor plan, with a nave and two aisles, and this certainly contributed to the development of facades on the short side of the entrance. In general, the facade was situated on the west side of the church, following the principle applied since Paleo-Christian times of "orienting" (from *oriens-orientis*, rising), in other words setting the monument in accordance with the points of the compass: The upper area faced north, the lower area faced south, facade west and, lastly, the apse would face the Orient (east), directly opposite the facade. As the architecture historian Erich Kubach wrote, "thousands upon thousands of Romanesque buildings, and hundreds of cathedrals have survived [. . .] and we have information about just as many more from sources and from archaeological excavations." The solutions adopted in the structure and decoration of facades have endless variables: bare facades or those decorated as elaborately as a jewel box; encrusted with

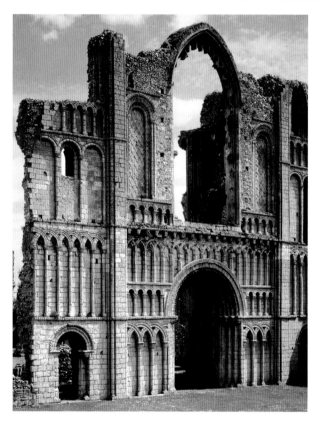

Ruins of the west facade of ancient Cluny's priory church
building begun in 1089.
Castle Acre (Norfolk).

Little remains of this marvelous construction: only the six bays of the lengthwise section and a splendid facade, conceived in the Anglo-Norman scheme: a central and two side portals, with round arches, surrounded by blank arches on several orders, decorated with geometrical carving.

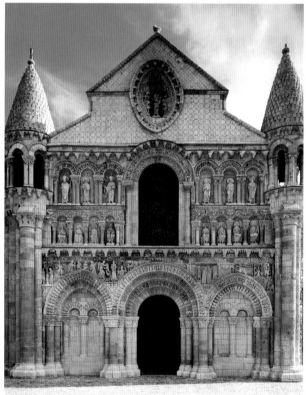

Facade of the former collegiate of Notre Dame la Grande
completed in about the mid-twelfth century.
Poitiers (Vienne), Notre-Dame-la-Grande.

Just like a casket, the building is typical of the fully decorated facade style characteristic of western France.

stone or made in brick or in marble; with sloping roofs and with squared-off roofs; with portals, using projecting porches or covered atriums set against the facade itself; or flanked by two towers or by a single campanile (bell tower). It is really quite impossible to include every single typology: Here we will settle for mentioning some of the most characteristic decorative motifs found in England, France, and Italy. The Norfolk church of Castle Acre, despite being derelict, still has a west facade decorated with carving but without figurations: It was founded in 1089 by William de Warenne, the second Duke of Surrey, and he immediately affiliated it with the Benedictine abbey of Cluny, following the institution in 1077 of a Benedictine priory by his father, at Lewes (Surrey). The facade of Notre Dame la Grande in Poitiers is even more elaborate, with images from the Old and New Testaments on several registers. The ground floor of the church has a tripartite layout of a nave and aisles, and on the higher levels, figures are set into arches with a continuous register, like ancient sarcophaguses. The facade of Saint Trophime in Arles is also inspired by sarcophaguses as well as by the Gallo-Roman triumphal arch, while San Miniato in Florence symbolically echoes the harmony of the celestial spheres.

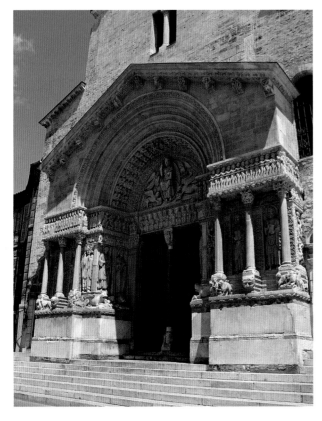

Facade of Saint-Trophime Church
post-1150.
Arles (Bouches-du-Rhône).

Arles' mock-classical facade, on the pilgrim route, features a jutting portal, obviously inspired by Gallo-Roman triumphal arches.

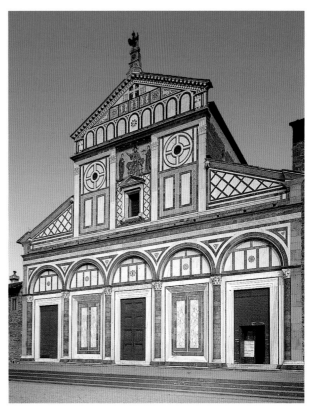

Facade of the Basilica of San Miniato al Monte
a building begun in the eleventh century and completed in the thirteenth century, with a mosaic above the central window.
Florence.

San Miniato al Monte is the prime example of a group of churches on Florentine territory, all faced in green Prato and white Carrara marble, but it is the most difficult to date, since work on the basilica stretched out over a long period of time.

Cupolas and Towers

The exterior of the more magnificent Romanesque churches were enhanced with cupolas and towers, quite spectacular elements, both in height and in girth. The cupola (from the Latin *cupula*, diminutive of *cupa*, meaning barrel) is a roofing structure. Technically, as dictionaries say, it is a "surface obtained from the rotation around a vertical axis of a circumference arch or a parabola, installed on a drum and connected to an underlying polygonal flat surface by pendentives." The latter, called *pinnaculum* (pinnacle) in Latin, are the corner elements that relieve side arches. The cupola has ancient origins (it seems to have been in use in the Minoan era) and was the ideal fulcrum of the building, already used with mastery by the Romans (for instance, for the Pantheon in Rome), then in many buildings in the Middle East. One of the first and most impressive examples of Romanesque is the dome of Pisa Cathedral (originally without the large arches and loggetta, added in the Gothic period, decorated in openwork, like embroidery). It was inspired at least in part by Middle Eastern, Arab, and Byzantine architectures (of Syria, Jerusalem, and Cairo, but also Cordova and Byzantium). This inspiration is no surprise, given that this flourishing maritime city traded frequently with distant countries. Inside the building, which has a nave and four-aisle interior,

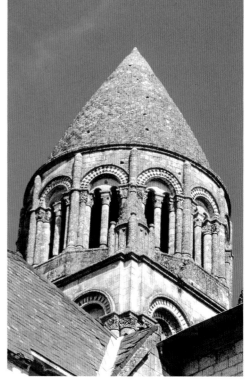

The Cupola of Pisa Cathedral as it appears from the Cemetery's Gothic arches
end of the eleventh century.
Pisa, Piazza dei Miracoli.

For its striking height (48 meters or 157 feet) and for its elegance (faced totally in marble), this is considered the masterpiece of all Romanesque cupolas.

Center:
Five-story crossing tower, crowned with a parapet
1080–1150.
Toulouse (Haute-Garonne), Saint-Sernin.

One of the most daring towers conceived in the Romanesque era, with the arches of all five floors sloping upwards to the balustrade roof.

Right:
View of a crossing tower, with its various sectors, columns, and capitals
twelfth century.
Poitiers (Vienne), Notre Dame la Grande.

four pillars support two large arches and two openwork walls at the junction with the transept. The walls then support the cupola, underscoring the church's two largest dimensions: the width of the nave and that of the three transept aisles. While Pisa has a Latin cross floor plan, Saint Mark's in Venice, designed during the same period, has a Greek cross plan. Here, no less than five tall cupolas, laid out in a cross shape, support columns inside, connected by arches and vaults. A similar layout can be found in a group of churches in southwest France: at Solignac, Souillac, and Périgueux, where a cross vault and four bays each support a cupola. About sixty more Romanesque buildings in those regions,

however, have a single nave with a cupola roof. There is discussion as to whether the French, five-cupola model came from distant lands or whether it was copied from Saint Mark's Basilica, which had been inspired by the Byzantine *Apostoleion*. Towers englobed within the sides of the facade (or in the apse or with the cross vault) decorate many other French and German churches, while in Italy it was more common to find a different type of belfry, located at the side of the facade.

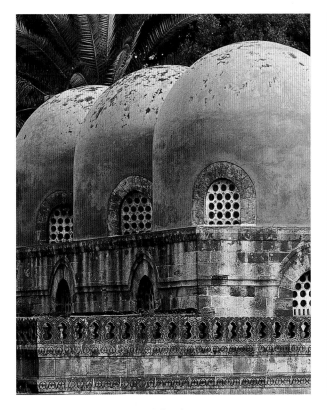

Triple cupola and parallelepiped church
founded in c. 1160.
Palermo, San Cataldo.

The preceding Arab domination clearly left its mark on the church's three-colored onion cupolas dating back to the Norman reign.

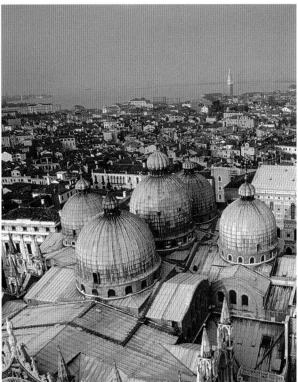

The five cupolas, bird's-eye view
end of the eleventh century.
Venice, San Marco.

It is now fully acknowledged that the five cupolas on a Greek cross plan were inspired by Byzantine architecture. Moreover, there are theories that the Venetian building was a go-between and model for similar structures, like the equally impressive Saint Front church at Périgueux in western France.

Narthexes, Porticoes, Portals, and Porches

The various solutions found in Romanesque architecture some-times included a type of facade that was preceded by a narthex, a prothyrum, or a portal, inspired by the great Paleo-Christian basilica porticoes. The narthex (from the Greek *nartheks*, cane) was originally the part of the basilica set aside for catechumens and penitents. It is a vestibule or atrium with a portico, in front of the entrance, resting completely against the front, in other words the facade, of the church. The narthex, occasionally created inside the building, was adopted in the Romanesque period mainly in French churches, like the Burgundian Autun and Vézelay, and in

several Italian locations (here we have illustrated the atrium of Casauria, in Abruzzo). It can be regarded, really, as a sort of reduced quadriporticus, comprising a four-sided court enclosed by a portico, that was expertly applied as early as the end of the eleventh century in the Milanese basilica of Sant'Ambrogio. Whether or not they have porticoes or atriums, Romanesque churches nonetheless always have at least one entrance portal on the facade (sometimes, in more complex layouts, there are extra portals on the sides and at the end of transept arms). In buildings with a nave and two aisles, the central portal, usually bigger and aligned with the nave, was flanked by two more doors, one for

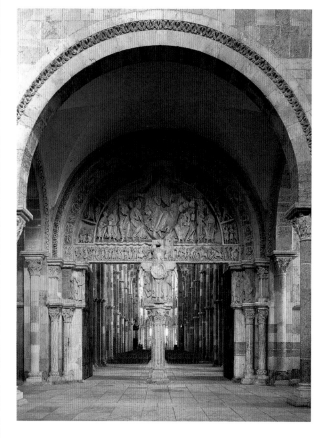

Central narthex portal, with sculpted tympanums and architraves
c. 1125–40.
Vézelay (Yonne), Madeleine church.

The first abbey church was destroyed by fire in 1120 and was later rebuilt with the addition of a narthex. This was precisely where, dur-ing Easter 1146, Bernard of Clairvaux made his appeal for the Second Crusade, surrounded by a crowd of believers and princes.

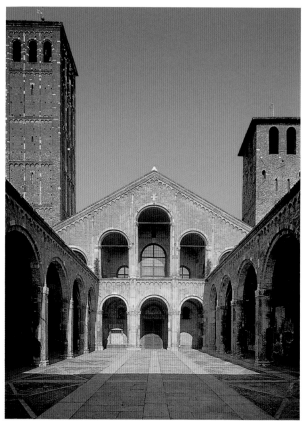

Quadriporticus
c. 1098.
Milan, basilica of Sant'Ambrogio.

This basilica, a masterpiece of Lombard Romanesque architecture, is characterized by a vast quadriporticus: Here the building's aisles extend gracefully along the portico sides.

each aisle. Again in this case, the functional requirements of an entrance portal generated a plethora of structural and decorative variations. It was precisely Romanesque art, especially in France and Spain, that established the historiated portal, initiating plastic solutions that went on to reach their peak in the Gothic era. Above the entrance—at least in France and Italy—it was not unusual to find a triangular space, called a *tympanum*, which as early as Greek times was ornamented with sculptures. Moreover, the most frequent design was that of a portal with lateral niches, sometimes decorated with bas-relief figures, as in Provence and in many Lombard and Emilian churches, forerunners of the famous Gothic column statues. A central pillar called a *trumeau* was used in many French and Spanish churches (see Compostela and Vézelay), dividing the entrance into two. Above this, a lunette surrounded by archivolts was supported by an architrave: These were the spaces exploited with great creativity by Romanesque sculptors. A typically Italian solution, on the other hand, was that of the prothyrum, a sort of loggetta with a double-pitched roof, upheld by columns and column-bearing lions, and set forward of the facade.

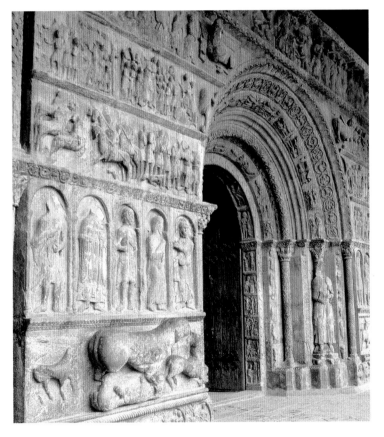

Facade portal sculpted in various registers
church reconsecrated in 1032, with a number of later remodelings, portal dated 1125–50.
Ripoll (province of Gerona, Cataluña), abbey church of Santa Maria.

Despite damage to the church caused by various remodelings and structural damage, a lavish decoration still covers the portal (without tympanum) of Ripoll abbey church, considered the first example of Spanish Romanesque sculpture. It is certainly the first Spanish portal that does not feature any of the usual Mozarabic influences.

Façade prothyrum
c. 1138.
Verona, San Zeno.

Nicolaus's fine reliefs flank the aedicule loggetta with lion supports.

The Romanesque Period | *Narthexes, Porticoes, Portals, and Porches*

Church Morphology

Scholars of Romanesque architecture in the nineteenth century often made reference to the existence of various regional schools, but in general this method is deemed valid only in the case of small groups, and only for delimiting geographical areas like Auvergne, in France, or Germany's imperial churches. Anne Prache (2003) specified that Romanesque architecture actually appears "simultaneously very differentiated and international." Impressive constructions like the imperial cathedral of Speyer, and the abbeys of Cluny III (rebuilt thanks to Kenneth J. Conant's excavations) or Clairvaux, have certainly exercised "a considerable influence," whereas others, like Saint Mark's Basilica in Venice (which, as we have seen, may well have been a go-between for French Périgord churches, with their Byzantine-style cupolas), are really unique, being neither completely Byzantine nor totally western. Then, in some parts of Italy, the Constantinian basilica plan used for Saint Peter's, destroyed in the sixteenth century, had an enormous impact. The most frequent building layouts are a Latin cross, with an ambulatory and side chapels; or with at least three parallel apses. The central plan, inspired by Santo Sepolcro, and the

The abbey church of Cluny III at the end of the eighteenth century, before the destruction, which occurred between 1809 and 1823
Etching by Émile Sagot.

The abbey was built in three phases, conventionally called Cluny I (consecrated in 926), Cluny II (c. 1000), and lastly, Cluny III (consecrated in 1130).

Cutaway of the nave side wall of Modena Duomo
twelfth-century reconstruction drawing.

This drawing shows the typical structure of a wall with women's gallery. The first floor has the clerestory (a "light area," a vertical top light); on the second floor the women's gallery or *triforium* (three lights); and on the ground floor, supporting arches.

Greek cross, are rarer. Nevertheless, it is a universally valid consideration, as Marco Bussagli (2003) quite aptly concluded, that the fundamental principle of Romanesque architecture, "inherited from the Roman world and filtered through Carolingian and Ottonian monuments, is the systematic use of space expressed in a clear plan, usually of the basilica type, and in the efficiency of the divisions." In this respect, the round arch plays a crucial role, dividing space "according to double and triple proportional ratios." In this "binding system," the square module used for the bay (in turn, divided in half for the aisles) becomes strategic. It was precisely the dimensions of the bay that define the proportions of the church's main section, the transept, and any atrium or narthex. Moreover, a crossing tower may be set at the point where the nave meets the transept, where a cupola would otherwise be found. One of the most noteworthy innovations of Romanesque architecture was the women's gallery (originally the area reserved for women), located on the upper floor and in the side walls of the nave. Accessible women's galleries or blank triforiums may then be surmounted by the clerestory, the "illuminated place."

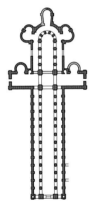

Norwich Cathedral
1096.
East Anglia.
Nave and two aisles,
three chapels in the
ambulatory, and transept
with two chapels.

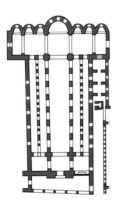

Abbey church of Santa Maria a Ripoll
c. 1032.
province of Gerona
With seven apses.

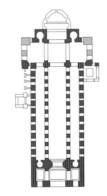

Speyer Cathedral
c. 1030–61.
Rheinland-Pfalz.
With two towers next
to the choir.

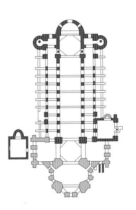

Mainz Cathedral
c. 1081.
Rheinland-Pfalz.
With double choir,
double transept, and crypt.

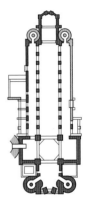

Worms Cathedral
c. 1188.
Rheinland-Pfalz.
With towers in the facade
and in the west choir.

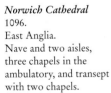

Supporting Structures

One of the most important innovations achieved by these anonymous Romanesque architects was the ingenious (and spectacular) method for roofing buildings. Between the eleventh and twelfth centuries, the original flat roof found on Paleo-Christian basilicas evolved progressively, with the simplest solution being the barrel roof, with the half-columns set against aisle columns, stretching up into a vault with archivolts. The ribbed cross-vault, however, reinforced with groins, emerged thanks to the permeation of transverse and lengthwise naves. The impressive Vézelay Madeleine, whose abbey was controlled directly by the Holy See from the ninth century, as was Cluny, is emblematic of an increasingly complex roofing system. After a fire that devastated the nave of the original 1120 Carolingian building, the church's longitudinal block was rebuilt. Officially designated by Cluny as the major stop on the Compostela route, Saint Madeleine was designed on a vast scale so that it could deal with large numbers of pilgrims. Thus, the solution adopted of cruciform pillars with semicircular piers on each side, to support the grand archways and vault archivolts, emphasized the upward development in the structure. A string-course

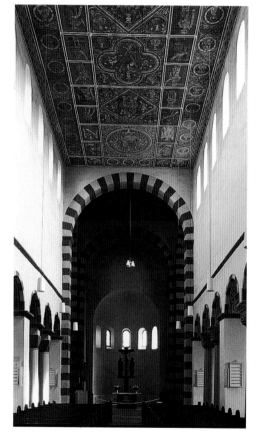

Interior of the Church of San Michele
1010–33.
Hildesheim (Lower Saxony).

The church has a nave and two aisles, with two transepts, and despite remodeling, its fine proportions are still evident.

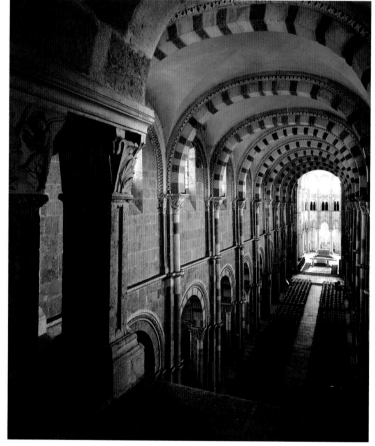

Nave towards the Gothic choir
rebuilt 1125–40.
Vézelay (Yonne), Madeleine abbey church.

Dedicated to Madeleine, sister of Saint Lazarus, who is venerated near Autun. This is one of the most significant churches on the Santiago route. The Carolingian nave, in wood and metal, was destroyed by fire in 1120 and rebuilding was completed by 1140.

cornice separates the first and second floors, where the bare wall and ample windows are "framed" by side arches that, in turn, support ribbed vaults. In fact, in Romanesque architecture the nave walls are usually built on two levels, with the upper section set aside for lighting (the clerestory, mentioned earlier). In more complex structures, the elevation could even reach four floors, with arches on the ground floor, women's galleries, a blank triforium, and clerestory. The choir could also be on several levels, but other designs developed in this period, especially within the Cistercian (the name comes from the mother house of Citeaux, in Burgundy)

reform movement, which began in the late eleventh century, later revived under Bernard of Clairvaux, who wanted to contrast his order with the ostentatious "luxury" of Clunian Benedictine abbeys. The only intact abbey church retaining its cloister is Fontenay, whose structures are marked by their utmost simplicity: smooth bare stone walls, round arches on square columns with semicircular piers, and pointed arches in the nave.

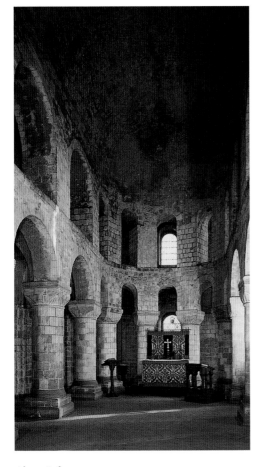

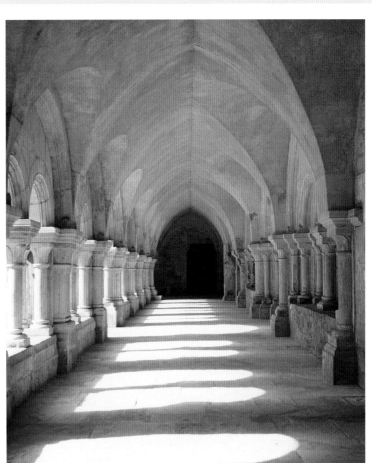

Above Left:
Norman chapel dedicated to Saint John
from c. 1078.
London, White Tower.

The White Tower had a threefold function: as a defense, a residence, and for entertainment. On the third and fourth floors there was a semicircular stone chapel commissioned by Gundulf, the Bishop of

Rochester. The chapel had a women's gallery with a nave and two aisles, with solid round pillars. The nave is barrel-vaulted, the aisles are ribbed, and the women's gallery is semicircular.

Above Right:
Cistercian abbey cloister
pre-1150.
Fontenay (Cote-d'Or, Burgundy).

Fortresses, Castles, and Stave Churches

The medieval landscape was not dotted just with the "white mantle of churches" that Ralph Glaber described in the eleventh century. Castles, towers, fortresses, of which few survive, and all too often derelict, must have hallmarked the hill-dominated countryside, as written sources tell us. Their function was primarily for lookout and defense, since it is an ancient tradition—and not only in the western world—to erect tall buildings or a citadel (the ancient Greeks called it an *acropolis*, tall town). In the event of attack, the rough terrain made these points inaccessible. From

the Dark Ages, the castle (from the Latin *castrum*, fortress) became widespread and was used as a dwelling. If no high spots were available, the castle erected on flat land would be surrounded by a moat, which could be filled with water. Sheer vertical walls made it difficult to seize these fortified territories, sometimes so vast as to cover 6,000 square meters (7,200 square yards). The "motte castle" of the late tenth century, found along the Rhine and Loire (comprising a base supporting a square wooden tower, with a defense and residential function), gave way to the twelfth-century *keep* or *donjon*, an inappropriate term coined in the nineteenth

Castle ruins
eleventh–twelfth century.
Loches (Indre-et-Loire).

Loches lies upon a strategic point of northwest France, between Poitou, Touraine, and Berry. It was a royal residence and later an inaccessible prison. The massive four-sided master tower (*donjon*) with semicircular bulwarks is 36 meters in height (118 feet tall), with a 25-meter (82-foot) wall perimeter.

Fortress with round keep, reinforced by towers
twelfth century.
Conisborough (Doncaster, Yorkshire).

The name of this ancient Norman castle derives from a combination of old Scandinavian and English: *Konoug-burh*, in other words, "Kings' Castle."

century to describe the master tower, a brick castle also endowed with a keep (or *magna turris*), popular in western France and England. In Italy, the donjon, encircled by fortifications, also had a keep or a stronghold with several floors (*turris maior*), and next to it the lord's residence. Stone had progressively replaced wood, a material that is nonetheless typical for a group of buildings that were constructed in Scandinavia between the eleventh and twelfth centuries, called *stavkirker*, or "stave churches," in other words, with vertical supporting struts. These churches of the Norman era are a unique genre, built in their hundreds in medieval Scandinavia,

although very few have survived—less than thirty, mostly in Norway. The most significant are those of Urnes (c. 1060), Lom (eleventh century), and Borgund (Fagusnes, c. 1150). The latter is outstanding for a series of dragon-head decorations, serving an apotropaic purpose, jutting from the corners of the roof, and seeming to emulate the rostrums of a Viking longboat. The roofs are arranged on various levels (Borgund has six), and must have been designed to allow snow to slide off easily. Portals and pediments have lavish sculpted decorations, all in wood.

Wooden gallery in a stave church
c. 1060.
Urnes (Norway).

The stave church (*stavkirke*), typical of medieval Scandinavian architecture, generally comprises a series of perpendicular wooden planks

that form the walls, and round posts set at the corners or supporting the arches, up to the ceiling of the main internal chamber. These buildings actually comprised, in most cases, more than one chamber. Urnes' *stavkirke*, in Norway, is the oldest of this type known to us, and one of the best preserved, with delicately decorated dado capitals topped by a wooden group.

Gothic

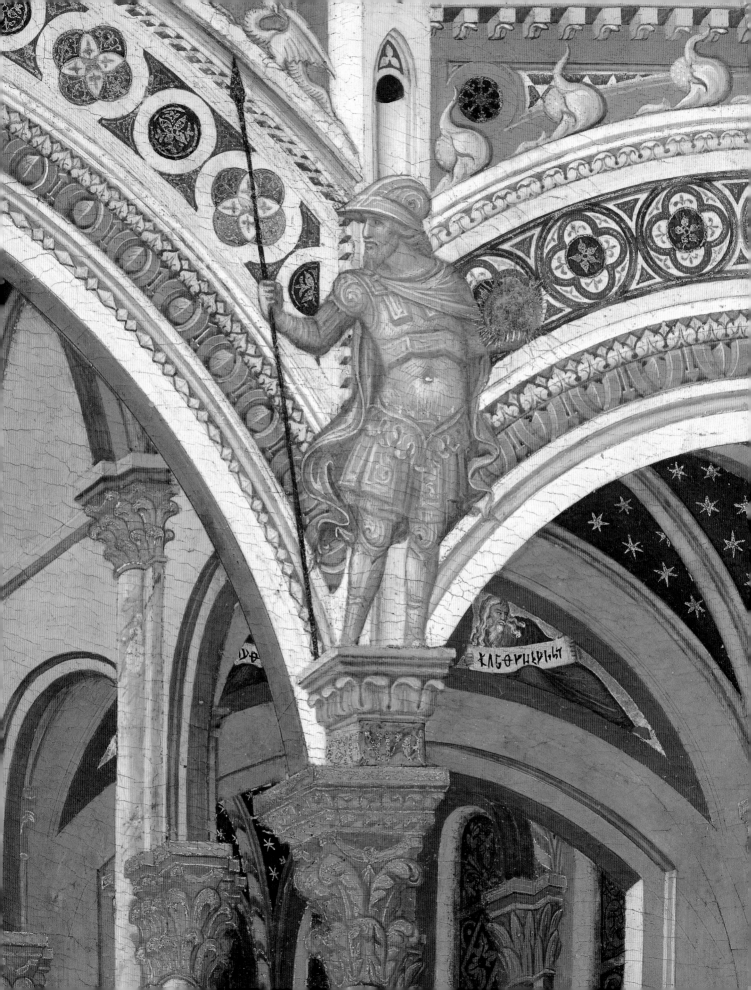

A "Torrent" of Light

"For altar service we have adapted with gold and silver a porphyry vase, beautifully made by the sculptor and the polisher, but left to rot for countless years in a chest, and now we have transformed it to the shape of an eagle, writing the following words on it: *This stone deserves to be surrounded with gems and gold. It was marble but in its new function it is now more precious than marble.*" The object of extraordinary beauty, described with justifiable pride in the twelfth century by Abbot Suger (or Sugerius) of Saint Denis, still exists (it can be found in the Louvre), proving its patron and designer to be capable of inspiring a refined and farsighted artistic culture. The Abbot in person describes, in the text above, how he ordered an eagle's head, long neck, wings, and talons to be made in silver and fitted to an antique porphyry vase, probably of late Roman or Fatimide origin. A vase, in itself, utterly precious for its age and its material—since ancient times porphyry was one of the rarest and most costly types of marble—was thus transformed into a liturgical object for serving Mass. The Abbot of Saint Denis started a practice (recovering and adapting ancient vases) for which the Florentine Lorenzo de' Medici became renowned three centuries later. "Il Magnifico" was a passionate antiques collector and, for dynastic

Previous page:
Ambrogio Lorenzetti
Joshua dressed as a captain, detail from *Presentation of Jesus in the Temple*
1342, panel.
Florence, Uffizi Gallery.

The elevation of the bronze serpent, detail from *Stories of Moses* c. 1145, stained glass. Saint Denis (Paris), ancient abbey church, window in the transept's fourth side chapel, north side.

Facing page:
Abbot Suger's vase with eagle
late antique (vase), mid-twelfth century (eagle), porphyry and gilt silver.
Paris, Louvre.

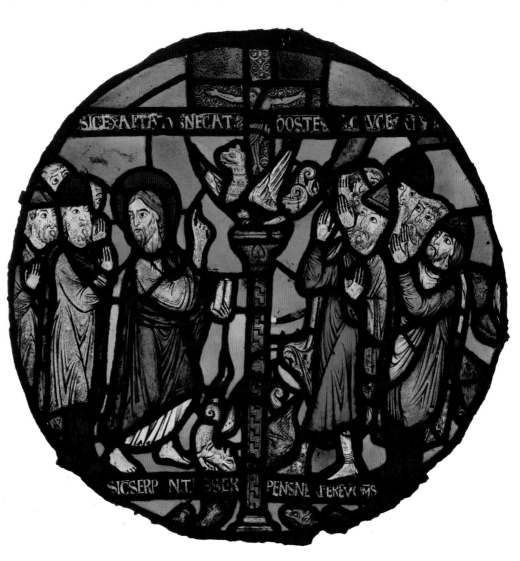

Angel with thurible detail of a plaque from the *Saint-Aignan Triptych* thirteenth century, gilt bronze, champlevé and gemstones. Chartres (Eure-et-Loire), Cathedral Treasure.

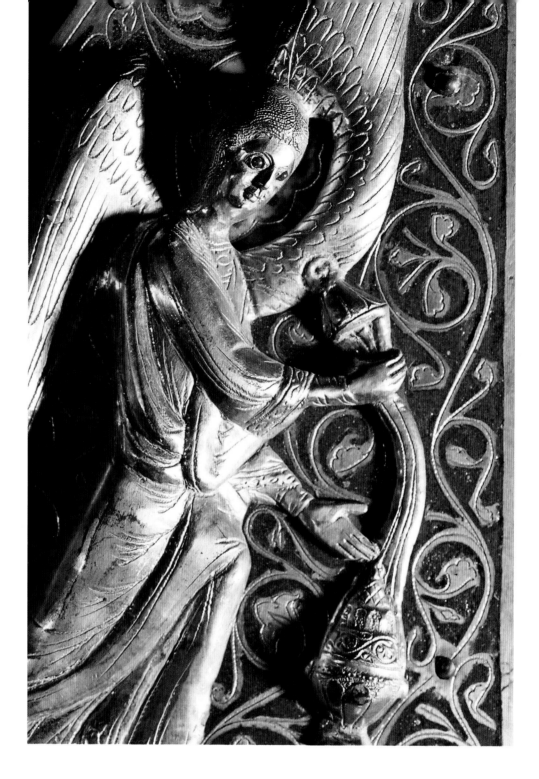

prestige, had his initials etched into porphyry vases or on the gilt edges of luminescent jasper bowls. Here lies the difference with his medieval predecessor: Suger never went so far as to add his name to the sumptuous objects from the Abbey of Saint Denis (several of which are now in the Louvre and Washington National Gallery). He preferred to kindle the spirituality of the faithful with "brilliant" expedi-

ents: The beauty—or rather the splendor—of a church and its works would lead to a meditation on divine greatness. Even kaleidoscopic rose windows and tall stained glass windows, filtering their unique light into the church, acquired a symbolic value. The warm atmosphere of the vaults, nave, and aisles lit by the stained glass, and the gleaming gilt chalices and shimmering enamels shown on feast

Eucharistic dove, detail
1300–25, etched gilt
bronze, champlevé,
and gemstones.
Salzburg (Austria),
Cathedral Treasure.

days, underscored the holiness of the place and encouraged devotion, ensuring the believer a "passage," or *transitus* (to use Suger's expression), an ascent from the visible to the invisible. Suger's position, which may have been influenced, as has been suggested by Pseudo-Dionysius's "theology of light," (Dionysius Areopagite, in turn inspired by the Neoplatonic ideas of Plotinus and Augustine), was

in complete contrast with the philosophy of Bernard of Clairvaux. As we have already mentioned, during that same period Bernard was a strong critic of pomp in ecclesiastical art, as he felt it distracted monks and worshippers from their devotions and reading of the Holy Scriptures. Two such divergent perspectives, in the same period, are often compared in order to show of how "modern" Suger's

Above:
Decorative strip
c. 1140–44, fragment of
a stained glass window
from Saint Denis abbey.
London, Victoria &
Albert Museum.

Top right:
The Tree of Jesse
("There shall come forth
a shoot from the stump
of Jesse, and a branch
shall grow out of his
roots. And the spirit of
the Lord will rest upon
him, the spirit of wisdom
and understanding, the
spirit of counsel and
might, the spirit of
knowledge and fear of
the Lord"), detail
1145–55, stained glass
from the rear western
facade, right aisle.
Chartres (Eure-et-Loire),
Notre Dame Cathedral.

***Young Lubin studies
the abacus as he tends the
flock, and his companions
drink wine***
detail from *Stories of Saint
Lubin, Bishop of Chartres*
early thirteenth century,
stained glass window in
south transept.
Chartres (Eure-et-Loire),
Notre Dame Cathedral.

approach was. In reality, both Suger and Bernard
can be considered—albeit for contrasting reasons
—the exponents of the two main trends in late
medieval art. So Bernard, the most tenacious
promoter of Cistercian reform, and thus of its
architecture, demanded the church have bare walls
that fostered spiritual concentration, while Suger
declared that even pagan objects could assume a
function that was fruitful for religion, just like the
ancient columns, the *spolia* recovered from Roman
temple remains, which he had repurposed for the
construction of the abbey church at the gates of
Paris, from 1129 to 1144. Although it has been
remodeled on various occasions, Saint Denis is
unanimously held to be the prototype of the reli-
gious architecture usually defined as "Gothic." As a
consequence, since he managed every aspect of
its construction, Suger is considered to be the
inspirer of this new architectonic style. In renewing
the ancient abbey church, founded in 630, and also
the royal Merovingian-era necropolis, one of his
major concerns was how to support the building's
roof, since it was designed to be of an unprece-
dented size. Suger says that after some considera-
tion, and thanks to prayers during the night office, it
came to him that the royal forests near Saint Denis
might have trees big enough to be felled and their

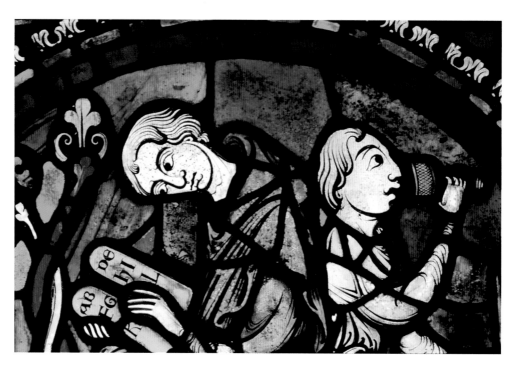

entire length set transversally against the walls of the church. Prayer was always, unfailingly, the answer to everything, and the beauty of light was a go-between with the divine: "Whoever you may be, if you wish to celebrate the glory of these doors, admire not the gold nor the expense, but the work they required. The noble opus glows, but the opus that glows nobly illuminates the mind so that it can advance, through real light, towards the real light where Christ is the real door. This golden door shows how Christ exists in the things of this world: The unseeing mind ascends to the truth through what is material, and from its darkness rises towards this light," declares Suger's inscription over the portal, decorated with gilt bronze doors. The facade was completed before 1140, fitted with a rose window along the axis of the three portals, and distinctive for a series of column statues that were destroyed in 1771, but which are known to us from the Montfaucon engravings. This harmonious scheme—three portals sculpted with a series of column statues in the splays, the rose window installed along the axis of a facade flanked by two towers—went on to establish itself in all the great Gothic cathedrals. The first was Chartres, followed by Amiens, Paris, Strasbourg, Rheims, then Salisbury in England, and Orvieto in Italy. In Saint

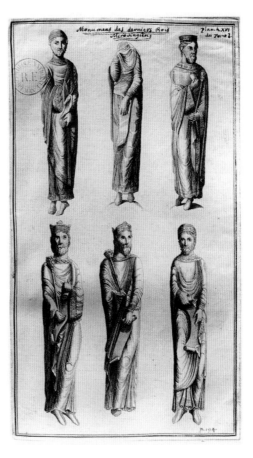

Bernard de Montfaucon
Drawing of six column statues in the central portal of Saint Denis abbey church (destroyed 1771) facade, showing kings and prophets from the Old Testament engraving from *Monuments de la Monarchie Française*, Paris 1729.

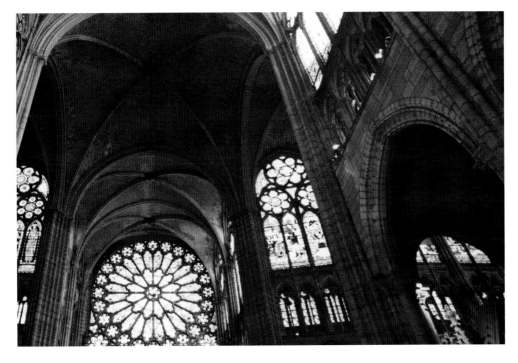

View of the vaults, rose and stained glass windows c. 1140–1238. Saint Denis (Paris), abbey church.

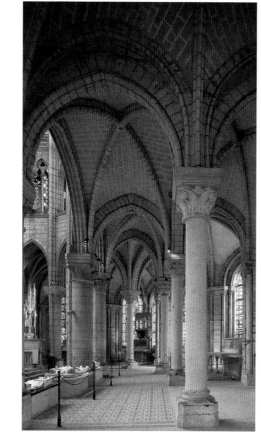

Ambulatory and side chapels
c. 1140–44.
Saint Denis (Paris).

Denis, the surviving features of Suger's interior are the ambulatory and the side chapels, whose ogival vaults are supported by slim columns. The many stained glass windows create, as was the Abbot's intention: "an uninterrupted shaft of light." This model was further developed at Chartres, with a triple series of overlapping supporting arches on the outside, and even larger windows inside. The stained glass at Chartres, set into rose and lancet windows, constructed over a long period of time, follows an extensive iconographic program, and recovers several themes dear to Suger. One is the *Tree of Jesse* (inspired by an excerpt from the Book of Isaiah, 11:1–2), which represented one of the "greatest expressions of the royal lineage of Jesus, descendent of David." (Le Goff 2004). On the other hand, it was Suger himself, close to the monarchs of France and actually regent for Louis VII during the second crusade (1147–49), who was the mind behind the "official" image of the Capetian dynasty. The twenty column statues of kings, queens, and Old Testament prophets, planned for the central portal splays, acted as a precise reference to the French monarchy, legitimizing its sacred role even at a time of bitter dispute, including with the Church. This was the symbolic prototype for the Chartres Cathedral facade's Portal of Kings (which

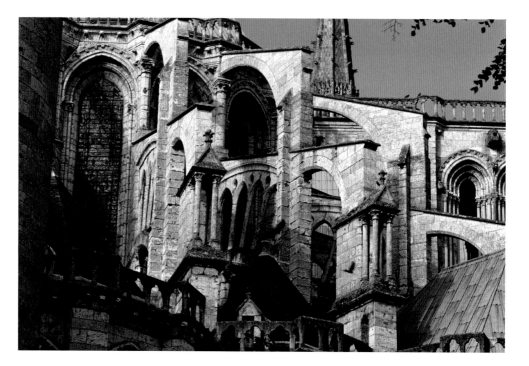

Exterior of the choir with buttresses and rampant arches
building begun in the twelfth century, consecrated 1260.
Chartres (Eure-et-Loire), Notre Dame Cathedral.

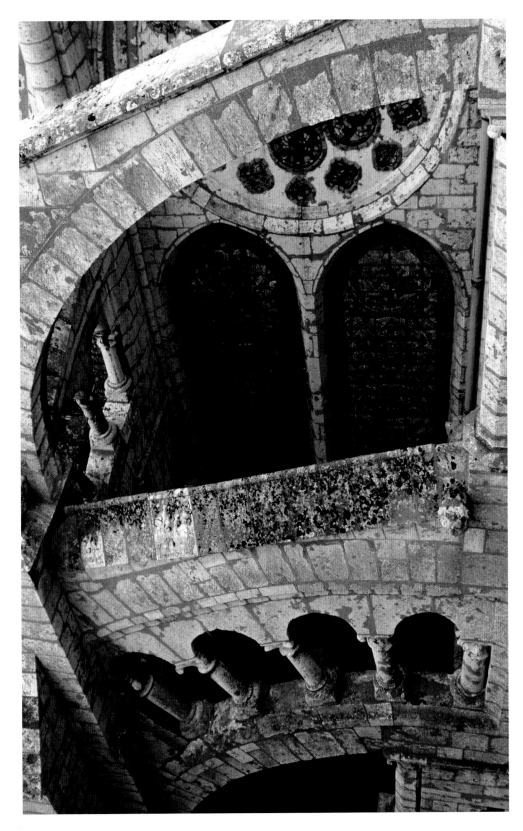

*Stained glass and rose
windows, in a view
of the tower*
1150 to the early
thirteenth century.
Chartres (Eure-et-Loire),
Notre Dame Cathedral.

fortunately survived the fire that devastated the church in 1194), and also the structural model for the column statues that since then have decorated almost all of the great French Gothic cathedrals. Thanks to the writings left by Suger, Erwin Panofsky was able to describe, in his famous essay, the Abbot's personality as a little rhetorical and enamored of greatness, but realistic and reasonable in his personal habits; a hard worker, sociable, polite, and full of common sense, vain, shrewd, and energetic. In a century of saints and heroes, Suger is outstanding for his humanity. And it was precisely a renewed sense of humanity and interaction that began to emerge from the first Gothic sculptures.

The Smile that Triumphed

The column statues first seen at Saint Denis began to have more complex poses and project increasingly from the surface. The great structural and symbolic development of the "protogothic" cathedrals, and sculptures now in the round (seemingly anticipated as early as 1188 by Master Mateo of Compostela, with his smiling prophets), are striking for another reason: compared with the figures that enliven Romanesque columns, the figures acquired intense expressions, shaking off their fixed gaze and often exchanging reassuring smiles, in a fond dialogue of sentiments. One example is the famous Rheims *Ange au Sourir*, which led several Italian sculptors of the 1300s,

Old Testament King
detail from the portal of the Kings
1145–55.
Chartres (Eure-et-Loire), Notre Dame Cathedral, western facade.

The Tempter and The Foolish Virgin
details from the left splay on the right portal
c. 1276.
Strasburg (Alsace-Lorraine), Notre Dame Cathedral, western facade.

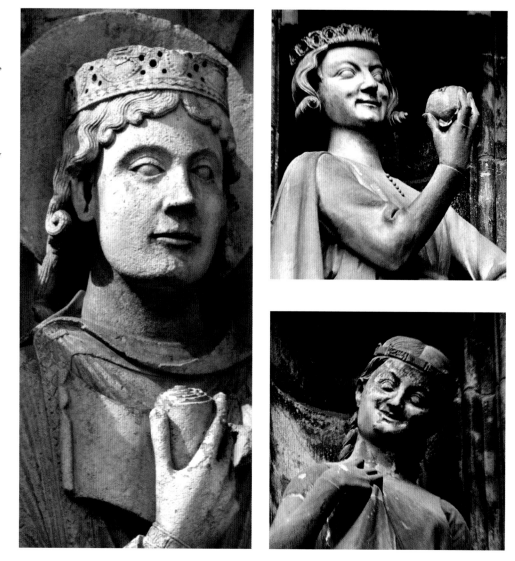

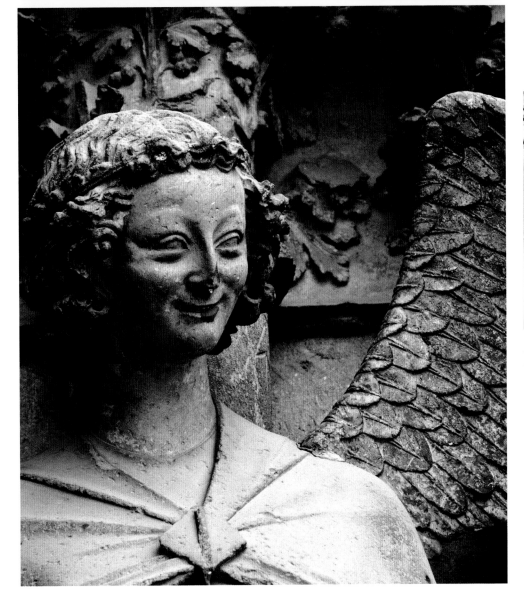

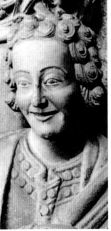

Above:
Master Mateo, Prophet
detail of a column statue
from the Gloria portico
c. 1188.
Santiago de Compostela
(Galicia, Spain).

Left:
**Visitation workshop,
Ange au sourir
(Smiling angel)**, detail
from the *Annunciation
and Visitation*, right side
of the central portal
c. 1252.
Rheims (Marne),
Notre Dame Cathedral,
western facade.

chiefly Giovanni, Andrea, Nino, and Tommaso Pisano, to work in the round, not just in marble but also in ivory, evolving a tender model: the Madonna embracing her Child, almost rocking Him as He nurses, their eyes locked in a loving gaze. The Virgin Mary had actually become a leading figure throughout European Gothic, even in the earliest figurative and symbolic representations. Churches and, above all, cathedrals dedicated to *Notre Dame* (Our Lady) sprang up in France, and to *Santa Maria* (Holy Mary) in Italy and in Spain. The Virgin was the patroness of these churches, and worship of her figure was revitalized: her effigy is found on facades, lunettes, portals, and cusps, almost as if she was an ancient protector and mother goddess. Other female figures of Romanesque tradition pervaded the popular mind with their powerful gazes, their smiles, and their very human posture, even when symbolizing metaphysical concepts or personifying Old Testament figures. Hence we find the *Wise and Foolish Virgins*, lined up on the Magdeburg *Paradiesportal* piers (c. 1245), and just a few decades later, the *Foolish Virgin*, silly and giggling, exchanging meaningful glances with the *Tempter*, on Strasburg Cathedral's facade. In that same cathedral, the southern transept portal is decorated with sophisticated statues, the exaggeratedly elongated bodies representing the *Church* and the *Synagogue*. One is a crowned woman, armed with a cruciform standard, and symbolizing the New Law of triumphant Christianity with great sovereign spirit. The other is a blindfolded woman who stands for the Synagogue, that is to say, the Old Law, defeated Judaism, her covered eyes symbolizing the Jews' "blindness" towards Christ; even so, she exudes an aristocratic beauty, almost denoting that she represents a phase in the history of human redemption, a

defeat seen through the eyes of the "most noble of victors," not a precise race. These figures were originally completely isolated from the wall behind them, as if conversing in the presence of another personage, that of Solomon, on the central pillar. The intention of the artist was to suggest to viewers that they were watching a sacred drama, a "scenic action," to use the definition of Marcel Aubert (1963), which united all three figures. Here we have the emergence of a new trend, that of making groups of statuary the fulcrum of surrounding space: In this respect also, juxtaposing statues of women and men was a masterly solution. In point of fact, women in monumental Gothic sculpture appear alongside their husbands. The most famous and surprising example is by an unknown but talented sculptor, known as the Naumburg Master, who seems to have trained in Ile-de-France, and about whom much has been written,

much of it contradictory. His life's journey seems to have taken him from France to Germany, if we follow the traces suggested by some: His sculptures are found in Amiens, Chartres, Noyon, and as far as Metz and Mainz. The sculptor produced for Naumburg the fascinating *Uta*, seen as shy by some, as haughty by others, but definitely mysterious, hidden in her heavy cloak. Uta was the wife of the margrave Ekkehard of Meissen (1032–46) and two centuries after her death was portrayed for eternity in the garb of the new era, realized as a polychrome statue next to her husband, along the walls of Naumburg's west choir. It seems that her figure even influenced some of the cartoon queens created by Walt Disney, who was certainly deeply influenced by the Gothic idiom. The two statues were part of an eleventh-century group that was intended to eulogize the church's established benefactors. Their real faces

Master of the Justice Column
Ecclesia and Synagogue
post-1230, sandstone.
Strasburg (Alsace-Lorraine), Frauenhaus Museum, from the right side of the southern portal, Notre Dame Cathedral.

Facing page:
Andrea and Nino Pisano
Madonna Lactans
c. 1350, polychrome marble.
Pisa, Museo Nazionale di San Matteo, church of Santa Maria della Spina.

Gothic · *The Smile that Triumphed*

Naumburg Master
Uta, wife of the
margrave Ekkehard
detail of a group of two
column statues in the
western choir, depicting
Ekkehard and *Uta*
church benefactors
post-1249.
Naumburg
(Saxony-Anhalt),
Saint Peter und
Paul Cathedral.

Facing page:
Giovanni Pisano
Marguerite of Brabant
detail of a fragment from
Elevation of the Soul to
the sky, supported by
angels
c. 1313.
Genoa, Museo
di Sant'Agostino,
Sepulcher of Marguerite
of Brabant.

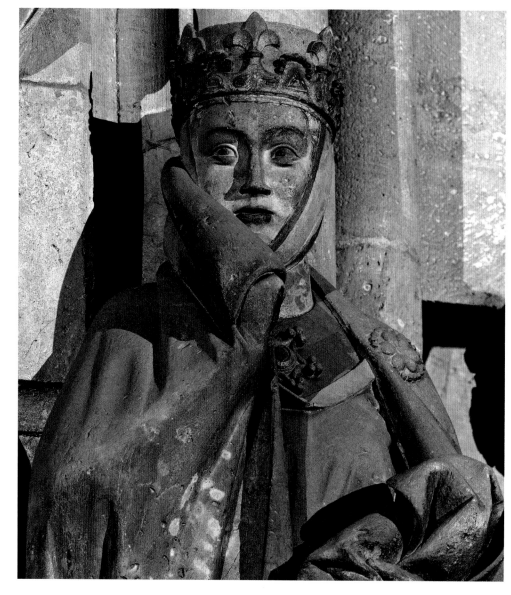

were certainly no longer remembered, but the statues present a striking realism, to the point that we think some contemporary personages must have modeled for the artist. There is also a lovely portrait in the famous *Bamberg Horseman*, whose identity is unknown and who seems almost as though captured in a snapshot, his lips slightly parted. The *Horseman* is an icon of Swabian nobility, on equal footing with other German Gothic sculptures, differing from French statuary of the same period in that it is not closely linked with the architectural structure.

Gothic: The Origin of the Word

Just from these brief considerations, we can see how difficult it is to narrow down the chronological and stylistic definitions of what is called Gothic art. As we have seen, the basilica of Saint Denis, inaugurated by Louis VII c. 1144, is indicated as the Gothic "keystone." Thus, the new style, emerging chiefly in the field of architecture and monumental sculpture, coexisted with most of the architectonic and figurative installations that are now commonly grouped under the "Romanesque" heading, including in France. To simplify the issue, Gothic art seems to have evolved slowly from Romanesque

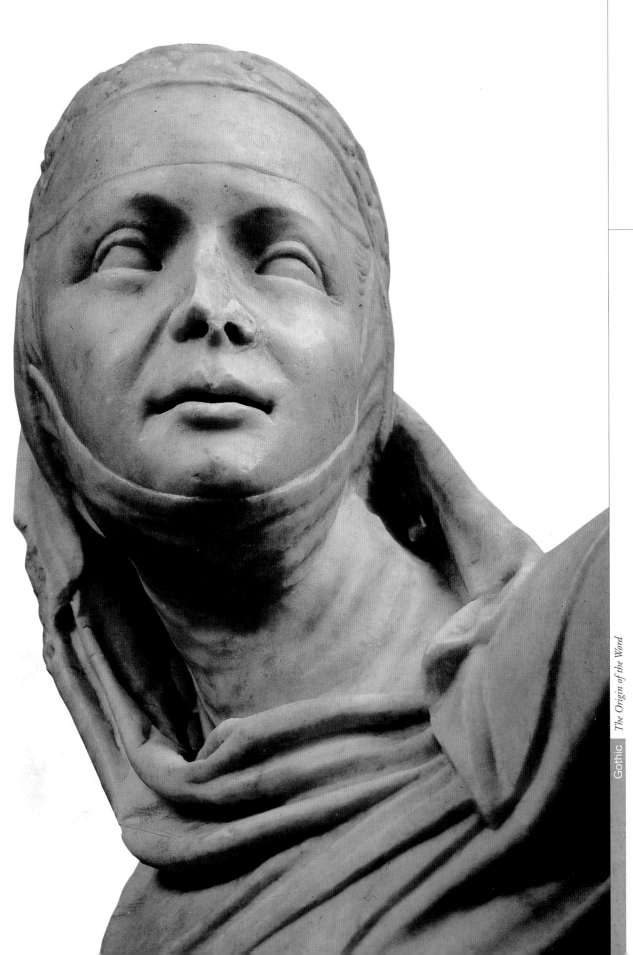

Right:
Saint Louis of France in battle in front of a Gothic cathedral
c. 1253–70, miniature page from the *Psalter of Saint Louis* (Louis IX, King of France, 1226–70).
Paris, Bibliothèque Nationale, ms. lat. 10525, c. 5v.

Below left:
Knight's head
c. 1237, sandstone.
Bamberg (Bavaria), Historisches Museum.

Below right:
Lower Saxony production
Ewer in the shape of a crusader
end of the thirteenth century, bronze (lance and shield added at a later date).
Florence, Museo Nazionale del Bargello.

Facing page:
King on horseback
(known as the **Bamberg Horseman**), detail
before 1237, sandstone.
Bamberg (Bavaria), cathedral, first column on north side of the St. Georg choir.

sources during the twelfth century, reaching its peak in the next century to dominate the 1300s, persisting—especially outside of Italy—through the fifteenth and even into the sixteenth centuries. Even more succinctly, we can state that Gothic art soon spread from Ile-de-France into the rest of the kingdom and across Europe. The growth of the Cistercian movement also played a determining role in the establishment of the new style in Spain, England, and Scandinavia. Perceived as the art of light, Gothic became, above all, the Nordic European "style" and was used extensively in civic architecture. One of its chief characteristics is an accentuation of linearity that immediately spread from architecture to sculpture and to all other figurative techniques: stained glass, painting, jewelry, and miniatures. The trend towards verticality and the broken line, seen in pointed-arch architecture, later combined with other elements to create many forms and types, like the multifoil arch (applied to tribunes and canopies) or the composite arch. The buildings became increasingly audacious in their structural methods, later emphasizing groins, once

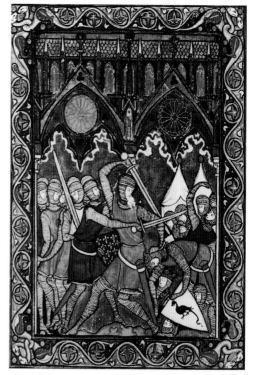

Rose window and pinnacles, Virgin and Child in the tympanum cusp, above Christ the Redeemer
detail from the upper section of the facade
c. 1276.
Strasburg (Alsace-Lorraine),
Notre Dame Cathedral.

Berenguer de Montagut, Ramon Despuig, Guillem Metge
Aisle vaults
1328–83.
Barcelona,
Santa María del Mar.

again reaching mainly England, France, and Germany. The term *Gothic*, associated with the idea of a "German" manner—basically the Nordic world—actually has distant origins: It seems to date back to 1515, when Raphael referred to "the manner of German architecture, which is very distant from the manner of the Romans and ancients, as can still be seen in the decoration [...]; and the Germans, whose manner is still quite stiff in many places, often add as ornamentation small, crouching figures—badly made and serving as a poor sort of bracket, that supports a beam—and other strange animals, shapes, and foliage without rhyme or reason." German, that is to say *Gothic* or *barbarian*, was a term found often in Giorgio Vasari's *Lives*, in the mid-sixteenth century, and always in a depreciatory sense. For centuries, "Gothic" remained a synonym for unrefined, "monstrous" and "barbarian" (Vasari's words) buildings, when compared with the harmony and perfection of ancient classical art. As late as 1850, the Neoclassical architect Quatremère de Quincy declared: "How can you expect me to comprehend

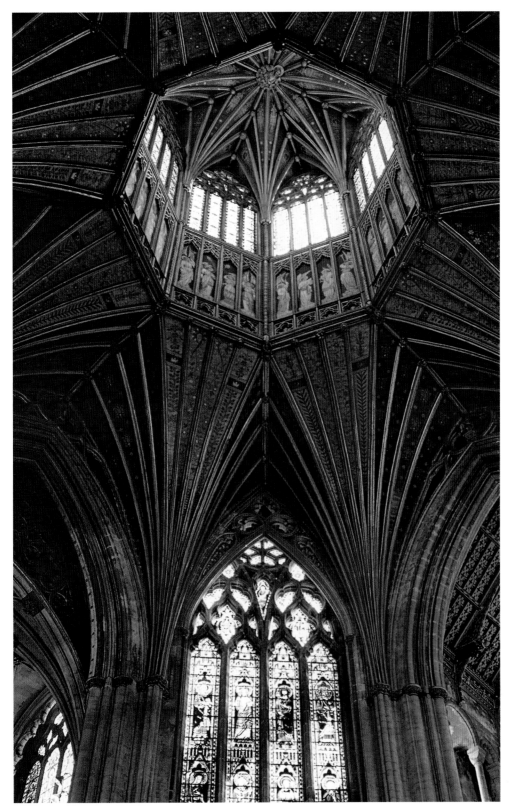

Above:
**View of the interior
towards the choir**
building begun in 1248.
Cologne (Rhineland),
cathedral.

Left:
**Crossing tower with
scissor arches**
1338.
Wells (Somerset),
cathedral.

*Decoration on
the exterior*
1388–1533.
Batalha (Portugal),
Santa María da Vitória
monastery.

**Heinrich Parler, Peter
Parler, and others**
*Decoration on the
exterior*
1350–58.
Nuremberg (Bavaria),
Frauenkirche, upper part
of the facade.

these monuments, after I have studied Greek art?
These walls look as if they might collapse at any
moment, staying upright only thanks to a forest of
struts and bulwarks, creating for me the most
unpleasant effect." During the French Revolution,
many precious testimonies were destroyed, chiefly
statues and portals, but as the 1700s drew to an
end, a new movement began to spread in England.
Thanks to "eccentric" writers and collectors, like
Horace Walpole and William Beckford, the Gothic
Revival got under way, overturning negative opinions
on medieval art and initiating a "new" aesthetic in
the era of "Reason and Enlightenment," at the
dawn of "Romantic" thinking. From Walpole's
mock-Gothic Strawberry Hill mansion in London,
to Beckford's *Gothic folly* at Fonthill in Wiltshire
(an immense abbey conceived with a very tall tower
that collapsed in an undignified heap), Europe saw
a proliferation of Neogothic castles and forts, often
surrounded by fake ruins to add a further touch of
picturesque eccentricity and magic to the idea of
the Middle Ages, dear—although in different ways—
to figures of the caliber of Victor Hugo, Viollet-le-
Duc, or Ludwig II of Bavaria. Nevertheless, in 1836,

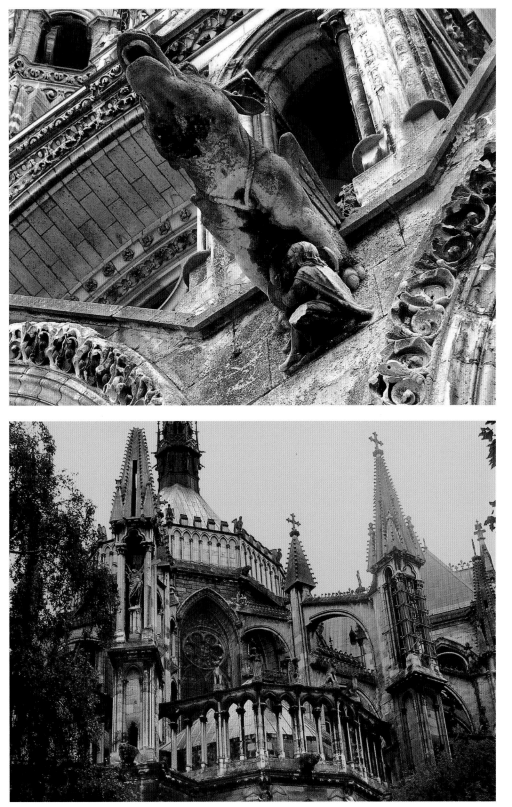

***Decoration on
the exterior***
thirteenth century.
Laon (Aisne),
Notre Dame Cathedral.

View of apse chapels
1220–41.
Rheims (Marne),
Notre Dame Cathedral.

Fortified medieval village
Monteriggioni (Siena).

Medieval tower-houses
San Gimignano (Siena).

Stendhal declared in his *Memoires d'un touriste*: "Only in the last thirty years have we been able to see clearly in these things. Gothic architecture is still awaiting its Lavoisier." The "Gothic Lavoisier" soon appeared in the figure of the archeologist Arcisse de Caumont, a colleague of the aforementioned Gerville, in Normandy's Societé des Antiquaires. Caumont suggested a distinction between Romanesque and "ogival" art, the latter characterized by the ogive or broken arch. Others later objected that the typical architectural element of the thirteenth and fourteenth centuries was not the broken arch, but a vault set on an ogival crossing; many other subtle definitions were then added to these initial attempts at definition. In any case, the term *Gothic* began to establish itself with positive nuances even if it was sometimes criticized in the early twentieth century as being "too Germanic," and even if another Frenchman, the archeologist Camille Enlart, author of pioneering studies on these themes, was actually proposing (without much success) to change the name to "French art" (from *opus francigenum*). So far we have merely hinted at "Nordic" art, but what limitations did (and still does) the use of the term *Gothic* make on Italian art, which is often said to have adhered only marginally to this new style?

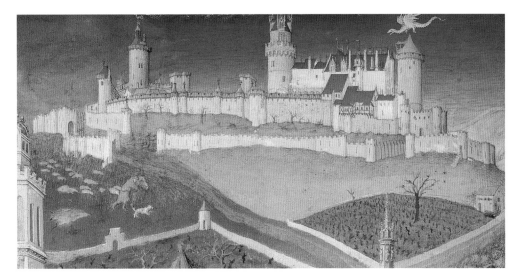

Paul de Limbourg and an anonymous painter
Lusignan castle in Poitou, the favorite residence of the Duke of Berry
detail of the miniatured page, with an allegorical illustration of the month of March, from *Très Riches Heures du duc de Berry*
1415–40.
Chantilly, Musée Condé.

Italianate, "Latinized" Gothic

It is accepted practice to declare that in Italy, Gothic took root mainly in Siena and Venice, also because there were diplomatic and trade relations between Siena and France, and between Venice and Germanic countries. The appearance of Siena Cathedral, the facade of Saint Mark's Basilica and

of Palazzo Ducale in Venice, are nonetheless examples of a quite original way of interpreting a new architectonic style. Siena Cathedral, for instance, covered with bands of alternating dark and white marble, stands out for its harmonious cupola and even more so for its campanile, set apart from the main building (this is repeated in Florence, with

Far left:
Walls of the medieval citadel built in various phases from during the twelfth to the fifteenth centuries and restored in Neogothic style by Eugène-Emmanuel Viollet-le-Duc
from 1849.
Carcassonne (Aude).

Left:
Eduard Riedel and Georg Dollmann
Emperor Ludwig II of Bavaria's Neogothic-style castle
begun in 1869.
Neuschwanstein (Füssen, Bavaria).

Ambrogio Lorenzetti
*View of Siena with
cathedral campanile and
cupola*, detail of a cycle
depicting the *Effects
of Good Government
in the City*
1337–40, fresco.
Siena, Palazzo Pubblico,
Sala dei Nove.

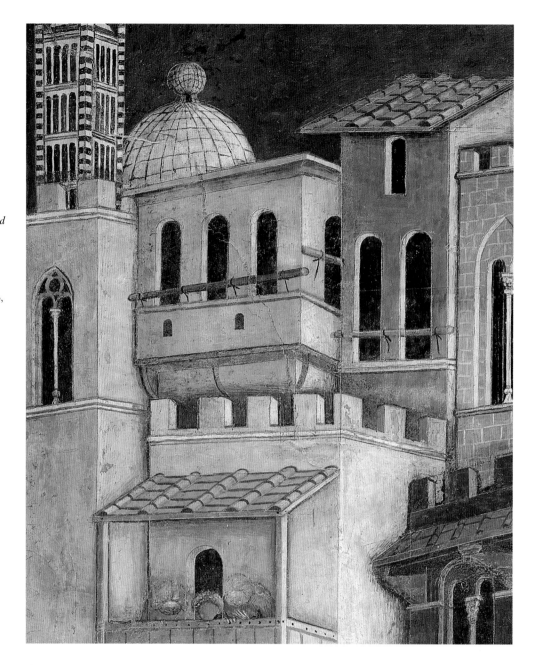

Giotto's famous bell tower next to the duomo).
Unlike the Ile-de-France cathedrals, it has no portal
sculptures, since the facades of Italian churches of
the period were usually designed as a unitary sur-
face. There are no facade towers, replaced pre-
cisely by the campanile, nor are there any rose
windows, although Orvieto's duomo boasts a mas-
terly example conceived by Orcagna. While the
Orvieto monument resembles Siena's duomo
because it, too, is faced with narrow strips of poly-
chrome marble, the former seems to be the only
one whose essential construction is truly inspired
by French art, to the point that, after its recent
restoration (2004), it has been dubbed "Italy's Notre
Dame." Moreover, some of the most famous artists
of the time took part in the development of these
marvelous monuments, acting not only as sculptors
but also as master builders and architects: Arnolfo
di Cambio and Giotto in Florence; Nicola Pisano
and his son Giovanni in Siena; and Andrea Orcagna

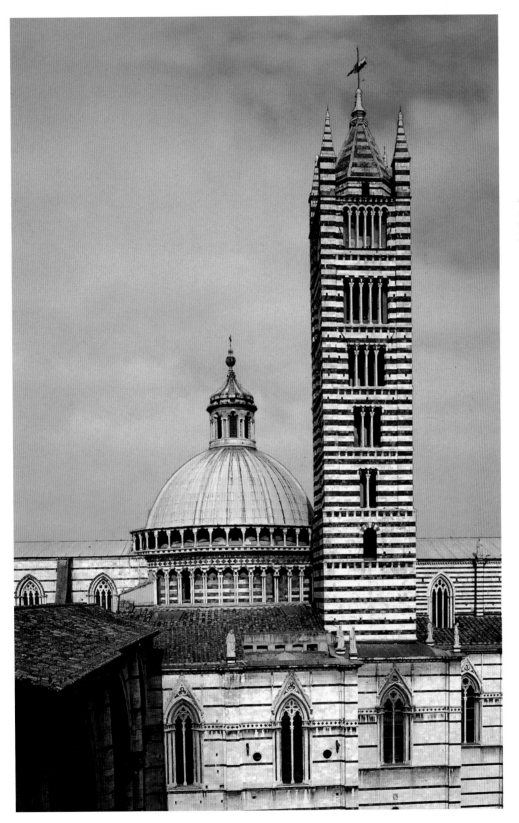

*View of the campanile
and south side of the
cupola*
Siena, cathedral of Santa
Maria Assunta in Cielo.

View of the aisle in the abbey church
1197–1208.
Fossanova (Latina).

Giotto and others
Cathedral bell tower
1334–59.
Florence, Santa Maria
del Fiore.

Outer wall facing in white and black registers
detail of the south
side portal
post-1330.
Orvieto, cathedral of
Santa Maria Assunta
in Cielo.

Facing page:
View of the nave towards the apse, faced with alternating black and white marble
1215–post-1376.
Siena, cathedral of Santa
Maria Assunta in Cielo.

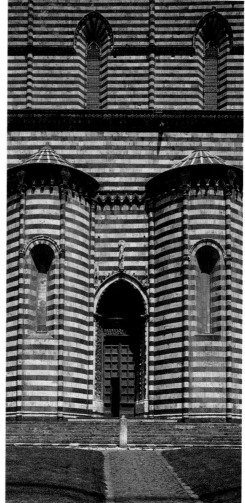

and Lorenzo Maitani in Orvieto. The building of Siena Cathedral began in the first quarter of the twelfth century, but work dragged on at length. The nave and aisles were not completed until 1259, and the crossing was covered with the octagonal cupola in 1264. We know that the Cistercian monks of nearby San Galgano Abbey (now in ruins) contributed to the main phase of the building. It is no coincidence that it was actually the Cistercian penetration from Burgundy (between the twelfth and thirteenth centuries), where the order's main abbeys were, that played a very important role in the development of Gothic style in Italian regions, in the same measure as occurred in Spain and Portugal. Interiors of Italian churches, however, do not enjoy the vertical soaring effect so typical of

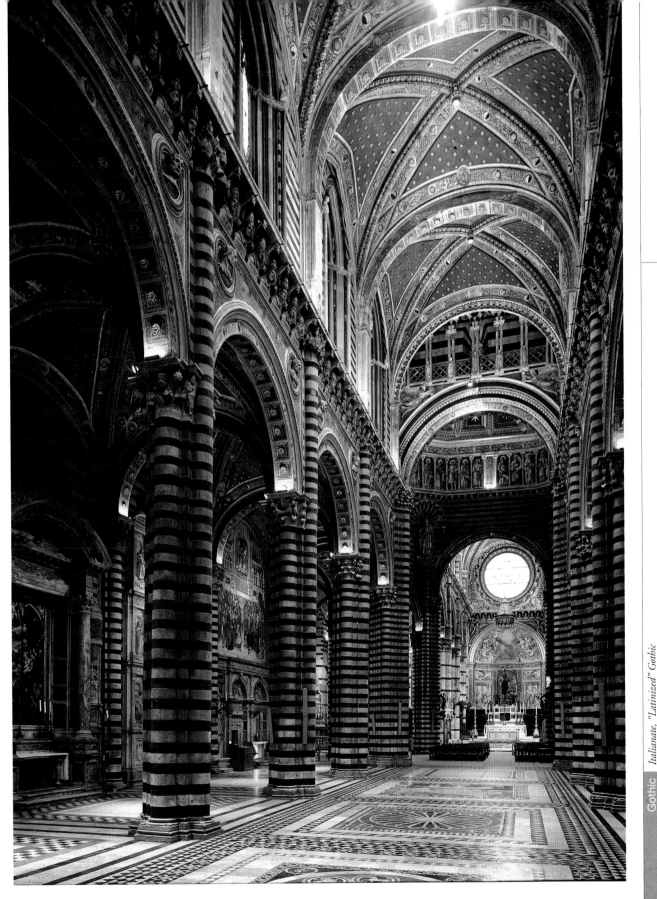

Top left:
Facade decoration, detail
begun in 1340.
Venice, Palazzo Ducale.

Top right:
**Gothic facade coping
with composite arch
(inflected and round)**
fourteenth century.
Venice, Saint Mark's
Basilica.

Below right:
**Facade seen from
northwest**
post-1450–mid-1500s.
Orvieto, cathedral of
Santa Maria Assunta
in Cielo.

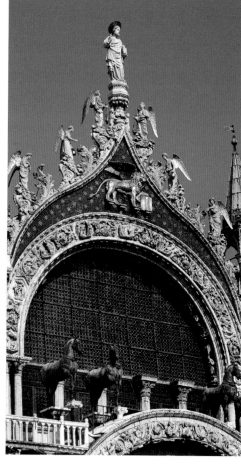

French monuments: the pillars are well separated,
the walls are simple—to leave space for large
fresco cycles, as can be seen in the Franciscan
basilica of Santa Croce in Florence. The nave and
aisle walls in Siena and Florence are in two orders,
and the ground floor arches are separated from
upper story windows by a projecting cornice. Other
churches in northern Italy, like that of Sant'Andrea
in Vercelli or the Duomo in Milan (which took cen-
turies to build), make no secret of their debt to
French architecture, and in the case of Milan, the
late-1300s phase of the construction owes much
to the contribution of many French and German
masters who had arrived specially from Lombardy.

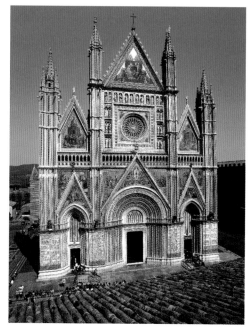

***Choir wall with
apse chapels***
1294.
Florence, basilica
of Santa Croce.

Frederick II of Swabia's hunting castle
c. 1240.
Castel del Monte
(Andria, Bari).

Facing page:
Southern Italian miniature
The falconer, leaving his clothes on the lakeside, swims to reach his falcon with its captured prey before 1258, miniature on parchment from the falconry treatise *De Arte Venandi cum Avibus* (*The Art of Hunting with Birds*), which belonged to Manfred of Swabia, son of Frederick II of Swabia (1194–1250), copied from the original manuscript commissioned by his father and already lost by 1248. Rome, Biblioteca Apostolica Vaticana, Pal. Lat. 1071, c. 69r.

Artistic Culture in the Time of Frederick II

The Kingdom of the Two Sicilies boasted a refined culture, and early scholars (like the Frenchman Emile Bertaux) on these themes considered French influence to have been stronger in other Italian regions, although this is now disputed. Southern Italy was first dominated by the Arabs, then by the Normans, and lastly by the Swabians, so it was no stranger to eclectic cultures. New lifeblood came, without doubt, through the huge personality of Frederick II of Swabia, whose birth was announced as an exceptional event for various reasons. Frederick was born in Jesi, in the March of Ancona on December 26, 1194, to Constance, the daughter of the Norman King, Roger II of Sicily. Constance was already forty years old and it was

her first child: quite an unusual circumstance at that time. Her husband was the Emperor Henry VI, who had been crowned King of Sicily in Palermo just the day before his son was born, a birth considered miraculous, given the mother's age. At the age of three, Frederick's father died, Italy was in tumult, and his succession in Germany seemed impossible. Constance somehow managed to salvage the Sicilian throne for her son, so at just four years of age the child was crowned King of Sicily and Palermo. In an intrigue of diplomatic moves, Pope Innocent III was appointed his tutor. Between 1212 and 1215, after a series of contrasting political events, Frederick was quite unexpectedly elected *rex romanorum*: first in Frankfurt, then in Mainz, and lastly in Aachen. The man had vast power and was unusually well educated, a lover of poetry and

literature, who belonged to myriad "linguistic worlds," not only German and Italian, but also French, Hebrew, Latin, Greek, and Occitan. He also married several times, and with each matrimony created bonds with different countries, his wives including Constance (the daughter of Peter III of Aragon and widow of the Hungarian monarch Emmerich), Isabella-Yolanda of Brienne, and Isabel of England. He fathered many children, including Enzo and Manfred, who were illegitimate but recognized by Frederick. Manfred was his father's favorite and became governor for Conrad IV in Sicily, from 1250 to 1252, and was then crowned king of that territory in 1257. Southern Italy was possibly the area that Frederick loved best, for he had many castles built there, the most famous and the best-preserved today being Castel del Monte, built deep in the woods of Apulia to a perfectly octagonal plan. Although Frederick's castles prefer cross-vaults—an element that in some theories proves the existence of a "sort of umbilical cord connected to religious architecture in northwestern France"—nowadays, undoubted links are recognized with defensive architecture throughout the Mediterranean basin (Cadei 1998), not overlooking the fact that Frederick personally took part in the Crusades. He was a great hunter and is known to have commissioned a treatise on falconry, a masterpiece from a figurative perspective, but also of great scientific interest, even today, for ornithology scholars.

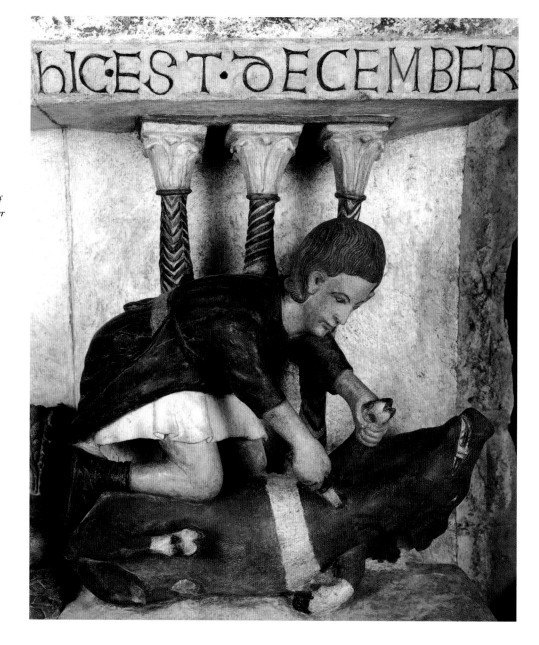

Butchering a Sienese "cinta" pig, allegory of the month of December archivolt detail on the central portal first half of the thirteenth century, polychrome stone. Arezzo, Pieve di Santa Maria.

The Figurative Vision

When considering Gothic, a sort of connecting theme (leaving aside regional peculiarities and many style differences) seems to draw together the great architecture, sculpture, and many items of sumptuary arts realized across Europe. It is very difficult to imagine a common language in the field of painting, especially Italian painting, and in this, Gothic is just a convenient adjective. The Gothic *weltanschauung* (vision of the world) is seen in Italian figurative art,

at least in principle, in the style of methods that were also to influence large sectors of European art, which appear substantially different from those of other regions. If the sinuous linear style typifies the line are features of Gothic, it certainly does not suit the art of Giotto, the undoubted protagonist of Gothic-era painting, and in many ways does not suit that of the Lorenzettis either. In reality, over the 1200s, artistic culture was renewed in Italy in processes that were quite similar to what occurred

in France: The increase in universities and urban theological schools, the establishment of Cistercian reform (not to mention the diffusion of the mendicant orders in various Italian cities and regions), all started to assume independent aspects. However, between the thirteenth and fourteenth centuries, art, town planning, social organization, and the development of financial activities seem to take on a leading role on the European horizon, at least in several Italian centers, chiefly Florence, a city that

historians have defined as the "1300s capital of art and urban planning." At this time not just painting, but also sculpture, took on a primary role. The thirteenth century had closed with absolutely innovative plastic artworks, as far as style was concerned, with renewal in terms of architectonic structure, and a huge variety of original designs in pulpits, fountains, and tomb monuments. The solemn classicism, and equally, a powerful naturalism of the figures portrayed in high relief or in the round, by Arnolfo di Cambio

Ambrogio Lorenzetti
Knight riding with his
retinue outside the city;
peasant and his pig in
a field
details from the cycle
The Effects of Good
Government in the
Country
1337–40, fresco.
Siena, Palazzo Pubblico,
sala dei Nove.

Gothic *The Figurative Vision*

Giotto
*Vase with lily and white
and red roses, symbols
of the Virgin Mary and
incarnation of Christ*
detail from *Madonna di
Ognissanti* (*Madonna
in Majesty*)
1310 panel.
Florence, Uffizi Gallery.

Giotto
Weeping mothers
detail from the *Slaughter
of the Innocents*, cycle of
*Old and New Testament
Stories*
1303–05, fresco.
Padua, Scrovegni
(or dell'Arena) Chapel.

and Giovanni Pisano, have no equivalent in other artistic centers. In the field of painting, artists like Duccio, Pietro Cavallini, and Cimabue in Rome, Umbria, and Tuscany were starting to detach from the traditional Byzantine linearism that had dominated Italian figurative style until the mid-1200s. It was Giotto, and with him the Sienese Simone Martini, Ambrogio, and Pietro Lorenzetti, who made the decisive move towards a realistic notion of nature, humanity, and the "inhabited" space. After centuries of anonymity, Giotto made a name for artists, bursting forth with all the force of one who knew the significance of his actions, with pride in the mastery and role of his craft. Giotto proved he was an artist, but also a businessman, who was able to manage, not without acumen, a shop where many assistants worked. Often they took over from their "boss" on works that he would actually just sign when they were finished, not without some question and arguments with the sharper, more obdurate patrons. This was confirmed by the

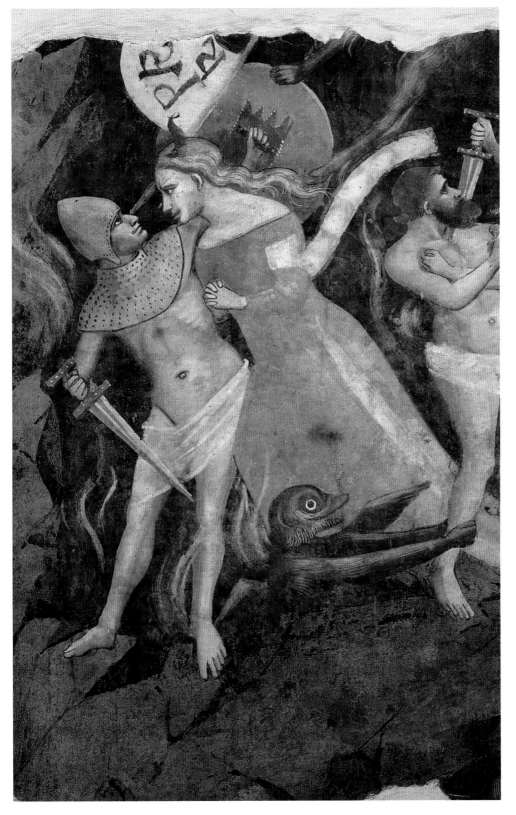

Andrea Orcagna
The Damned in Hell
detail from the *Triumph of Death*
c. 1350, fragment of a
fresco from the right wall
of Santa Croce Basilica.
Florence, Museo di
Santa Croce.

**Jacques de Baerze
Melchior Broederlam**
*The Temptation of Saint
Anthony,* detail from
the Champmol
Charterhouse reredos
c. 1394–99, carved wood
(Jacques de Baerze),
painted and gilt
(Melchior Broederlam).
Dijon, Musée des
Beaux-Arts.

Altichiero
Cavaliere, detail from
lunette with *Liberation
of the Disciples and the
Death of the Horsemen*
c. 1379, fresco.
Padua, Basilica del Santo,
San Giacomo Chapel.

writers of the time, who contributed to the myth of Giotto, both as the artist and as the man with a strong personality. Fourteenth-century culture, which in Italy could boast not only Giotto, Simone Martini, and the Lorenzettis, but also the inimitable literary triad of Dante, Petrarch, and Boccaccio, was nevertheless marked (just as Transalpine culture was) not only by strong unrest but also by profound transformations. The 1300s, throughout Europe, were rocked by famine and decimated by the bubonic plague, which in 1348 had wiped out almost an entire generation. It was also a century undermined by ferocious battles between the Papacy and the Empire, and by many contrasts even within the Church itself. Thus, the collective imagination, now truly universal—in Italy as in the European courts, in France, Spain, Germany, England, and in Bohemia—"recorded" psychologically assimilating events, we might say, and seemed to lean towards a sort of figurative expressionism that left precious traces in retables, fresco cycles depicting the *Triumph of Death*, *danses macabres*, variegated scenes of frightening devils, and plague victims. So the golden world of precious fabrics and costly works of art was contrasted by the violence of daily life, always overshadowed by the threat of death. A vision of torment, pathos, and pain that was succinctly described in 1399 by Tuscan poet and writer Franco Sacchetti, taking his

leave of that century: "I see the universe with such terrible signs of decline that I think the divine trumpet will send everyone off to the valley of no return and turn its back." Perhaps this was the autumn of the Middle Ages, in a famous definition by Johan Huizinga, a brilliant scholar at the Burgundian court, but it was neither its end nor its moment of decline. Gothic, this "style" of such variety and appeal, did not end with the turning of the century. If anything, it lived on for a considerable time beyond the Alps, often with expressions of lofty artistic quality, and through the work of established masters from Spain (Lluís Borrassà, Bernardo Martorell, and Bartolomé Bermejo); France (Jean Malouel, of Dutch origin, Henri Bellechose, and Enguerrand Charonton); Flanders (Melchior Broederlam); and Germany (Hans Pleydenwurff), to mention just a few. A large number of these artists are considered part of the so-called International Gothic movement (also called "courtly Gothic"), comprising a series of figurative (and architectonic, in the case of Late Gothic) depictions of a cosmopolitan nature. One of the most interesting and common aspects of the style was a new focus on portraying nature, often from life: flowers, birds in a rose bush. We have selected to close this short description with such engaging images, which will guide the reader, in the pages that follow, into a display of the most significant artists and works, techniques, and styles of Gothic.

Mosaic decoration with naturalistic motifs fourteenth century, marble and glass tesserae. Orvieto, cathedral of Santa Maria Assunta in Cielo.

Stefano da Verona *Madonna of the Rose Garden*, detail early fifteenth century, panel. Verona, Museo di Castelvecchio.

Gentile da Fabriano *Orris*, detail of a pillaret on the *Adoration of the Magi* cornice 1423, panel. Florence, Uffizi Gallery.

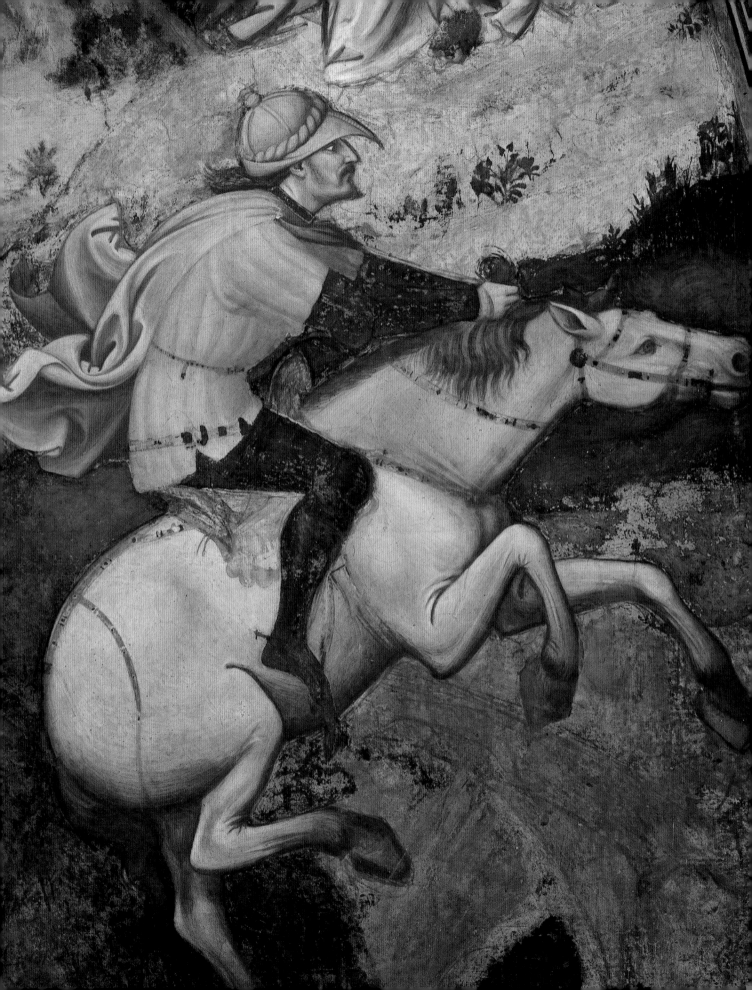

Gothic:

Key Figures, Artists, and Artworks

Portrait of Nicola Pisano, from Giorgio Vasari's *Lives*, Edizione Giuntina, Florence 1568.

Nicola and Giovanni Pisano
(Nicola, ? c. 1215–78/84; Giovanni, Pisa c. 1245–post-1317 Siena)

Nicola and Giovanni were father and son, and two of the first to study ancient art and human proportions. Nicola (documented as being in Pisa in 1265 with his son), trained in a Southern Italian classically inclined atmosphere, was influenced by the court of Frederick II. His main works can be found in Pisa and Siena, where he worked with Arnolfo di Cambio and with Giovanni. The *Fountain*, Perugia (1278), dense with reliefs, is also the fruit of his work with his son, who is documented as already being the master builder for the cathedral of Siena, the city where he had been living since 1285. Giovanni's many works include the pulpits in the church of Sant'Andrea (Pistoia, 1301) and in Pisa cathedral (1310), as well as the intense, superbly crafted *Sepulcher*, of which only fragments remain, dedicated by Henry III to Marguerite of Brabant, his young, much-loved wife, venerated in Genoa as a saint (see page 110).

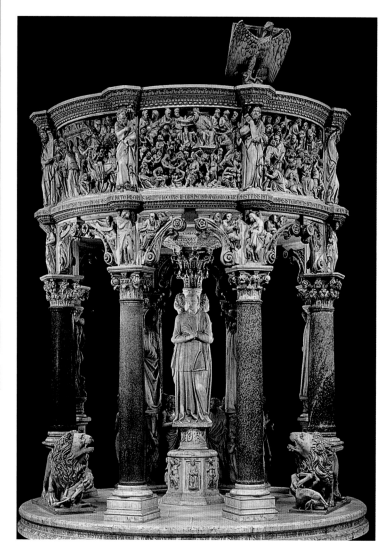

Left:
Giovanni Pisano
Pulpit
c. 1310, Carrara marble.
Pisa, Duomo.

Giovanni praises himself in an inscription on the base, and his talent emerges in all its complex maturity in this octagonal pulpit block, one of the finest examples of Gothic sculpture. The column-bearing lions and allegorical figures acting as a central support are stunning. Above, nine historiated, slightly convex tiles create a sort of precious crown.

Facing page, right:
Nicola Pisano
Ercole, pulpit detail
1260, marble.
Pisa, baptistery.

Nicola disregarded
Medieval legends that
attributed idolatrous
meanings to ancient—
that is to say "pagan"—
sculptures. Nicola's
Hercules was inspired by
a Roman sarcophagus
figure, probably studied
among the many
archeological findings
available in Pisa. Thus, we
have the first known nude
medieval heroic figure
in the round, idealized
according to the tenets
of classical forms.

Giovanni Pisano
*Fortitude and
Temperance*, pulpit detail
c. 1310, marble.
Pisa, Duomo.

Here we find the most
intense female figures
of the Middle Ages,
including a nude in the
round, which is rare for
the time. The clothed
woman, holding a lion
cub's paw, symbolizes
Fortitude, whereas the
naked figure seems to be
Temperance. The work
clearly derives from a
model from antiquity,
the *Venus Pudica*, known
to the Tuscan sculptor
thanks to a version found
in Siena at that time, but
now lost.

Portrait of Arnolfo di Cambio,
from Giorgio Vasari's *Lives,*
Edizione Giuntina, Florence 1568.

Arnolfo di Cambio
(Colle Val d'Elsa c. 1245–1302 Florence)

Arnolfo, *subtilissimus et ingeniosus magister,* as the people of Perugia called him in 1277, was a follower of Nicola Pisano and owes his fame more to his architectural skills than to his talent as a sculptor. Until the nineteenth century his statues, refined ciboria, sepulchers, and fountains all took second place to the architectonic designs for religious and civilian buildings (in Florence for the Basilica of Santa Croce, the Duomo, and the Palazzo dei Priori). Moreover, the artist declared himself an *architectus* on Boniface VIII's sepulcher, although he was also referring to the monumental tombs whose complex and "humanized" structures marked a fundamental turning point in this field, almost anticipating the humanistic formula of Florence's early 1400s. Nowadays, Arnolfo's sculptures are acknowledged as having that *dolce stil novo,* "sweet new style" that confers the same level of distinction afforded to Giotto for painting and Dante for poetry.

Arnolfo di Cambio
The Thirsty Cripple
c. 1281, marble.
Perugia, Galleria Nazionale dell'Umbria.

In 1277, Arnolfo was in the service of Charles of Anjou, Lord of Naples, who allowed the artist to travel to Perugia to direct the Fontana Maggiore works, although for unknown reasons, the work was actually completed by Nicola Pisano and his son Giovanni. It was not until 1281 that Arnolfo created a fountain—albeit smaller—for the city, at the foot of Piazza del Comune. Arnolfo's fountain was removed twenty years later, and just a few fascinating fragments remain, including this thirsty cripple approaching the fountain to drink. The opus was conceived with the sense of drama of human life, and seems to evoke antiquity in the realistic forms of the distorted limbs.

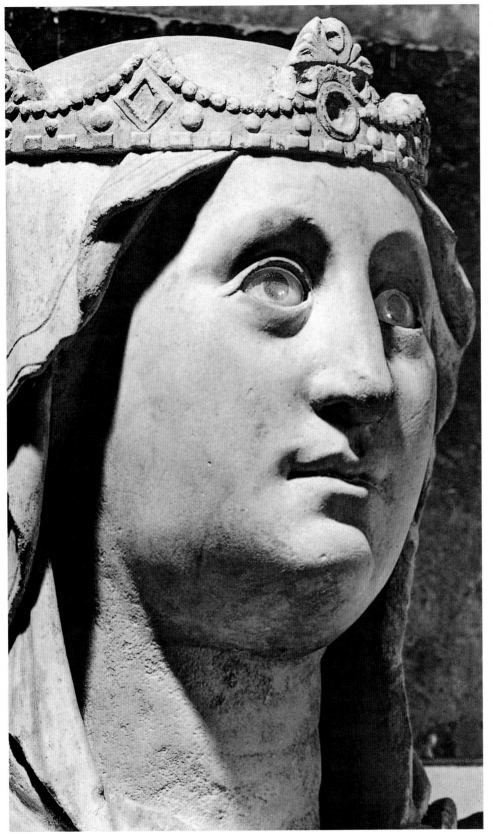

Arnolfo di Cambio
Madonna and Child
c. 1296, detail, marble
and glass paste.
Florence, Museo dell'Opera
del Duomo.

In about 1294, Arnolfo was
appointed architect for the
Duomo of Florence, and it is
odd that he was never men-
tioned by illustrious contem-
poraries like Dante,
Boccaccio, and Sacchetti,
although he was an estab-
lished artist by that time,
with the city of Perugia try-
ing to tempt him away from
the Angevin court, as well as
working as a sculptor in
Rome and Orvieto. The
facade of the Florentine
Duomo he designed
(destroyed in 1587) was not
described until 1400, in
Istoria by Gregorio Dati:
"all white marble and por-
phyry, with marvelously
beautiful carved figures."
The surviving statue, an
*Enthroned Madonna and
Child*, comes from a "lovely,
mysterious little chapel"
above the central door. It
was framed by a marble
pavilion, imitating the cur-
tain held open by two
angels. Judged to be one of
Arnolfo's masterpieces, the
statue with the bright—
almost ecstatic—eyes,
rendered lifelike by colored
glass, is comparable to the
gentle *Madonna of San
Giorgio alla Costa*, the most
intense painting realized by
a youthful Giotto, and
shown here on page 150.

Pietro Cavallini, *Serafino,*
detail of the *Last Judgment,*
c. 1299, Rome, Santa Cecilia
in Trastevere.

Pietro Cavallini
(active in Rome and Naples, 1273–1321)

From the thirteenth to the fourteenth centuries, central-southern art emerged thanks to renewed papal prestige and the refined tendencies of the vibrantly cosmopolitan Neapolitan court, with patrons who encouraged experimentation that was crucial for the evolution of Italian figurative culture. In Rome, Iacopo Torriti and Filippo Rusuti were skilled artisans in several pictorial and mosaic projects, but the leading role was played by Cavallini. Nothing is known about his training, although there is no doubt that he collaborated on mosaics and frescoes in many Roman churches, where a new sensitivity for Classical art and spatial interpretation can be seen. Pietro may have been in contact with Arnolfo di Cambio, when they were both working in Santa Cecilia in Trastevere. In 1308, famous, and with a multitude of assistants, he was called to Naples by Robert of Anjou, where this monarch compensated him with generous remuneration.

Pietro Cavallini (attr.)
Faux enclosure, detail
c. 1310, fresco.
Naples Duomo, Sant'Aspreno Chapel.

Pietro Cavallini's work in Naples, documented by an invitation to the Angevin Court in 1308, is not confirmed by sources that specify any actual opus. We can presume that the Master, assisted by various of his pupils, worked in the main monumental complexes. He was certainly the author of a decorative program for Santa Maria Donnaregina (1310–20). On the other hand, there is no certainty as to his role in the Duomo's construction, where one of the surviving frescoes is stunning for its masterly sense of illusion and the drawing's impeccable geometry: The *ad fresco* imitation of a stucco screen, seen in perspective, was realized on the projecting pediment of the Sant'Aspreno chapel.

Pietro Cavallini
Christ
detail from the *Last Judgment*
c. 1293, fresco.
Rome, Santa Cecilia in Trastevere.

Following modifications to the church of Santa Cecilia in Trastevere, the masterpiece by Pietro Cavallini is now in the cloistered nuns' choir and can be reached only by passing through part of the convent. The fragments of surviving frescoes were discovered in the 1900s, and had been much praised in the fifteenth century by Lorenzo Ghiberti. They occupy three walls, depicting an extraordinary *Last Judgment, The Annunciation,* and several biblical excerpts. The artist's talent is evident, in his rich palette, solidly modeled faces, and the individualization and exceptional authority of the figures. Although they are now almost unrecognizable (several are damaged), with anatomical details exposed with crude realism, they are still among the most forceful nude paintings of the time. The *Christ* here has lost some of the typical Byzantine fixity of gaze.

Portrait of Cimabue, from Giorgio Vasari's *Lives*, Edizione Giuntina, Florence 1568.

Cimabue
(Cenni di Pepe, or Pepo, Florence, doc. 1272–1301)

Cimabue's fortunes were overshadowed by Giotto's rising star, according to Dante's cliché. There is little to document his life, and we have only two certain dates: In 1272 he was in Rome, and in 1301–02, when he died, he was in Pisa. Apart from his work on the basilica in Assisi, his probable design of several mosaics in Pisa Cathedral and the Florence baptistery, Cimabue left some of the most intense panel *Crucifixes* and *Madonnas* in Medieval art. His painting is deeply expressive, with intense colors that exalt the plasticity of the bodies, and registers a gradual liberation from Byzantine lifelessness, tending towards an independent figurative and, finally, Western language, already partly initiated in Florence by another original master, Coppo di Marcovaldo (d. 1280).

Fate decreed, however, that two of Cimabue's masterpieces ended up seriously damaged: the first was the Santa Croce *Crucifix* (c. 1275) in Florence, ruined by the 1966 floods (ironically, until just a short time earlier, it had been safe in the Uffizi Gallery); the other was the *Evangelists in Assisi*, of which a number of details were destroyed by the 1998 earthquake.

Cimabue
Crucifix, complete
(detail on facing page)
c. 1270, panel.
Arezzo, San Domenico.

A few years before painting the Santa Croce *Crucifix* in Florence, Cimabue was experimenting on a suffering Christ for the Arezzo church: The result is vibrant with pathos, the body dynamically arching.

Gothic *Cimabue*

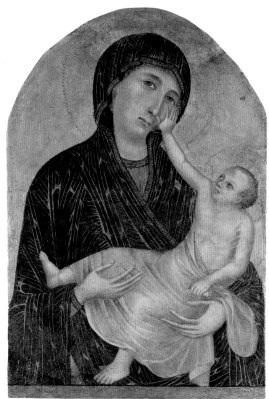

Cimabue and Giotto (?)
Madonna and Child
c. 1290, panel.
Castelfiorentino (Florence),
Pinacoteca di Santa Verdiana.

This is one of the most famous and debated paintings
of the late 1200s, once attributed to Duccio. Some
have even suggested that young Giotto had a hand
in it, as he was active in the Cimabue workshop at
that time.

Cimabue
Ytalia
detail from the crossing vault, *Saint Mark the Evangelist*
c. 1278–80, fresco.
Assisi, San Francesco, upper church, Evangelists vault.

It is thought that the frescoes in Assisi's four crossing vaults were commissioned by
Pope Nicholas III (a life senator from 1278) to underscore the universality of Christianity
and the centrality of the Papacy. Each vault is dedicated to an Evangelist, to the country
he Christianized, and to the most representative city: Mark's country was *Ytalia*, and
Rome was his city, seen here with the most emblematic monuments of the time.

Cimabue
The Santa Trinita Majesty
c. 1280–90, panel.
Florence, Uffizi Gallery.

The impressive altarpiece, which measures 385 x 223 cm (152 x 88 inches), must have appeared even more stately to the worshippers, since it has had a 30 cm-wide (12 inch) frame, now lost. The opus was originally installed above the high altar in the Santa Trinita church in Florence, and stayed there until 1471. One step ahead of Giotto's exploration of space, Cimabue depicted the Madonna's throne as a curved cavity. In this singular architectonic structure, there are eight angels around the Madonna, and beneath her four prophets, Jeremiah, Isaiah, Abraham, and David, with their scrolls, announcing the arrival of the Savior, and alluding to the virgin birth of Jesus.

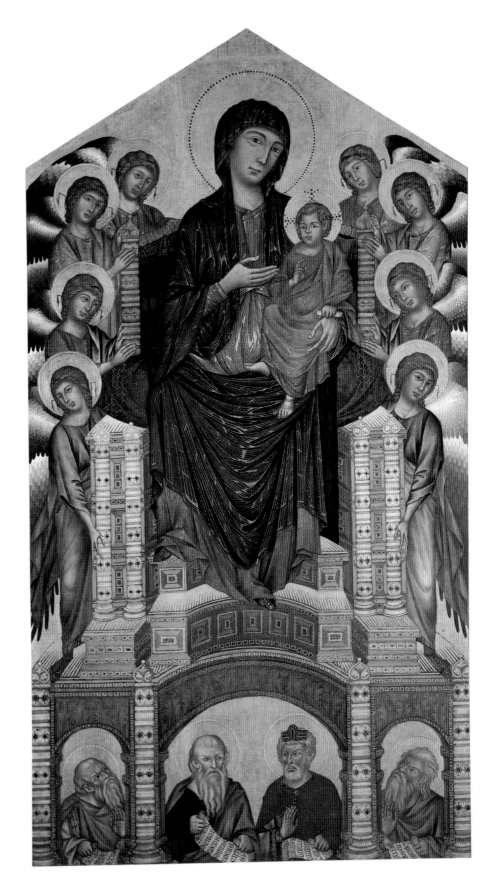

Duccio di Buoninsegna
Figure of a saint in a Medallion
detail from the *Laudesi Majesty*
frame, 1285, panel. Florence,
Uffizi Gallery.

Duccio di Buoninsegna
(Siena c. 1255–1319)

The life of this prolific artist from Siena is well documented. In 1278, the Commune paid him to paint document cases; later he was asked to paint a number of panels (now lost) that would, in a typically Sienese tradition, decorate the city's tax registers; in 1285 he realized the *Pala di Santa Maria Novella* altarpiece for the Compagnia dei Laudesi; around 1288 he produced the rose window for the Siena Cathedral. In 1302 he painted the lost *Majesty* for the Nove Chapel in Palazzo Pubblico, followed by the great Duomo *Majesty* in 1308, now in the Museo dell'Opera: This was a complex project that took him three years, painted with numerous scenes and a multitude of figures, front and back. For many years, Duccio was considered to be a follower of Cimabue, but is now deemed capable of having paid early attention to the young Giotto's investigations into spatial realism.

Duccio di Buoninsegna
Madonna and Child,
called the *Madonna di Crevole*
c. 1285, panel.
Siena, Museo dell'Opera del Duomo.

This famous panel is considered exemplary in confirming the stylistic affinities between the works of Duccio and those of Cimabue, which are obvious in the Castelfiorentino *Madonna and Child* (where it is thought young Giotto may also have contributed; shown here on page 144). The authorship of several works, in doubt between Cimabue and Duccio, were even given an imaginary name: "Cima-Duccio." In 1948, however, Roberto Longhi (one of the first modern scholars of the Italian thirteenth century), believed that Duccio was "not just Cimabue's pupil, he was his creation." Besides, Cimabue, the most important painter in Central Italy in those years, played a crucial role in the development of late thirteenth-century painting.

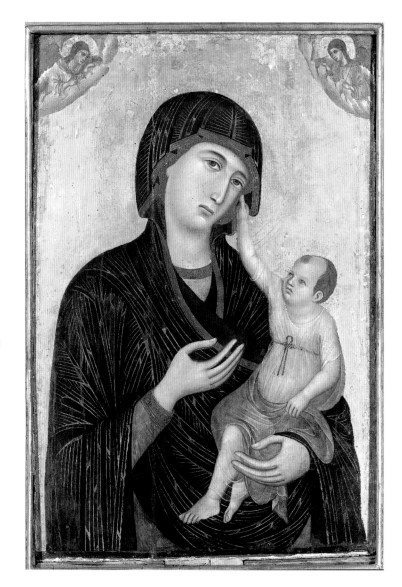

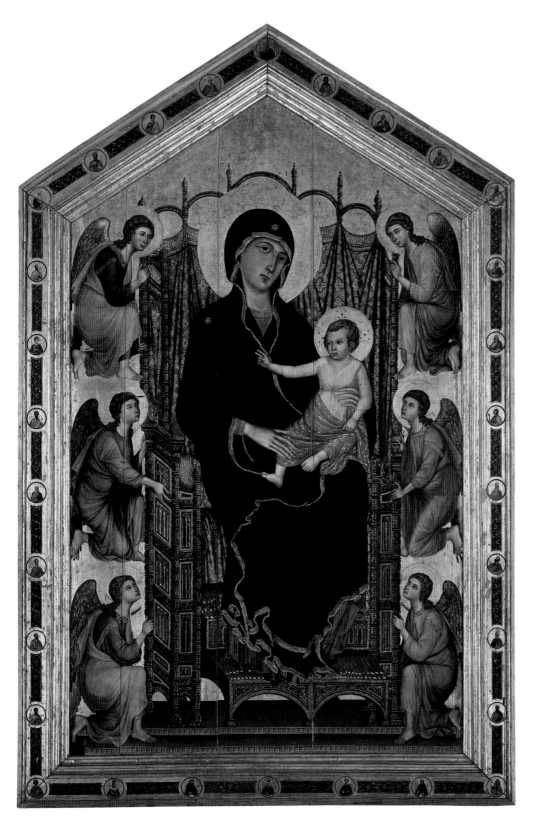

Duccio di Buoninsegna
Laudesi Majesty
full view (*left*) and a
detail (*facing page,
above left*)
1285, panel.
Florence, Uffizi Gallery.

This is the first great
opus known to us by the
great Sienese painter. It
was produced for the
Laudesi confraternity
chapel in the basilica of
Santa Maria Novella,
Florence, as indicated in
the contract dated April
15, 1285. Six angels at the
sides of the throne make
a symmetrical frame for
the immense Madonna
figure, her face still as
vaguely enigmatic as an
icon, but already tem-
pered by the hint of a
smile. The beaded frame
also plays a fundamental
role in the composition:
The 1989 restoration
brought to light the
medallions with half-bust
biblical figures and saints
(including Saint Peter
Martyr, founder of the
Laudesi Company) who
can be identified, despite
the reduced size, thanks
to their precise, distinct
physiognomies.

Duccio di Buoninsegna

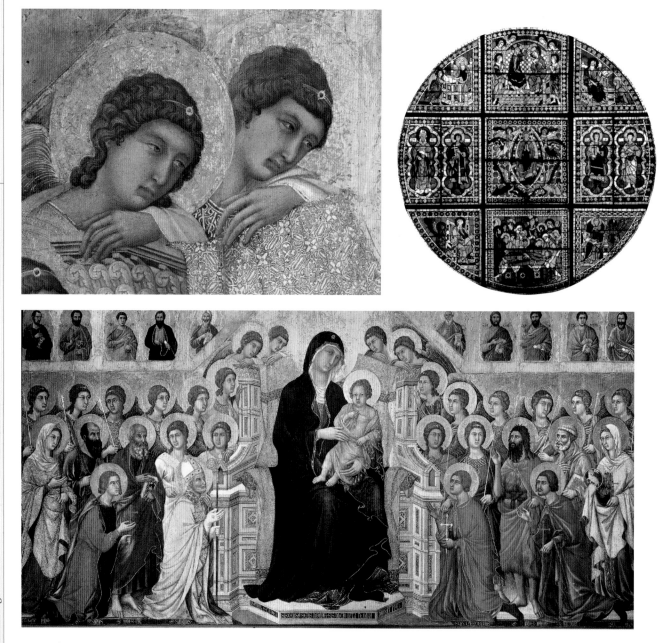

Duccio di Buoninsegna
Majesty
front, full view and detail of angels at the sides of the throne
1308–11, panel.
Siena, Museo dell'Opera del Duomo.

Duccio's masterpiece, the *Majesty* painted for the Duomo's high altar, has thirty-two large figures on the front and ten half-bust Apostles at the top; there are about eighty more figurations in the *Stories*, the predella prophets and the scenes shown on the back and on the cusps. It took the artist less than three years to paint, and on June 9, 1311, when it was completed, there was a solemn procession, accompanied by the municipal band.

Above right:
Duccio di Buoninsegna
Stories of the Virgin
1287–88, stained glass.
Siena, Santa Maria Assunta Cathedral.

A recent restoration was able to confirm the theory put forward in 1947, that Duccio—an artist leading the transition from Byzantine tradition to Gothic renewal—was the designer of the Duomo's splendid stained glass.

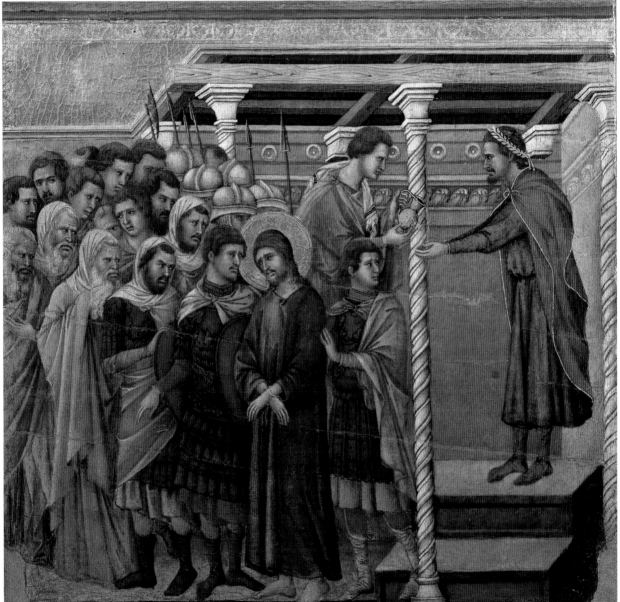

Duccio di Buoninsegna
Pilate washes his hands, detail from a *Majesty* reredos
1308–11, panel.
Siena, Museo dell'Opera del Duomo.

The great reredos was to be found on the high altar of Siena Cathedral only until 1505. We know that at the end of the fourteenth century, a device was manufactured in iron and wood, with four candle-bearing angels and another three descending to pass the Host, the chalice, and the corporal to the priest. Over the centuries, the opus was further modified and parts were lost. The greatest damage to the surface of the paintings was caused when the back was removed in 1771; several predella panels (also painted on both surfaces) are now in the National Gallery in London and other European and U.S. museums. Duccio had painted twenty-six scenes on the back, portraying the events related to the *Passion of Christ*, and this is where he seems to have expressed his illustration talent to the fullest.

Paolo Uccello (attr.), *Giotto*, detail of the *Portrait of Five Illustrious Men*, c. 1450. Paris, Louvre.

Giotto
(Agnolo di Bondone, Colle di Vespignano c. 1266–Florence 1337)

Giotto, the protagonist of a stunning development in medieval painting, is unanimously considered to be the most talented and versatile artist of his time. Contemporaries compared him to the great masters of antiquity, admitting his superiority over them for his rare brilliance and his ability to depict passions. Above any other, Giotto had "transformed Greek art into Latin," as the theorizer Cennino Cennini wrote in the late 1300s. In this statement it is clear that the revolutionary impact of Giotto's painting was already acknowledged at that time: The "Greek" language (in other words, the Byzantine style handed down for centuries), thanks to Giotto, had been replaced by a new "modern and natural" style. He transformed the notion of pictorial space, showing it as three-dimensional. His depiction of the figure was also innovative, as it became solid, volumetric—no longer ethereal bodies, floating in an unbelievable space lacking in perspective, but of flesh and blood people,

Left:
Giotto
Madonna and Child
fragment
c. 1290–95, panel.
Borgo San Lorenzo (Florence), Pieve di San Lorenzo.

The fragment, surviving from an altarpiece depicting the *Majesty*, is considered the oldest proof of Giotto's experiments with panel painting. The style has been compared to the *Stories of Isaac* and other *Old Testament* scenes that a young Giotto painted in the upper registers of the nave in Assisi's upper basilica.

Right:
Madonna of San Giorgio alla Costa
c. 1295, panel.
Florence, Museo Diocesano di Santo Stefano al Ponte.

A lovely work, showing Giotto's early spatial explorations, and the intense plasticity of the figures.

portrayed with realistic physiognomies, even with tears pouring down their faces (see page 130). The man was unique for his practicality and confidence in his own skills, which allowed him a privileged interaction with his patrons and perfect, shrewd entrepreneurial organization. There is some dispute about the chronology of his early works, whilst it seems likely that he served an apprenticeship in Florence to Cimabue, whom according to tradition, even repeated by Dante, was surpassed by his own pupil ("Cimabue thought himself master in painting/ and now the cry is Giotto" *Purg*. XI, 94–95). Contrasting theories say that from 1290 to 1304, Giotto frescoed the Upper Basilica of Assisi with the *Stories of Saint Francis*. In any case, before the century drew to an end, he was in Rome and in Rimini. By 1305 he was finishing the Scrovegni Chapel in a Padua. On his return to Florence, now well respected (and very well paid), he worked in Santa Croce for the wealthy Bardi and Peruzzi families. Robert of Anjou called him to Naples in 1329, together with his pupil Maso di Banco, and here he was named *protomagister* and *protopictor* ("chief master and painter"). He died in Florence, where he had meanwhile become master builder for the Duomo and superintendent for the city's fortifications.

Giotto
Devils Cast Out from Arezzo
detail fresco, 1296–1304.
Assisi, San Francesco, upper basilica.

The *Stories of Saint Francis* comprise twenty-eight scenes on the nave walls in the upper basilica, dedicated to the founder of the Franciscan order. The iconography follows to the letter the *Legenda Maior*, written by Saint Bonaventura between 1260 and 1263. In the episode of the devils cast from Arezzo, there is the outstanding view of the turreted city, its houses fitted with the typical medieval shutters. Winged demons with falcon claws flee in attitudes of despair, and the pathos is emphasized by the harsh appearance of bearded anthropomorphous faces. Doubts—albeit not very convincing— have been expressed on more than one occasion as to whether Giotto really was the author of this cycle.

Giotto
Majesty (Madonna Ognissanti)
c. 1310, panel.
Florence, Uffizi Gallery.

The great Umiliati confraternity altarpiece from the Ognissanti church in Florence. Here Giotto perfected his spatial research, as can be seen in the architectonic structure of the Virgin's throne, finally three-dimensional enough to make the setting of the scene convincing: This is Giotto's revolutionary "perspective box," which did not stop the great artist from using a traditional gold background. The throne that seats the *Madonna and Child* almost seems an open triptych, or even a ciborium, decorated in the Gothic manner with refined marble encrustation. The obvious disproportion of the Virgin compared with the other figures is probably due to the need for as many worshippers as possible to see the image of the *Virgin in Majesty*, since it was presumably placed off-center, as was Duccio's version for the Florentine church of Santa Marina Novella. The angels' ampullae with roses and lilies (symbols of the Virgin Mary, see illustration on page 130 are some of the finest medieval examples of still life, already attempted in the Scrovegni Chapel, Padua.

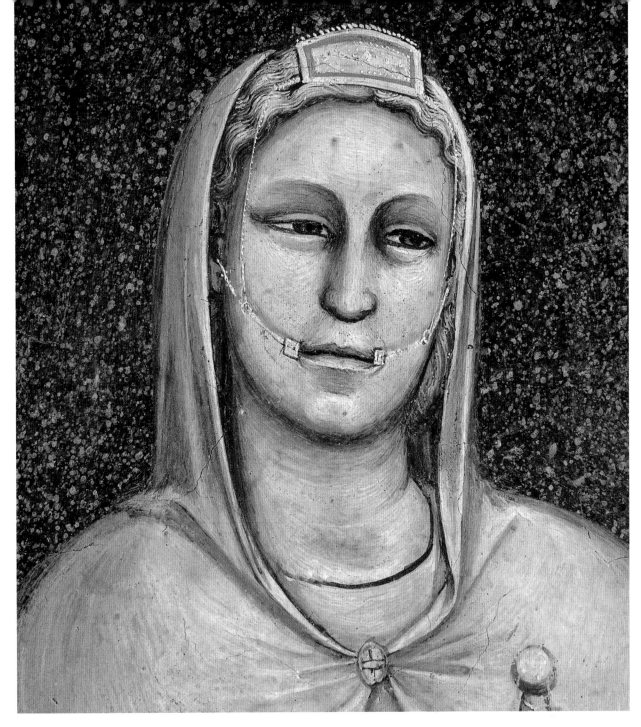

Giotto
Temperance
1303–05.
Detail from a monochrome base with allegories of *Vices and Virtues*.
Padua, Scrovegni (or Arena) Chapel.

The lower register of the Scrovegni Chapel is painted to resemble a base with figured rectangles, alternating with faux marble graining, which recent restorations have revealed as being made using a *marmorino* or Roman stucco technique. Giotto used it to explore the sense of realism and space, with the monochrome *Virtues* and *Vices* emerging from the background, almost like sculptures. These allegories, alluding to the Christian path to salvation, are the integration of the iconographic fresco cycle along the chapel walls, ending with the magnificent *Judgment* on the counterfacade. The Arena chapel was commissioned by the wealthy Enrico Scrovegni, to redeem the sins of his family, accused of usury. In the monochrome figures, Giotto emphasized the gestures, lingering on aspects of the allegories, and gave us some exceptional details, creating an antecedent for Andrea del Castagno's *Illustrious Men* fresco in Florence over a century later.

Simone Martini
(Siena c. 1284–Avignon 1344)

In a sonnet by Francis Petrarch, Simone ascends to Paradise to paint the "lovely face" of the legendary Laura, the poet's true love. We know nothing of that parchment portrayal, which could be the first independent example in history of western portraiture. Certainly the friendship with Petrarch contributed in no small measure to the immediate fame of this refined artist from Siena. For him, Simone also illustrated the famous *Allegoria virgiliana* in the frontispiece of a codex now in Milan's Biblioteca Ambrosiana. He was skilled at small works but equally in large paintings, and in Siena he was the master of a shop with various *chompagni* (companions), as well as working in Pisa, Orvieto, Assisi, and at the Angevin court of Naples. The Assisi frescoes may seem to betray a hint of rivalry with Giotto, but more often he was true to his own personal, aristocratic language, where color plays a primary role in conveying light and depth. In 1340 he moved to Avignon, at that time the papal seat, and here he worked for Benedict XII.

Portrait of Simone Martini, from Giorgio Vasari's *Lives*, Edizione Giuntina, Florence 1568.

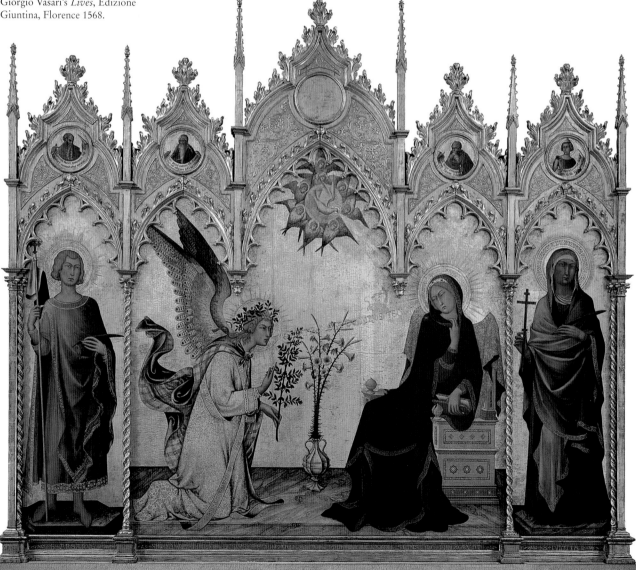

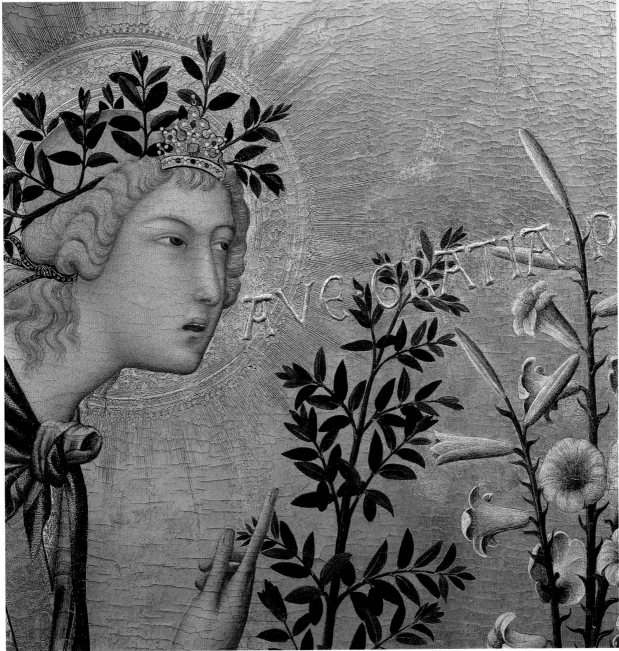

Simone Martini and Lippo Memmi
Annunciation
full view and detail
signed and dated 1333, panel.
Florence, Uffizi Gallery.

This altarpiece, now in the Uffizi, was originally conceived for the Siena Cathedral by Simone and his brother-in-law. The composition is typically Sienese in the linearity of the contours, enhanced by the sumptuous details that stand out from the gleaming gold background, and there is a strong theatrical stress: The shy, apprehensive Virgin is retreating from the angel, whose message is impressed on the panel like an *ante litteram* cartoon strip. The recent restoration has revealed unsuspected details, like the realistic olives that can now be seen very clearly on the branch that the announcing angel holds in this right hand.

Gothic Simone Martini

Simone Martini
Madonna and Child,
detail from *Majesty*
signed and dated
1315, fresco.
Siena, Palazzo Pubblico,
Sala del Mappamondo.

The 7 x 15 m (23 x 49
feet) opus is the biggest
mural depiction of the
period, and stretches all
along one wall of the
room used at that time
for the General Council
of the Siena Republic,
which comprised three
hundred citizens. The
scroll that the Child
Jesus holds is an
exhortation to the
citizens to love Justice:
*Diligite Iustitiam Qui
Indicatis Terram*. The
fresco, restored in 1994,
of which we show two
details, is dominated by
the *Madonna and Child*.
Siena's patroness is seated
under a cloth canopy, on
a golden throne, crowned
like a queen. Despite the
recent, excellent restora-
tion, the fresco has lost
almost all of the pre-
cious colors applied
"dry" for the clothing.
The Sienese artist was
able to express a com-
plex symbology here,
thanks in part to the
wording of a political
nature that he inscribed
around the painting,
(certainly requested by
the patrons), is already
showing his confident
departure from the
Byzantine style of the
thirteenth century.

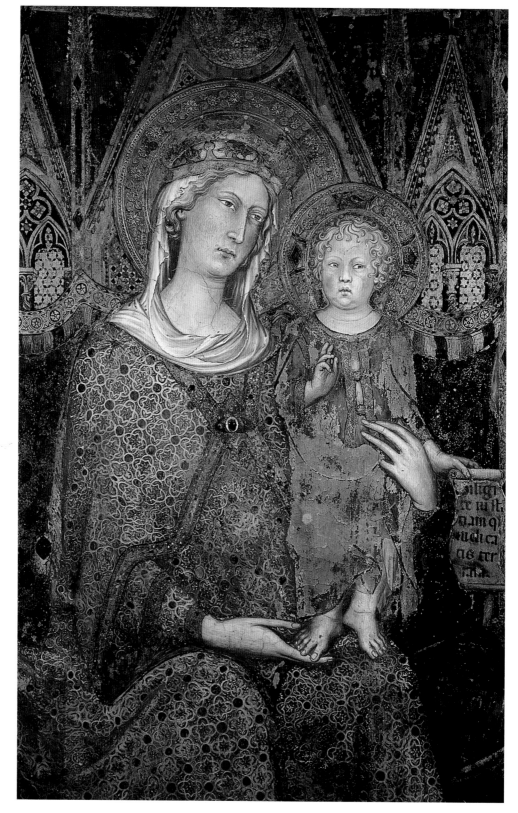

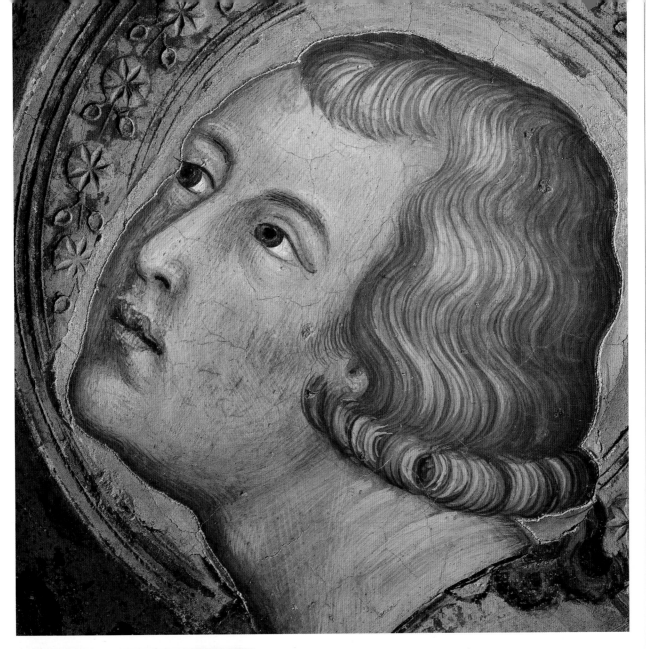

Left:
Simone Martini
Two chanting altar boys
detail of the *Funeral Rites*, from
the *Stories of Saint Martin* cycle
1315–18, fresco.
Assisi, basilica of Saint Francis,
lower church, San Martino Chapel.

The chapel is virtually a jewel box
immersed in lapis lazuli blue, and with
lyrical detachment, Simone describes
the life of this knight and saint.
A Giottoesque echo is visible in the
foreshortened faces and in the architec-
tonic wings separated by slim winding
columns, but the effect is really that of
a courtly, enchanted world.

Above:
Simone Martini
Angel's head
detail from *Majesty*
signed and dated 1315, fresco.
Siena, Palazzo Pubblico, Sala del
Mappamondo.

Gothic Simone Martini

Portrait of Ambrogio Lorenzetti, from Giorgio Vasari's *Lives,* Edizione Giuntina, Florence 1568.

Pietro and Ambrogio Lorenzetti
(Siena c. 1280–1348?) (Siena, documented 1319–48)

The fame of these two brothers from Siena soon reached Florence. Near the city, Ambrogio, perhaps the more brilliant of the two, painted the first dated work we know: the lovely, troubled *Madonna di Vico l'Abate* (1319, now in Florence, Museo Diocesano). In 1327 Ambrogio was a member of Florence's corporation of physicians and pharmacists. Although Pietro's frescoes for the Siena's Ospedale della Scala (1335) were lost, we do have many panels and a cycle in Assisi of the *Passion Stories.* After Simone left for France, Ambrogio became the official painter of the Sienese republic, and his surviving works include the famous frescoes on the *Effects of Bad and Good Government* in Palazzo Pubblico's Sala dei Nove. Later, Ghiberti called him "a most singular master," "a most noble draftsman," "far more erudite than the others."

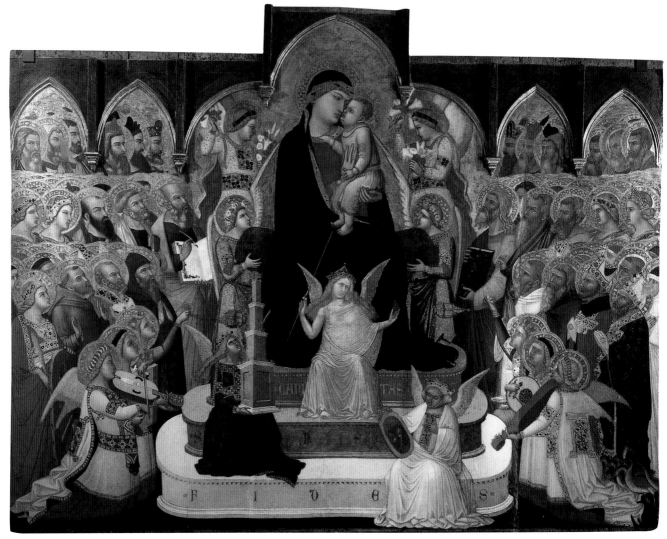

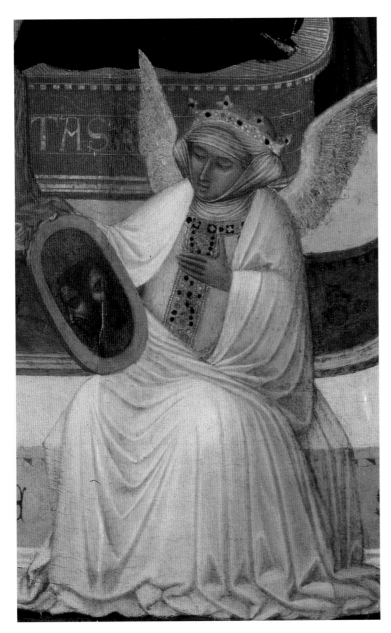

Ambrogio Lorenzetti
Faith
detail from *Majesty*
c. 1335–37, panel.
Massa Marittima (Grosseto), Museo Archeologico,
Palazzo del Podestà.

Faith, together with *Hope* and *Charity*, is depicted on
the steps of the Massa Marittima *Majesty* as a winged
woman looking into a mirror reflecting the triple
image of the *Trinity*.

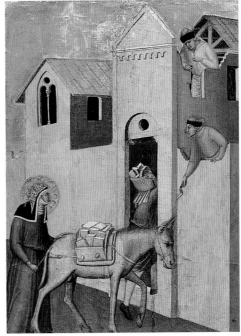

Pietro Lorenzetti
*Blessed Humility Leads Her Mule With the Stones
Gathered in the Mugnone to Build the Convent*, detail
from the *Blessed Humility Altarpiece*
c. 1340, panel.
Florence, Uffizi Gallery.

Rosanese dei Negusanti of Faenza, who died in 1310,
was the generous abbess of a Florentine convent. Her
image at the center of the altarpiece (not visible here)
was surrounded by eleven panels (another two are now
in Berlin) showing fascinating scenes from her daily life.

Facing page:
Ambrogio Lorenzetti
Majesty
c. 1335–37, panel.
Massa Marittima, Museo Archeologico, Palazzo del Podestà.

For the citizens of lovely Massa Marittima, in the Tuscan Maremma area, Ambrogio
showed "how important judgment and skill are in painting." So Vasari wrote in the
sixteenth century, and we can only support his words. A multitude of saints, prophets,
holy men and women, and angels scatter lilies and roses around the Madonna. The
most compelling figures of the Italian fourteenth century, the personifications of
Faith, *Hope*, and *Charity* (the latter in a transparent gown), sit on the steps at the
Virgin's feet, enhanced by inscriptions of a similar nature.

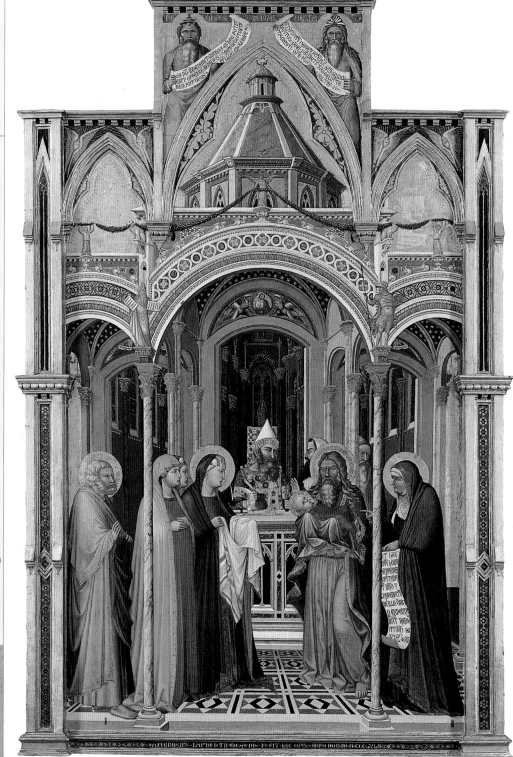

Ambrogio Lorenzetti
Presentation of Jesus in the Temple
signed and dated 1342, panel.
Florence, Uffizi Gallery.

A few years prior to his death, Ambrogio painted a masterpiece of the 1300s for the San Crescenzio altar in the Siena Duomo. It is considered almost a prelude to Van Eyck's famous *Madonna in the Church*. The composition (originally with two side panels) leads to a single vanishing point, which proceeds from the refined polychrome checkered floor in the foreground to the back of the apse. Keeping a careful eye on the perspective, Ambrogio also varies the color of marble used in the slim columns, depending on the depth of space they occupy. The opus is full of symbolic references, and the mock statue of *Joshua Dressed as a Soldier*, armed with a lance and clad in armor, is a clear allusion to the ideals of classical heroics. Set atop a column, and part of a matching pair, this figure seems almost to breathe (see detail on page 97).

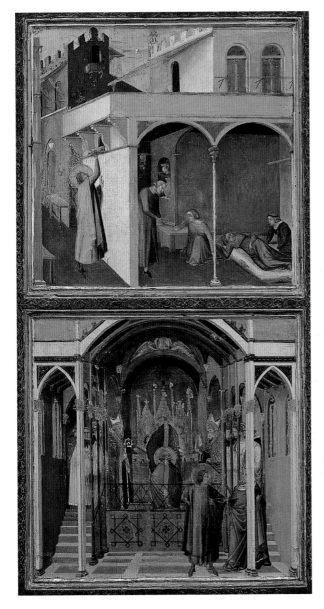 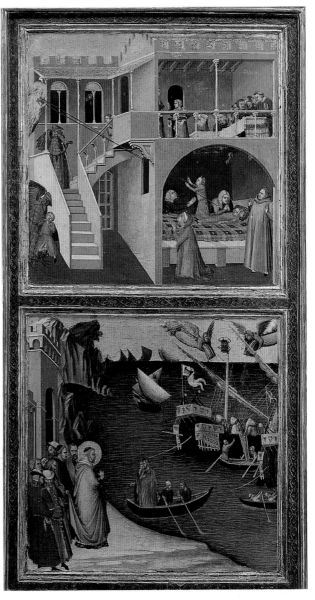

Ambrogio Lorenzetti
Four stories from the Life of Saint Nicholas of Bari
c. 1332, panel.
Florence, Uffizi Gallery.

The four scenes, painted for the Florentine church of San Procolo, are probably from a lost reredos or tabernacle. Ambrogio, an analytical narrator and a skilled examiner of perspective, investigates daily life with masterly spontaneity, successfully depicting characters with their backs turned or emerging from behind church columns. The artist challenges the viewer in a daring fishbone perspective of the seascape sketched out on the horizon by the sails billowing in the wind. As Giorgio Vasari pointed out, it is more than likely that for this work, the Siena artist immediately achieved a "boundless reputation" in Florence, whose citizens were more used to seeing Giotto's stark compositions.

Andrea Orcagna, *Angel*, detail of the *Triptych of Saint Matthew*, c. 1367–68, panel. Florence, Uffizi Gallery.

Andrea di Cione, known as L'Orcagna
(active in Florence and Orvieto, 1343–68)

Orcagna exemplified an eclectic fourteenth-century master, with the skills of a sculptor, painter, poet, and architect, as well as being the head of a flourishing Florentine family workshop. He is actually known mainly as the sculptor who created the refined marble tabernacle for the oratory of Orsanmichele, in Florence, enhanced with octagonal tiles, reliefs, sculptures, and openwork, with polychrome glass and marble inserts that give it the appearance of a magnificent item of jewelry (c. 1359–66). Orcagna worked on the construction site of Orvieto's marvelous cathedral, and even designed the extraordinary rose window in the facade (c. 1350–62, restored in 2004). He is less famous as a painter, although he did leave, through his workshop, several expressive works, like the frescoes in Santa Croce with the *Triumph of Death*, the *Judgment*, and the Inferno (illustrated on page 131), and the *Triptych of Saint Matthew*.

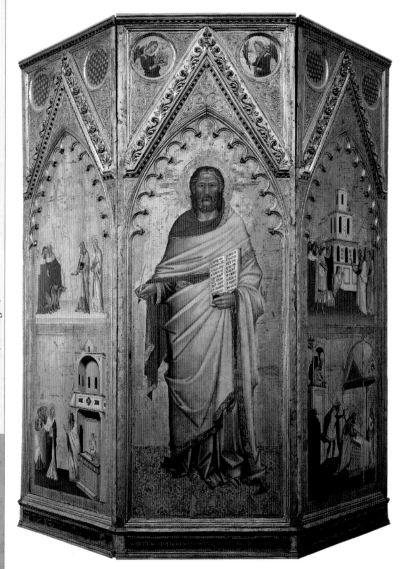

Andrea di Cione, known as Orcagna, and Jacopo di Cione
Triptych of Saint Matthew
c. 1367–68, panel.
Florence, Uffizi Gallery.

On September 15, 1367, the *Arte del Cambio* Bankers' Corporation consuls entrusted Orcagna with a prestigious appointment. Orcagna had already been the advisor for the *Opera del Duomo* for the Santa Maria del Fiore construction site in Florence, and had worked on Orvieto Cathedral. Now he was being asked to paint a panel depicting *Saint Matthew*, the patron of bankers. The work was intended to cover three sides of a pillar owned by the exchange house in Orsanmichele, the Pantheon of the Florentine corporations. Andrea accepted, but in August 1368 he had still not delivered the work because he was seriously ill. Prior to his death, he passed the work on to Jacopo (known as "Robiccia," the youngest of his brothers, who lived until at least 1383). The central figure of the *Saint Matthew*, drawn by Andrea in a refined multifoiled frame, is flanked by four little scenes; *Miracle of the Two Dragons*, *The Call of Matthew*, *Resurrection of the Son of King Egippus*, and *Martyrdom of the Saint* (entirely by Jacopo). The result is a polished opus enhanced by tondi with gold coins, the emblem of the Bankers' Corporation, and a sumptuous brocade at the saint's feet, identical to the other fabrics painted by Jacopo (Florence, Galleria dell'Accademia; London, National Gallery). The unusual trapezoidal shape was designed to fit the panel to a pillar.

Facing page:
Andrea Orcagna,
Rose window, detail
1359, marble.
Orvieto, Santa Marina Assunta in Cielo.

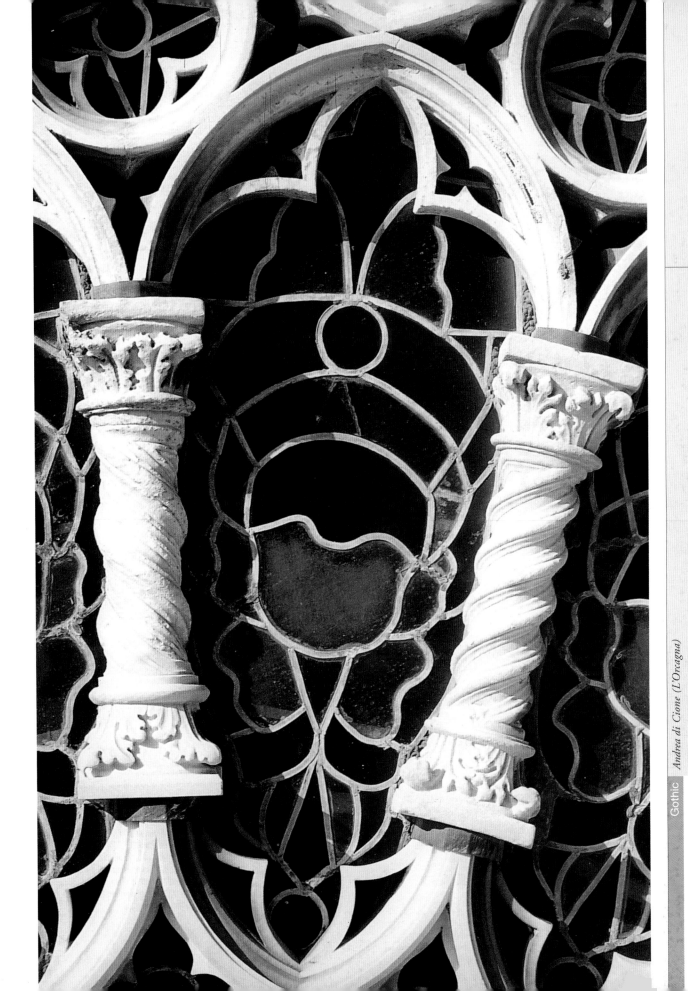

Buonamico Buffalmacco
(documented from 1315 to 1340)

"Buonamico Buffalmacco, a Florentine painter, who was a follower of Andrea Tafi, was a jocular man, celebrated by *Sor* Boccaccio, and was a dear friend of Bruno and Calandrino, painters who were also droll and pleasant; and as we can see in his works found throughout Tuscany, he was very good in the art of painting." Thus Vasari described Buffalmacco, already praised as a skilled artist by Boccaccio and Franco Sacchetti. Buffalmacco was the man behind some fantastic jokes, and in *The Decameron* and in *Trecento Novelle* he epitomizes one of the first literary examples of an astute and ingenious artist. He was apprenticed to Andrea Ricchi, known as Tafo (or Tafi as Vasari called him), and in 1320 Buffalmacco was the first to register with the corporation of Florentine painters. There are many testimonies of his character and his artistic talent but few attributable works over his painting career, reconstructed only recently with some very reliable theories.

Portrait of Buffalmacco, from Giorgio Vasari's *Lives*, Edizione Giuntina, Florence 1568.

Left:
Buffalmacco
Young Woman With Pet Dog,
detail from the *Triumph of Death* cycle
c. 1340, fresco.
Pisa, Cemetery.

The Pisa Cemetery fresco cycle, once generically attributed to a hypothetical "Master of the Triumph of Death," is unfortunately in a very bad state of repair. Nowadays the research undertaken by Luciano Bellosi shows this to have been the major opus of the Florentine painter Buffalmacco. Three vast scenes with the *Triumph of Death*, the *Judgment*, the *Inferno*, and the *Tales of the Desert Fathers* stretch across the eastern and southern walls of Pisa's monumental cemetery complex which, among other events, once suffered a dramatic fire. Buffalmacco, perhaps helped in this enterprise by assistants, uses an original, varied, and syncopated language, underscoring the physiognomies and showing that he was a perspicacious observer of flora and fauna. Compared with other Florentine masters of the Giotto school, Buffalmacco seems to be a "breakaway" artist, so to speak, with a style more in keeping with the expressionism of contemporary Emilian painting, and also with the acute liveliness of painters and miniaturists, who were far from minor, although they were as yet unfamiliar to the general public, including Lippo Benivieni or the so-called Master of the Saint George Codex.

Facing page:
Knights and Pages
detail from the *Triumph of Death* cycle
c. 1340, fresco.
Pisa, Cemetery.

Giottino
Portrait of a Young Patron in Prayer, detail from *Pietà*, 1360–65, panel.
Florence, Uffizi Gallery.

Giottino (Giotto di Maestro Stefano)
(active in Florence, post-1350)

The sobriquet of Giottino, the name used by fifteenth-century sources, conceals the real name of the Florentine painter Giotto di Maestro Stefano. The enigmatic figure's real identity and the identification of his works have been discussed at length by critics. In reality, only two dates refer to his existence with any certainty: 1368, the year when he enrolled with the corporation of Florentine painters, and 1369, when it is known that he was working in the Vatican with other Florentine masters. In the past, in distinguishing between Giotto's three great pupils (Maso, Stefano, and Giottino), these figures have often been confused. Nowadays, Giottino's persona has been reconstructed around a work considered almost certainly to be his, the San Remigio *Pietà*, characterized by that pictorial softness that Vasari called "painting with unity."

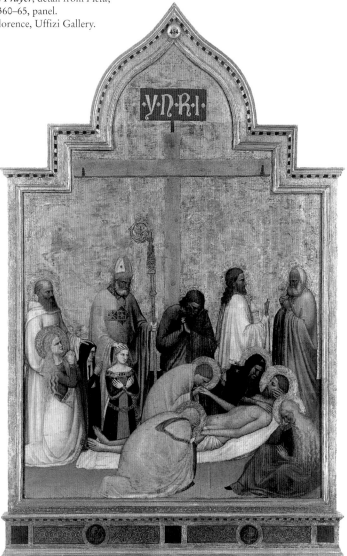

Giottino
Pietà
full view and detail
c. 1360–65, panel
Florence, Uffizi Gallery.

Giottino's *Pietà* was painted for the Florentine church of San Remigio, and although it is not very well known, it may be considered the greatest expression of late fourteenth-century Florentine painting. In contrast with the traditional gold background, there is a striking "modern" psychological lingering on the faces, a totally personal perception of the drama, and the sublime glow of the pictorial matter. Apart from the usual characters in the *Mourning of the Dead Christ*, Giottino has added two women in contemporary garb: a Benedictine nun and a young, lavishly dressed woman, who are kneeling to participate in the event, with its immense pathos, and seem to be protected by the hands of the patron saints, saints Benedict in monk's robes, and Remigius in his bishop's attire. The figure of Joseph of Arimathea stands out on the right, almost picked out in gold, showing the distressed Nicodemus the jar of unguent and the nails.

Tino di Camaino, *Faith*,
detail from the *Tomb of Marie de Valois*, 1332–37.
Naples, Santa Chiara.

Tino di Camaino
(Siena c. 1285–1337 Naples)

In Gaetano Milanesi's comment on Vasari's *Lives*, he describes Tino (and not Lino, as he was called by the art historian who mentioned him only once, and that as a follower of Giovanni Pisano) as "an artist unknown before our time." Now, however, he is considered one of the greatest sculptors of his time, even compared to modern artists for his exceptional notion of plasticity in his figures and for the simplification of the contours, his tendency almost to inflate or deflate volumes unnaturally, a style that can be defined as "anti-classical" only in appearance. Tino was introduced to sculpture by his father, and as a youth he worked in the Siena shop of Giovanni Pisano, then followed him to Pisa, where he is named in the inscription on the base of the cathedral's baptismal font (1312), later being appointed its master builder (1315). In 1317 he was back in Siena, then he went on to Florence (1321–23), later being called to Naples by King Robert of Anjou, where he worked and remained until his death.

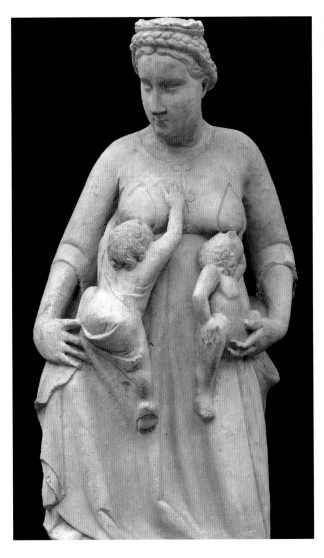

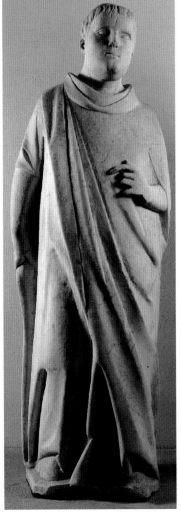

Left:
Tino di Camaino
Charity
1321, marble.
Florence, Museo Bardini.

A touching image of a woman, nursing two lively babies. A masterpiece of sculpture thanks to the plain, full volumetric forms.

Side:
Tino di Camaino
An advisor of Arrigo VII
detail from the *Funeral Monument of Arrigo VII*
1315, marble.
Pisa, Cemetery.

The fragment, along with the statue of *Arrigo VII* and an advisor, comes from the tomb of the Emperor who died at Buonconvento, in 1313. The figure has been identified as Francesco Tani degli Ubaldini, vicar of Pisa.

Spinello Aretino, *The devil tempting a monk*, detail of the episode of the *Exorcized monk*, from the *Stories of Saint Benedict* c. 1387, fresco.
Florence, basilica of San Miniato al Monte, sacristy.

Spinello Aretino
(Arezzo c. 1350–1410)

Spinello was born in Arezzo, the son of a rich goldsmith, and he trained in his hometown, later becoming a pupil of Orcagna. He was one of the most active figures in the last generation of Giotto's successors and is considered an outright "missionary" for Giottism throughout Tuscany, where he worked until the early fifteenth century. His most interesting works include the vast decorative cycle comprising the *Stories of Saint Benedict* (commissioned by the wealthy Benedetto of Alberti for the sacristy of San Miniato al Monte, in Florence), which appears full of narrative annotations and many naturalistic details. The same patron commissioned another splendid fresco cycle, the *Stories of Saint Catherine* for the Antella oratory, at Ponte a Ema (Florence), dedicated to the saint of that name. Spinello later worked in Pisa and, lastly, in Siena, the city where he left the *Stories of Pope Alexander III* (1408, Sala Nova or di Balia, Palazzo Pubblico).

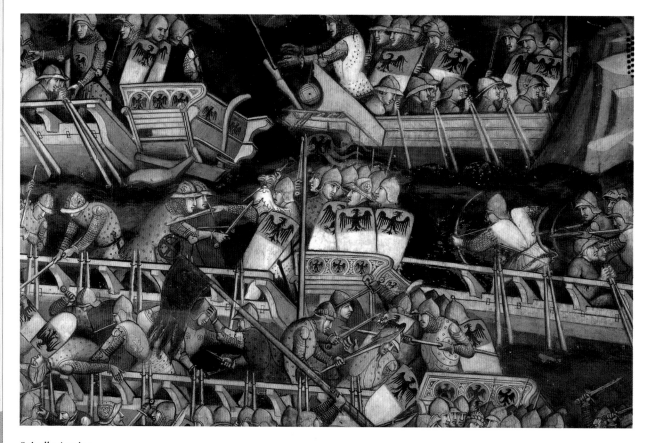

Spinello Aretino
The Venetian fleet defeating that of Emperor Frederick II at Punta Salvatore
detail from the cycle of the *Stories of Pope Alexander III*
1408, fresco.
Siena, Palazzo Pubblico, Sala Nova (later called Balia).

The last great work by the Arezzo master, the cycle he painted with his son Parri, narrates the life of Pope Alexander III, of the Siena Bandinelli family, the driving force behind the Lombard League.

The crowd sees the miracle of Saint James, detail of the *Miracle of the Possessed Oxen* c. 1379, fresco. Padua, Basilica del Santo, San Giacomo Chapel.

Altichiero
(documented from 1369–1388)

Altichiero, active in Verona and Padua alongside the painter of Bolognese origins, Jacopo Avanzo, seems to be the most interesting personality of late 1300s painting in northern Italy. He pursued the great pictorial tradition in those regions that had seen masters—following Giotto's fundamental lesson—of the caliber of Padua's Guariento (documented in Padua and Venice from 1338 to 1367) and the Florentine Giusto de' Menabuoi (already active in Milan in the middle of the century and dying in Padua in 1391). Altichiero was an elegant artist of Gothic painting, almost in the "courtly" sense, but was also sensitive to antiquity, as well as to Giotto's influence. He showed real talent in his powerful anecdotal realism in narrative, with sophisticated architectures. Some of his outstanding works included the frescoes in Verona's Sant'Anastasia Cavalli chapel (1380), those in Padua's Basilica del Santo (1379), and San Giorgio oratory (1384).

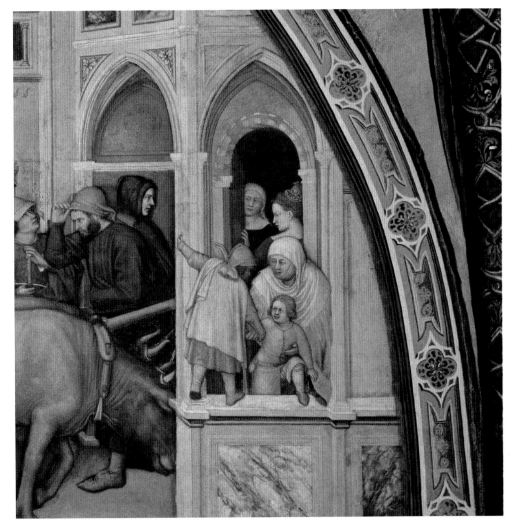

Altichiero
Women and children leaning from a window detail of the *Stories of Saint James* c. 1379, fresco. Padua, Basilica del Santo, San Giacomo Chapel.

The chapel in the basilica transept was requested by Bonifacio Lupi di Soragna (the Carraresi ambassador in Bologna and at the Hungarian court) from Andriolo de Santi, author of the refined architectonic design who commissioned Altichiero and Jacopo Avanzi for the frescoes. The entire surface is decorated with lunettes depicting the *Stories of Saint James the Great,* inspired by the story of the *Legenda Aurea* (another detail is shown on page 134), and with Altichiero's large *Crucifixion,* which accounts for at least three lunettes in the cycle. Like the one shown here, it is painted in soft colors and enlivened with superb architectonic views.

Lorenzo Maitani, *King David with a lyre*, detail of reliefs on the first pillar, c. 1310, stone. Orvieto, Cathedral of Santa Maria Assunta in Cielo.

Lorenzo Maitani
(Siena c. 1275–1330 Orvieto)

When Lorenzo Maitani, a sculptor and architect from Siena, arrived in Orvieto in 1308, the Duomo's construction (the foundation stone having been blessed by Pope Nicholas IV in 1290) was nearing the installation of the roof (cf. Illustrations on pages 122, 124, and 133). In 1310 Lorenzo was appointed *universalis caput magister* to the site, a role that he maintained until death, charged with the task of "repairing the building." Thus Maitani ordered the erection of the structure to support the transept, as well as spurs, counterforts, and rampant arches. He designed the facade, with its lavish reliefs and mosaics, and the grand, intricate rose window produced by Orcagna. Maitani's real masterpiece is the relief decoration of the four facade pillars, which describe in minute detail the Creation of the world and the human race, the messianic prophesies, the stories of the New Testament, the Judgment, and Heaven and Hell.

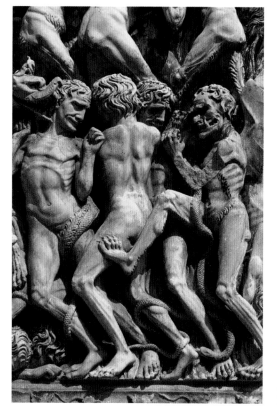

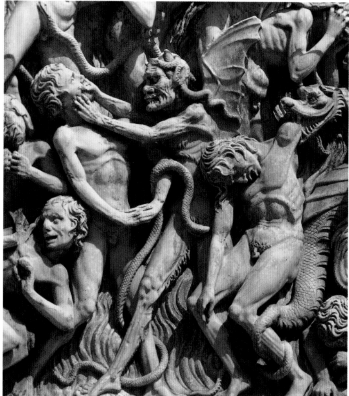

Lorenzo Maitani
***The Damned in Hell*, detail from a facade column c. 1310–30, stone. Orvieto Cathedral.**

Lorenzo Maitani's sculpture of *Hell* and the *Damned*, on a facade pillar of Orvieto Cathedral, is one of the most celebrated Gothic illustrations of its type. The author has used a style of shaping that emphasizes the linear flow of the contours, and is characterized by a pronounced tendency to the grotesque in the faces and poses of the devils and the damned, who are shown grimacing and in dramatic—almost theatrical—poses. Nor is it a coincidence that several of the more violent scenes that the Sienese sculptor created for Orvieto, like that of the *Resurrection of the Dead* (the *Novissimi*), appear to have been inspired by the farfetched descriptions of popular preachings.

Melchior Broederlam
(documented from 1381 to 1409)

The accounts of Philip the Bold, Duke of Burgundy, note that in 1387 Melchior Broederlam, born in Ypres and formerly serving Louis de Mâlle (Count of Flanders from 1346 to 1384), had been appointed *valet de chambre* to the Burgundian court; in 1391 he was nominated "court painter." As well as working in Paris and Lille, Broederlam then frescoed Hesdin Castle (Artois), and painted the portrait of the Duke of Burgundy and his wife for the chapel of the Counts of Courtrai. He also painted two outer panels and the wooden decoration of at least two altarpieces sculpted by Jacques de Baerze, intended for the Charter-house of Champmol, near Dijon (cf. page 132). Only two panels have survived, and this is the great artist's only extant work, discovered in the early nineteenth century by C. Févret de Saint-Mémin, who was the curator of Dijon Museum and researcher of the Charterhouse of Champmol archives.

Melchior Broederlam
Joseph drinks from a flask of water
detail from the *Flight to Egypt*, from a flap of the Champmol Charterhouse reredos, 1394–99. Dijon, Musée des Beaux-Arts.

Melchior Broederlam
Presentation in the Temple and Flight into Egypt, detail of the *Champmol reredos* c. 1394–99, panel.
Dijon, Musée des Beaux-Arts.

Broederlam is considered "the most talented and modern painter" of those working for the Duke of Burgundy, and with Jacquemart de Hesdin, "the greatest pictorial genius of the North in the late 1300s." (Castelnuovo 1966). The dual scene, with the *Presentation in the Temple and Flight into Egypt,* pairs with the other reredos leaf, sculpted by de Baerze (cf. illustration on page 132), of the *Annunciation* and *The Visitation*. It is striking for the details, including the basket and water flask, the glowing colors, and the scenic construction of the Gothic architecture, of Sienese inspiration but imaginatively developed.

Claus Sluter, *Weeper*, detail from
*Tomb of Philip the Bold, Duke of
Burgundy* (died in 1404), c. 1404–06,
sculpted, gilt, and painted marble.
Dijon, Musée des Beaux-Arts.

Claus Sluter
(c. 1340–1406 Dijon)

Towards the end of the 1300s, the most expert masters of the period (painters, sculptors, and minia-
turists of the caliber of Broederlam and the Limbourg brothers) headed for Dijon, then the capital of
the Duchy of Burgundy. The construction of the splendid new Charterhouse of Champmol abbey
brought together Jacques de Baerze, Jean de Marville, and Claus Sluter. The latter was a sculptor
who may have been born in Haarlem and had already worked in Brussels, where he was known to
have been in 1380. Nevertheless, any surviving works are connected to his time in Burgundy. We
know that in about 1383, Sluter worked on the Charterhouse of Champmol, which was intended to
house the monumental tombs of the Dukes of Burgundy, and he may have been invited by Jean de
Marville. Here he produced not only the *Tomb of Philip the Bold* (designed, however, by de Marville),
the *Portal of the Virgin*, with life-size figures, and the *Prophets' Well*, a symbolic monument, typical
of Nordic art, designed for the center of the cloister.

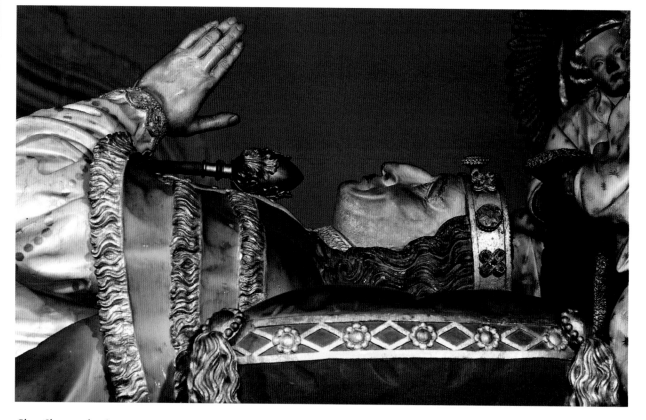

Claus Sluter and assistants
Tomb of Philip the Bold, detail
1404–06 (begun in 1381 by Jean de Marville, who died in 1389;
finished by Klaas van de Wervel, Sluter's nephew, in 1411),
sculpted, gilt, and painted marble.
Dijon, Musée des Beaux-Arts.

The tomb of the Duke of Burgundy, shown with breathtaking real-
ism, is really one of the period's most noteworthy works, and also
one of the first known to us in which the original *pleurants* (shown
on the facing page) theme is used. Although the figure of the deceased
Duke lying on the sumptuous decorated bier does not foresake the
Gothic tradition of royal tombs, the theme of grief is totally new,
interpreted by the figures under the sarcophagus.

Claus Sluter
Weepers, details from
the *Tomb of Philip
the Bold*
1404–06, sculpted,
gilt and painted marble.
Dijon, Musée des
Beaux-Arts.

The *pleurants* are set in
the Gothic arches,
some with their faces
concealed by a hood or
with their hands covered
by their tunics, frozen in
the fleeting moment of a
teardrop, a funeral prayer,
and recollection. The
modelwork influenced
the development of
European sculpture in
France, Spain, and Italy.

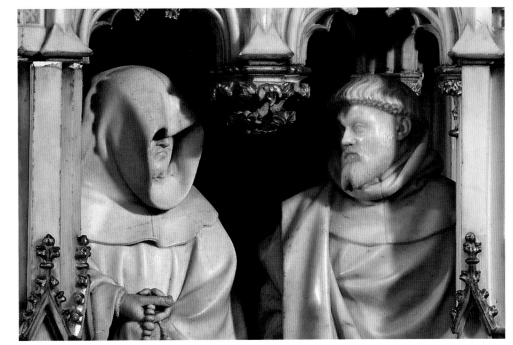

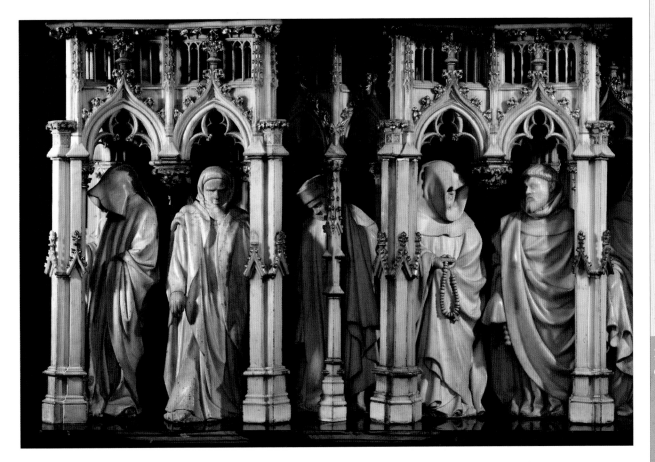

Jaime and Pedro (or Pere) Serra

(Cataluña, documented 1358–89) (Cataluña, documented 1357–c. 1406)

Jaime (the older of the two) and Pedro were the only two of the four Serra brothers, Catalan painters, to leave documented works. Nevertheless, it must be said that much of the painting produced in Cataluña after 1350 is generically attributed to their workshop. Jaime worked first in his brother Francisco's shop, producing his first known work, the *Santo Sepulcro Retablo* (Zaragoza, Museo Municipal) in 1361, the year of Francisco's death. The partnership with Pedro began in 1363, when they worked together on the *Todos los Santos* altarpiece (Manresa, now lost). Pedro, in the meantime, was apprenticed to Ramon Destorrents. From the time the two brothers began their association, they produced countless works, and it is difficult to distinguish their respective hands. Jaime also worked for Eleanor of Sicily, wife of Pedro IV.

Workshop of Jaime and Pedro Serra, *Figure of an Apostle*, detail from the *Last Supper*, scene from the *Retable with Stories of Mary and of The Passion*, c. 1375, panel, Barcelona, Museu d'Art de Catalunya.

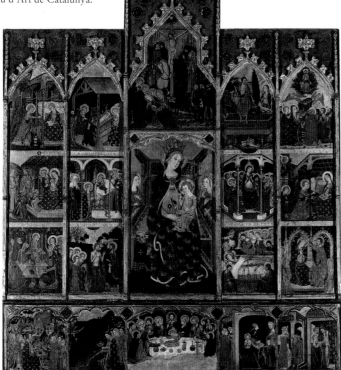

Workshop of Jaime and Pedro Serra
Retable with Stories of Mary and of The Passion
c. 1375, panel.
Barcelona, Museu d'Art de Catalunya.

The retable, commissioned by Brother Fontaner de Glera (shown at the Virgin's feet) for the monastery of Sijena (Huesca), shows how the Serra workshop had developed a style that was in part influenced by Sienese painting, which was also the model in those years for other Catalan masters. Later the style spread throughout Spain, from Barcelona to as far as Seville.

Pedro Serra, Guerau Gener and Lluís Borrassà
Resurrection of Christ
detail of the *Santes Creus retable*
1402–11, panel.
Barcelona, Museu d'Art de Catalunya.

The *Santes Creus retable* (Alt Camp) was realized in different periods by three famous Catalan artists; it was disassembled and much of it is now in the Museu de Tarragona (facing page).

Lluís Borrassà
(Gerona c. 1360–c. 1425 Barcelona)

Borrassà was one of the most important figures on Cataluña's International Gothic scene. He was the son of a humble family of artists who arrived in Barcelona in about 1383, organizing a prolific workshop where he began to produce various complex polyptychs, typical of the area. These early works took stylistic inspiration from Italian pictorial tradition, known in Spain through Italianate works by masters like Destorrents and the Serra brothers. Soon, however, Borrassà managed to evolve his own personal figurative language, with unique narrative qualities, taking Flemish and Burgundian influences, filtered with German and Tuscan elements which, among other things, contributed to making Valencia a capital city of International Gothic. Borrassà's brilliant colors and refined hand then inspired artists like Bernardo Martorell.

Saint Benedict, detail from
Santes Creus or Virgin Retable
c. 1402–11.
Tarragona, Museo diocesano.

Pedro Serra, Guerau Gener and Lluís Borrassà
(sculptures attributed to Pere Ça Anglada)
Santes Creus or Virgin retable
c. 1402–11, panel and carved wood, gilt and painted.
Tarragona, Museo diocesano.

The retable (the piece in Tarragona measures 18 x 11 feet) is one of the first examples of Spanish International Gothic and came from the high altar of the monastery of Santes Creus. The opus was originally far more complex but is now split between Tarragona and Barcelona (illustration at left). It was commissioned from Pedro Serra, who worked on it first, but it was then continued by the Catalan Guerau Gener (documented from 1391 to 1411), and finished by Borrassà. Originally the polyptych must have included four leafs of three sections each, framed by carvings and crowned with pinnacles, as well as having statues decorating the sides (still in existence), depicting *Saint Bernard*, *Saint Benedict*, and the *Enthroned Virgin and Child*. The predella was below. In the part still visible at Tarragona, we see, from the top: *Saint Luke*, *Annunciation*, *Adoration of the Magi*, *Saint Mark*, *Ascension*, *Dormition of the Virgin*, *Saint Matthew*, *Pentecost*, *Coronation of the Virgin*, as well as the wooden statues already mentioned, and a *Moses and the Patriarchs*, and various saints in the predella.

Page 176:
Lower Saxony production
Personification of the River of Paradise
detail of the support for the *Baptismal font*
c. 1225, bronze.
Hildesheim, Duomo.

The Gothic Period:

Styles, Arts, and Techniques

Life and Death in the City

The Gothic city was a microcosm of enormous vitality, and it was precisely between the "fall of Rome and the Industrial Revolution" (McLean 2000) that European urban planning reached its peak. Moreover, the increasingly common phenomenon of urbanization had reinforced municipal authority. This is the period of the finest symbolic and functional monuments of civic independence, created by famous architects; not only cathedrals, but also elegant public buildings, loggias, oratories, hospitals, and bridges. When the county territories were safer, the country areas became more dependent on the towns, and this could not fail to be reflected by trade and business between the towns and the countryside, and towns with other towns. During this period, every region in Europe developed its own civil architecture, and many of these features lasted at least until the end of the fifteenth century, in any case in northern Europe. Often arts and crafts workshops (in countless disciplines, from painting to illumination, tapestries to stained glass), especially in the North and once confined to monasteries, moved to work directly for bishops or for the court. In Italy, however, the phenomenon was less widespread, and as early as the

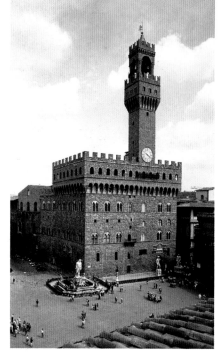

Arnolfo di Cambio
Palazzo dei Priori
begun in 1299.
Florence, Piazza della Signoria.

Arnolfo, who as an architect, city planner, and sculptor, was the mind behind one of the most famous monuments of Gothic civic architecture. In Florence, Arnolfo also contributed to the impressive fourteenth-century construction of the walls, cathedral, and various other churches. Recent research showed that his designs are all based on precise symmetries using the golden section.

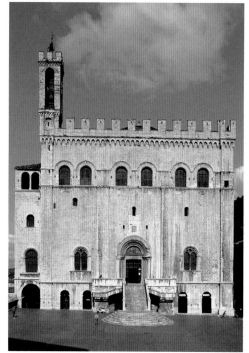

Angelo da Orvieto
Palazzo dei Consoli
1332–37.
Gubbio (Perugia), Piazza della Signoria.

One of Italy's loveliest public buildings stands in the rectangular plaza of this small medieval town. It is faced in ashlars and its roof is edged with small ogive arches and rectangular crenellations, similar to those on Palazzo dei Priori, in Florence. A fanned staircase leads to the portal, flanked by a pair of dual-light windows; the smooth wall simply has one order of windows.

Bonino da Campione
Funeral monument for Cansignorio della Scala
c. 1370–74.
Verona, Arche Scaligere.

This equestrian sculpture is at the apex of the Arca Scaligera, a complex Gothic structure with reliefs and sculptures, ordered built by Cansignorio.

1300s numerous noteworthy secular business flourished. Gothic culture had not just rediscovered the values of earthly life, but also those of death. As well as public buildings and chapels, architecture and monumental sculpture were dedicated extensively to sumptuous tombs, almost the prelude to Renaissance humanistic representations. This all occurred not only within urban boundaries, as in the case of the Arche degli Scaligeri in Verona (similar to miniature chapels surmounted with an equestrian monument of the deceased), but also in abbeys, like those of Champmol (Burgundy) and Alcobaça (Portugal), intended to house prestigious tombs.

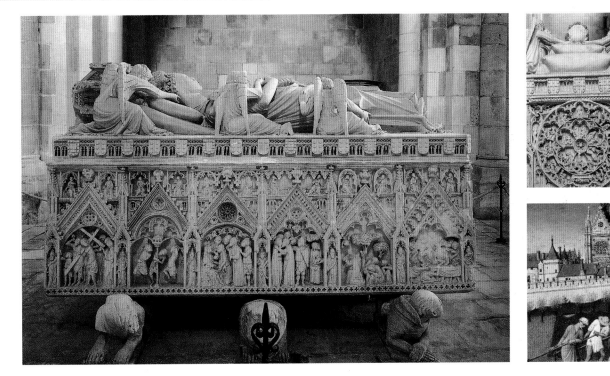

Above and center right: **Sarcophagus of Iñes de Castro, lover of King Peter I and lady-in-waiting to his wife Constance** full view and detail
1360–67, marble.
Alcobaça (Portugal), church abbey church of Santa Maria.

This sculpted sarcophagus has the traditional design of a funeral monument, an innovation brought to Portugal by Master Pietro d'Aragona. Here we see a large chest supported by lions, decorated like a Gothic reliquary, and the body of the deceased lying on the top.

Above, in box:
Villard de Honnecourt
Ornamental floral and human illustration in a study for the floor of a Hungarian church; section of the base of a column in Rheims Cathedral; a rose window from Chartres Cathedral, from the "Livre de Portraiture"
c. 1220–35.
Paris, Bibliothèque Nationale, ms. fr. 19093, cc. 5v and 15v.

The sketches that filled Villard de Honnecourt's famous notebook prove how much research this great Gothic architect undertook.

Bottom right:
Anonymous French painter
View of the Palais de la Cité, Paris, and of the Sainte-Chapelle and haymakers along the Seine
detail from the month of June, from *Les Très Riches Heures du duc de Berry*
c. 1440.
Chantilly, Musée Condé.

The Gothic Period Life and Death in the City

Schools of Painting and Miniatures

There is no doubt that cultural exchange was fostered among Late Gothic Europe's most important locations, not only by intensified trade relations, but also by powerful diplomatic contacts and court marriages. During the 1300s and for many decades in the subsequent century, several French, Bohemian, German, and Italian regions experienced the development of a revived, complex artistic panorama, especially as far as painting, miniatures, and tapestries were concerned. Schools of art, sometimes family-run, also flourished in Spain and Portugal, partly influenced by the

arrival of frequent exchanges with Italian, especially Tuscan, artists, but increasingly distinguishable, expressing an independent and realistically effective style. From 1309 to 1378, France had been home to the papal court, and in a short time the lovely Provencal city of Avignon had become a point of cultural and artistic reference for every court in Europe. The time spent at the papal court by Siena-born Simone Martini, and after him by Viterbo-born Matteo Giovannetti, the latter the author of the refined and imaginative fresco decoration of the *Palais des Papes* (Popes' Palace) in Avignon (1343), marked a stylistic turning point

Above left:
Jean Malouel
Reverse side of *The Most Holy Trinity and Lament (Grand Pitié ronde)*; on the front, the *Armorial Bearings of the Dukes of Burgundy*
c. 1400–10, panel.
Paris, The Louvre.

Above right:
French school
Symbols of the Passion (Petite Pitié ronde)
verso (on reverse side of the *Pietà*)
Second decade of the fifteenth century, panel.
Paris, The Louvre.

Facing page, top left:
English or French Master (?)
Wilton House Diptych (Richard II of England is presented to his patron saints, with Virgin and Child and angels)
1395 or 1413, panel.
London, National Gallery

Facing page, top right:
French school
The Emperor Charles IV and King Charles V of France Watching a Play about a Crusade,
miniature from *Great Chronicles of the Kings of France*, 1380.
Paris, Bibliothèque Nationale, ms. fr. 2813, c. 474v.

Facing page, bottom left:
Workshop of Jaime and Pedro Serra
Last Supper, detail from a *Retable with Stories of Mary* and of *The Passion*
c. 1375, panel.
Barcelona, Museu d'Art de Catalunya.

Facing page, bottom right:
Giovannino de'Grassi
Study for a swan and capital initials
late fourteenth century, pen and watercolor on paper.
Bergamo, Biblioteca Municipale, ms. DVII 14.

The works shown here are proof of the variety of figurative expressions that evolved throughout Europe from the mid-fourteenth century, above all, but not only, in the court context: refined diptychs, tondi, increasingly complex polyptychs, illuminated books, studies of nature, and tapestries.

of great significance for the "courtly" style of painting throughout Europe. Also in France, the swift cultural and political climb of the Duchy of Burgundy, thanks to complex diplomatic dealings, brought development of a flourishing culture in Flanders and northeast France, immortalized in a famous essay by Johan Huizinga. Dukes like Philip the Bold and Charles the Bold, as well as by the highest ranks of the court, were refined collectors and patrons of tapestries and pictorial works, outstanding for their perfect technique, enameled colors, and controlled, almost regal gestural expressiveness. Meanwhile, in Bohemia, the Prague court of Charles IV, King from 1346 and Emperor of the Holy Roman Empire from 1355, a figure of high caliber, was the backdrop for great artistic genius at work: from architects Matieu d'Arras and Peter Parler to painters like Master Visji Brod, Master Trebona, and Master Theodoric. The latter, who was also influenced by the presence of the Italian Tomaso da Modena at court, in about 1350 was the author (for Karlstein Castle, near Prague) of a series of panels with half-bust figures of saints that each occupy the panel space in quite an original way. This brings us to the world of International Gothic.

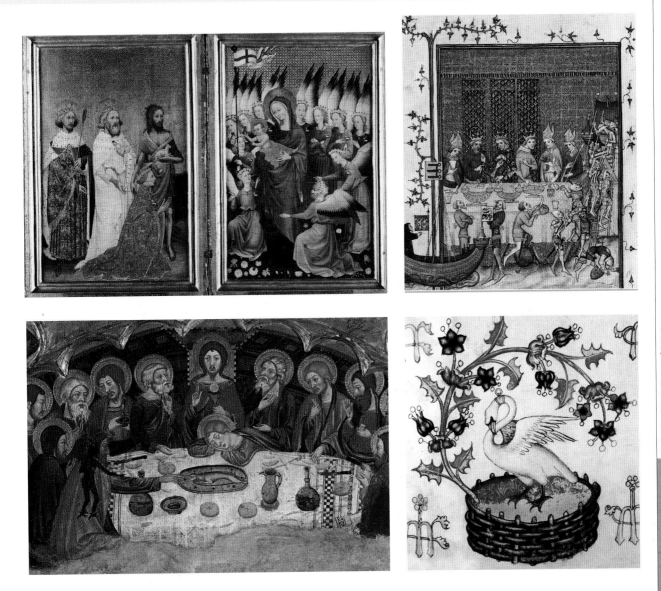

International Gothic

The term *International Gothic* was coined by Louis Courajod at the end of the nineteenth century. Nowadays there are other, similar expressions (see page 133), referring to an artistic language of European scope that evolved between the fourteenth and fifteenth centuries. The key element of this new style was a renewed interest in Nature, a sort of naturalism that was the forerunner of Renaissance explorations. Initial theories say that the style developed at the court of Charles V of Valois, in France, a fertile terrain for exchanges among Flemish and French masters, and later at the Burgundy court. Italian artists like Gentile da Fabriano, Pisanello and, later, various others also felt the influence of this new style.

The complexity of this particular moment of European civilization, including from a historical perspective, now makes it difficult to offer absolute definitions: the earliest scholars of this phenomenon asserted that when examining a painting of this era, it would be easier to establish the period than the place in which it was painted. The undisputed cosmopolitanism of this language means that the attribution of various paintings, like the *Wilton House Diptych*, now in London, to mention just one, still wavers between France and England. The common features of International Gothic, which flourished in the courts of Europe and elsewhere, are its fantastic fairytale atmospheres, accompanied by precious details and a preference for the darting line, even in tapestries.

Arras workshop
Annunciation
early fifteenth-century tapestry.
New York, Metropolitan Museum of Art,
The Cloisters Museum of Medieval Art.

The Flemish workshop of Arras, in its heyday in the fourteenth and fifteenth centuries, was made aware of the new figurative style, as we can see in this *Annunciation*, inspired by Broederlam's opus.

Arras workshop
Fromont Embraces the Chatelain Girart
detail from *Roman de Jourdain de Blaye*
c. 1380–90, tapestry.
Padua, Museo Civico.

The scene illustrated here is taken from a famous thirteenth-century courtly novel. It is the only surviving tapestry of a series that belonged to Philip the Bold, Duke of Burgundy. The composition of this recently restored opus (12.5 x 11 feet) confirms the exposure of Flemish weavers to Burgundian painting and Lombard illuminists, as we can see in the details of the grass and clothing.

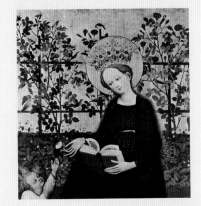
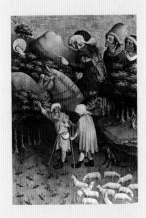

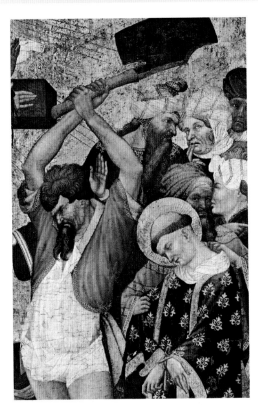

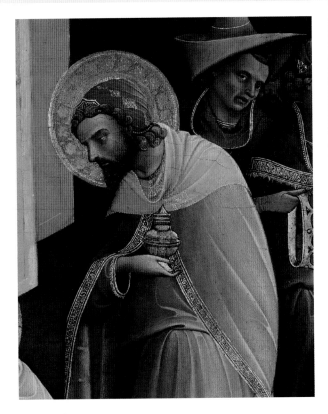

Bottom left:
Henri Bellechose
Martyrdom of Saint Dionysius, detail
1416, panel.
Paris, Museo del Louvre, originally from the Champmol
Charterhouse, Dijon.

Bottom right:
Lorenzo Monaco
Adoration of thei Magi, detail of a Magi with ancient
Arabic wording on the hem of his mantle
c. 1420, panel.
Florence, Uffizi Gallery.

Above, in box:
Master of the Trebona Altar
Saint Marguerite
detail from the now fragmentary altarpiece.
c. 1380, panel.
Prague, Národní Galerie.

Upper Rhine school
Madonna in the Garden of Paradise, detail
c. 1420, panel.
Solothurn, Kunstmuseum.

Meister Francke
*Sheep transforming into locusts when the shepherd reveals the daugh-
ter's hiding place to the King,* from the *Polyptych of Saint Barbara*
1415. Helsinki, Kansallis Museum.

Bibliography

General works and regional studies (in alphabetical order):

Jean ADHEMAR, *Influences antiques dans l'art du moyen âge français, recherches sur les sources et les themes d'inspiration*, London 1937.

Jonathan ALEXANDER, Paul BINKSI, *Age of Chivalry. Art in Plantagenet England 1200–1400*, exhibition catalog (London, Royal Academy of Arts, November 1987–March 1988), Weidenfeld & Nicolson, London 1987.

Marcel AUBERT, *Trionfo del Gotico* (Holle Verlag, Baden-Baden 1963), Il Saggiatore, Milano 1964.

J. BACKHOUSE, D.H. TURNER, L. WEBSTER, eds., *The Golden Age of Anglo-Saxon Art*, 966–1066, The Trustees of the British Museum, London 1984.

Jurgis BALTRUSAITIS, *Il Medioevo fantastico. Antichità ed esotismi nell'arte gotica* (1972), Adelphi, Milano 1973.

Xavier BARRAL I ALTET, François AVRIL, Danielle GABORIT-CHOPIN, *Il mondo romanico. Il tempo delle crociate* (Gallimard, Paris 1982), Rizzoli, Milano 1983.

Xavier BARRAL I ALTET, François AVRIL, Danielle GABORIT-CHOPIN, *Il mondo romanico. I regni d'Occidente* (Gallimard, Paris 1983), Rizzoli, Milano 1984.

Émile BERTAUX, *L'Art dans l'Italie méridionale*, Fontemoing, Paris 1905.

Vittore BRANCA, ed., *Concetto, storia, miti e immagini del Medio Evo* (Venezia, Fondazione Giorgio Cini, San Giorgio Maggiore), Sansoni, Firenze 1973.

Marco BUSSAGLI, *Capire l'Architettura*, Giunti, Firenze 2003.

Maria Stella CALÒ MARIANI and Raffaella CASSANO *Federico II. Immagine e potere*, exhibition catalog (Bari, Castello Svevo, February–April 1995), Marsilio, Venezia 1995.

Liana CASTELFRANCHI VEGAS, *International Gothic Art in Italy*, Leipzig 1966.

Enrico CASTELNUOVO, *Il gotico internazionale nei paesi tedeschi*, Fabbri, Milano 1966.

———, *Il gotico internazionale in Francia e nei Paesi Bassi*, Fabbri, Milano 1966.

Enrico CASTELNUOVO and Giuseppe SERGI, eds., *Arti e storia nel Medioevo*, II, *Del costruire: tecniche, artisti, artigiani, committenti*, Einaudi, Torino 2003.

Albert CHATELET, Roland RECHT, *L'Autunno del Gotico* (Gallimard, Paris 1988), Rizzoli, Milano 1989.

Marshall CLAGETT, Gaines POST, Robert REYNOLDS, *Twelfth-Century Europe and the Foundations of Modern Society*, The University of Wisconsin, Madison 1961.

Marco COLLARETA, "Oreficeria e tecniche orafe," in *Arti e storia nel Medioevo*, II, 2003: 549–59.

Kenneth John CONANT, *Carolingian and Romanesque Architecture 800 to 1200* (1959; 1966; 1974), Penguin Books, Harmondsworth-Baltimore-Victoria 1974.

Louis COURAJOD, *Les Origines de la Renaissance en France au XIVe et au XVe siècles*, Paris 1888.

Pina Belli D'ELIA, ed., *Alle sorgenti del Romanico. Puglia XI secolo*, exhibition catalog (Bari, Pinacoteca provinciale, June–December 1975), Dedalo, Bari 1975.

Georges DUDY, *Le Temps des cathédrales. L'Art et la societé 980–1420* (Genève 1966–67), Gallimard, Paris 1976.

———, *L'anno Mille. Storia religiosa e psicologia collettiva* (Julliard, Paris 1967), Einaudi, Torino 1981.

Jean EBERSOLT, *Orient et Occident*, Paris 1954.

Camille ENLART, *Manuel d'archéologie française*, 5 vol., A. Picard, Paris 1919–1932.

Henri FOCILLON, *The Art of the West in the Middle Ages, I. Romanesque Art; II. Gothic Art* (Colin, Paris 1963), Phaidon, London 1969.

Gloria Fossi, "Nani sulle spalle di giganti?
A proposito dell'atteggiamento degli artisti
medievali nei confronti dell'antichità," in
Scritti in onore di Federico Zeri, Electa,
Milano 1980: 20–32.

——, "La représentation de l'antiquité
dans la sculpture romane et une figuration
classique: le tireur d'épine," in *La représen-
tation de l'antiquité au Moyen Age*,
Université de Picardie, Centre d'Etudes
Médievales (March 26–28, 1981), Halosar,
Wien 1982: 299–324.

——, "Un insediamento benedettino
sul lago di Lesina e qualche problema di
arte medievale in Italia meridionale," in
*L'esperienza monastica benedettina e la
Puglia* (Università di Bari e di Lecce,
October1980), Congedo, Galatina 1984.

——, "Il Mediterraneo diviso. La rinascita
della società italiana e le nuove sintesi
artistiche," in *Storia dell'arte italiana*, I,
Electa–Bruno Mondadori, Milano 1986:
285–385.

——, Il dotto e il pellegrino di fronte
all'Antico," in *La storia dei giubilei, I*, J.
Le Goff, F. Cardini, G. Fossi, eds.,
BNL–Giunti, Firenze 1996: 104–17
(English ed. *Rome: The Pilgrim's Dream*,
Florence 1997).

——, "Fra il cielo e la terra. Armonie
celesti e mirabili difformità del corpo
medievale," in *Il Nudo. Eros Natura
Artificio*, Giunti, Firenze 1997: 40–75.

——, "Il Medioevo," in *L'Arte italiana*
(2000), Giunti, Firenze 2004: 17–64.

Cesare Gnudi, *L'arte gotica in Francia e
in Italia*, Einaudi, Torino 1982.

André Grabar, *Sculptures Byzantines
du Moyen Age*, 2 vol., Paris 1976.

Louis Grodecki, *Architettura gotica* (1976),
Electa, Milano 1978.

——, *Le vitrail roman*, Office du Livre,
Editions Vilo, Fribourg–Paris 1977.

Louis Grodecki, Florentine Mutherich,
Jean Taralon, Francis Wormald, *Il secolo
dell'anno Mille* (Gallimard, Paris 1973),
Feltrinelli, Milano 1974.

Konrad Hoffmann, *The Year 1200*,
The Cloisters Studies in Medieval Art, I,
The Metropolitan Museum of Art, New
York 1970.

Johan Huizinga, *L'Autunno del Medioevo*
(*The Waning of the Middle Ages*), Haarlem
1919.

Denise Jalabert, *La flore sculptée des
monuments du moyen-âge en France*,
Picard, Paris 1965.

Kein Krieg ist heilig. Die Kreuz-Zuge,
Herausgegeben von Hans-Jurgen Kotzur,
Verlag Philipp von Zabern, Mainz 2004.

Joseph Krasa, *Il Gotico internazionale in
Boemia*, Fabbri, Milano 1966.

Hans Erich Kubach, *Architettura romanica*,
Electa, Milano 1976.

Ulriche Laule, Uwe Geese, *Romanico*
(Feierabend Verlag, OHG, Berlin 2003),
Gribaudo, Milano 2003.

Jacques Le Goff, *La civiltà dell'Occidente
medievale*, Arthaud, Paris 1969.

——, *L'immaginario medievale*
(Gallimard, Paris 1985), Mondadori,
Milano 1993.

——, ed., *L'uomo medievale* (1987),
Laterza, Roma–Bari 1997.

Clive S. Lewis, *The Discarded Image: An
Introduction to Medieval and Renaissance
Literature*, Cambridge University Press,
1964.

Émile Male, *L'Art religieux du XIIe
siècle en France: Études sur les origines de
l'iconographie du moyen-âge*, Paris 1922.

Alick McLean, "Evoluzione della città nel
Medioevo," in *L'arte gotica*, 2000: 262–65.

Millard Meiss, *French Painting in the time
of Jean de Berry*, 4 vol., London
1967–1975.

Mireille Mentre, *Illuminated Manuscripts
of Medieval Spain* (Madrid 1994), Thames
& Hudson, London 1996.

Francesco Negri Arnoldi, *Gli sviluppi delle
sculture gotica in Europa*, Fabbri, Milano
1966.

Ornamenta ecclesiae, Kunst und Künstler der Romanik in Köln, 3 vol., Anton Legner, Köln 1985.

Raymond OURSEL, *Les pèlerins du Moyen Age*, Fayard, Paris 1963; 1978.

———, *La via lattea*, ed. it. Jaca Book, Milano 1985.

Valentino PACE, "Bronzo e arti della fusione," in *Arti e storia nel Medioevo*, II, 2003: 470–79.

Erwin PANOFSKY, *Gothic Architecture and Scholasticism*, Latrobe (Pa.) 1951.

———, *Early Netherlandish Painting*, Cambridge University Press, Cambridge (Mass.) 1953.

———, *Rinascimento e Rinascenze nell'arte occidentale* (Stockholm 1960), Feltrinelli, Milano 1971.

Joachim POESCKER, *Die Skulptur des Mittelalters in Italien. Romanik*, Hirmer, München 1998.

Arthur Kingsley PORTER, *Romanesque Sculpture of the Pilgrimage Roads*, Boston 1923.

La Puglia fra Bisanzio e l'Occidente, Electa, Milano 1981.

Josep PUIG I CADAFALCH, *La Géographie et les origins du premier art roman* (Barcelona 1932), Paris 1932.

Rhin–Meuse. Art et Civilisation 800–1400, exhibition catalog (Köln–Bruxelles), R. Muller, Köln 1972.

Marco ROSCI, *La scultura romanica in Spagna*, Fabbri, Milano 1967.

———, *La scultura gotica in Italia settentrionale*, Fabbri, Milano 1967.

Roberto SALVINI, *La scultura nel Medioevo*, Fabbri, Milano 1966.

———, "De l'art de cour à l'art courtois. Notes sur l'orfévrerie mosane," in *Clio et son régard, Mélanges Jacques Stiennon*, Lièges 1983: 551–64.

Matteo SANFILIPPO, *Il Medioevo secondo Walt Disney*, Castelvecchi, Roma 1993.

Mario SCALINI, *L'arte italiana del bronzo*, Bramante, Busto Arsizio 1988.

Meyer SCHAPIRO, *Arte romanica* (George Braziller, New York 1977), Einaudi, Torino 1982.

Costanza SEGRE MONTEL, *La pittura romanica nell'Italia settentrionale*, Fabbri, Milano 1966.

———, "Pittura," in *Arti e storia nel Medioevo*, II, 2003: 560–81.

Michel SOT, "Pellegrinaggio," in *Dizionario dell'Occidente medievale*, Jacques Le Goff and Jean-Claude Schmitt, eds., II, 2004: 885–98.

Rolf TOMAN, ed., *L'arte gotica. Architettura. Scultura. Pittura* (Köln 1998), Könemann, Köln 2000.

———, ed., *Il Romanico. Architettura. Scultura. Pittura*, Könemann, Köln 2004.

Michele TOMMASI, "Avori," in *Arti e storia nel Medioevo*, II, 2003: 453–567.

Pierre TOUBERT and Agostino Paravicini BAGLIANI, eds., *Federico II e la Sicilia*, Sellerio, Palermo 1998.

John WILLIAMS, *Early Spanish Manuscript Illumination*, Chatto & Windus, London 1977.

Paul WILLIAMSON, *The Medieval Treasury. The Art of the Middle Ages in the Victoria & Albert Museum*, The Trustees of the Victoria & Albert Museum, London 1986.

Georges ZARNECKI, Janet HOLT, Tristam HOLLAND, *English Romanesque Art*, 1066–1200, exhibition catalog (London, Hayward Gallery, April–July 1984), Arts Council of Great Britain, London 1984.

Artists and Works (in alphabetical order):

Gabriella ALBERTINI, "La scuola di Rogerio, Roberto e Nicodemo nel XII sec.," in *Abruzzo*, VI (1968), 2–3, May–December: 405–19.

Serafín Moralejo ALVAREZ, "L'omelia di pietra," in *FMR*, XII (1993), 97: 82–102.

Michael BAXANDALL, *Giotto and the Orators*, Clarendon Press, Oxford–Warburg Studies 1971.

Luciano BELLOSI and Giovanna RAGIONIERI, "Duccio di Buoninsegna," *Art e Dossier*, 193, October 2003.

Marco BURRINI, "Tre capitelli del Maestro di Cabestany nel chiostro del duomo di Prato," in *Prato Storia & Arte*, XXXVI (1995): 49–64.

Enrico CASTELNUOVO, ed., *La pittura in Italia. Il Duecento e il Trecento*, 2 vol., Electa, Milano 1986, under the entry for each artist.

———, *Artifex bonus. Il mondo dell'artista medievale*, Laterza, Roma–Bari 2004.

Francesca DELL'ACQUA, "Gerlachus: l'arte della vetrata," in *Artifex bonus*, 2004: 63.

Marcel DURLIAT, "L'oeuvre du Maître de Cabestany," in *La sculpture romane en Roussillon*, 4, La Tramontane, Perpignan 1954: 6–49.

———, "Le Maître de Cabestany," in *Cahier de Saint-Michel-de-Cuxa*, May 1973, 4: 116–27.

A. ERLENDE-BRANDEBURG, et al. Villard de Honnecourt. *Disegni* (Paris 1986), Jaca Book, Milano 1988.

Gloria FOSSI, "Ruggiti di marmo. Splendore dei Quattro leoni di Santa Maria del Castello," in *AD Sardegna* 1985: 32–37, and *Bell'Italia*, 4, June 1990: 76–79.

Chiara FRUGONI, *Wiligelmo. Le sculture del Duomo di Modena*, Panini, Modena 1996.

Denis GRIVOT, *Le monde d'Autun*, "Les points cardinaux" 1, Zodiaque, St Léger Vauban 1960.

Louis GRODECKI, "Maître Gerlachus et les atelier du Rhin moyen," in *Le vitrail roman*, 1977: 151–60.

Dietrich KOTZSCHE, "Nicolas de Verdun et l'orfèvrerie colonaise," in *Rhin–Meuse*, 1972: 314–23.

Claudio LEONARDI and Maurizio ARMANDI, eds., *Il Duomo di Modena. Atlante fotografico*, Panini, Modena 1985.

Roberto LONGHI, *Giudizio sul Duecento e altre ricerche sul Trecento nell'Italia centrale* (1939–1970), Sansoni, Firenze 1974.

Joaquín Yarza LUACES, "I grandi programmi iconografici," in *Arte e storia nel Medioevo*, III, *Del vedere: pubblici, forme e funzioni*, E. Castelnuovo and G. Sergi, eds., Einaudi, Torino 2004: 107 and notes.

Thomas LYMAN, "La table d'autel de Bernard Gilduin et son ambiance originelle," in *Cahiers de Saint-Michel de Cuxa*, 1982, 13.

William MELCZER, *La porta di bronzo nel duomo di Pisa*, Pacini, Pisa 1988.

Gian Lorenzo MELLINI, *Maestro Mateo a Santiago de Compostela*, Sadea Sansoni, Firenze 1965.

Antonio MILONE, "Bonanno Pisano," in *Artifex bonus*, 2004: 82–9.

———, "Mateo, una firma e una leggenda per i pellegrini di Santiago," in *Artifex bonus. Il mondo dell'artista medievale*, Enrico Castelnuovo, ed., Laterza, Roma–Bari 2004: 73–81.

Jaime Barrachina NAVARRO, "Las portadas de la iglesia de Sant Pere de Rodes," in *Locus Amenus*, 4, 1998–1999: 7–35.

Jean NUGARET, "L'oeuvre languedocien du Maître du tympan de Cabestany," in *Languedoc roman*, Zodiaque, St Léger Vauban 1975: 355–61.

Roberto SALVINI, *Wiligelmo e le origini della sculture romanica*, Martello, Firenze 1956.

Lanfranco e Wiligelmo. Il Duomo di Modena. Quando le cattedrali erano bianche, Panini, Modena 1984.

Angelo TARTUFERI, *Giotto. Bilancio critico di sessant'anni di studi e ricerche*, exhibition catalog (Firenze, Galleria dell'Accademia) Giunti, Firenze 2000.

Wiligelmo e Lanfranco nell'Europa romanica, Atti del Convegno (Modena, October 24–27, 1985), Panini, Modena 1989.

George ZARNECKI, "A sculptured head attributed to the Maître de Cabestany in the Fitzwilliam Museum, Cambridge," in *Studies in Romanesque Sculpture*, The Dorian Press, London 1979.

Index of Names

Adele, Countess of Blois, 14, 66
Aesop, 74
Aimone, Canon, 29
Albericus of Saint Denis, 66
Alberti, Benedetto of, 168
Alexander III, Pope, (born
 Roberto Bandinelli), 168
Alfano da Salerno, Bishop, 20,
 82
Altichiero, 132, *134*, **169**
Alto Adige, Master, *73*
Andrea del Castagno, 153
Andrea di Cione, *see* Orcagna
Andrea Pisano, 38, 39, 107, *108*,
 109
Angelo da Orvieto (Master
 Angiolo di Bartolo da), *178*
Anglada, *see* Pere Ça Anglada
Anjou, dynasty, 139
 Charles of Anjou, 138
 Robert of Anjou, 140, 151, 167
Anonymous French painter, *179*
Anselm, Abbot, 72, 73
Antelami, Benedetto, **44–45**, 83
Aragonese stonework, *16*
Arnolfo di Cambio, 120, 129,
 136, **138–139**, 140, *178*
Arras workshop, *182*
Arrigo VII of Luxembourg,
 emperor, *167*
Aurelius Augustinus
Auvergne art, *64*
Avanzi (or Avanzo), Jacopo, 169
Baerze, Jacques de, *see* Jacques
 de Baerze
Baldric, Abbot of Saint Pierre,
 66, 67
Bardi, Florentine bankers, 151
Barisano da Trani, 39, 63
Barral i Altet, Xavier, 81
Beatus of Liébana (or Beatus),
 74, 76, 77
Beckett, Thomas, 52
Beckford, William, 116
Becksmann, Robert, 34
Bédier, Joseph, 50
Bellechose, Henri, 133, *183*
Bellosi, Luciano, 164
Benedict of Norcia, Saint, *75,
 168*
Benedict XII, Pope, 154
Benivieni, Lippo, 164
Bermejo, Bartolomé de
 Cárdenas, 133
Bernard of Clairvaux, 17, 18, 67,
 88, 93, 101, 102
Bernardo Gilduino, **26–27**, 82
Bernward, Abbot, 12
Bertaux, Émile, 126
Blessed Humility (Rosanese dei
 Negusanti), *159*
Boccaccio, Giovanni, 131, 139, 164
Boezio, Severino, 74

Bogoljubskij, Andrea, 57
Bonanno Pisano, **39**, 63
Bonaventura of Bagnoregio,
 Saint, 151
Boniface of Conques, Abbot, 59
Boniface VIII, Pope, 138
Bonino da Campione, *178*
Bonsignore, Bishop, 28
Borrassà, Lluís, 133, *174*, **175**
Bozzalino, "Massaro," 29
Broederlam, Melchior, *132*, 133,
 171, 172, 182
Buffamacco, Buonamico, **164–165**
Buscheto, 20, **24–25**, 38
Bussagli, Marco, 90–91
Byzantine art, *63*, 67
Cabestany, Master, **36–37**, 82
Cansignorio della Scala, *see*
 Della Scala
Carraresi, Padua family, 169
Castelnuovo, Enrico , 171
Castilian artist, *15, 56*
Castilian Master, *79*
Catalan art, *65*, 68
Catalan stonework, 20, *21*
Catalan Master, 20, 22
Caumont, Arcisse de, 118
Cavallini, Pietro, 130, **140–141**
Cennini, Cennino, 150
Cézanne, Paul, 33
Charles IV of Luxembourg,
 King of Bohemia, later
 emperor, 180, 181
Charles of Anjou, *see* Anjou
 dynasty
Charles the Bold, last Duke of
 Burgundy, son of Philip the
 Good and Isabella of Portugal,
 181
Charles V Valois, King of
 France, 180, *181*
Charonton, Enguerrand, 133
Cimabue, 42, 130, **142–145**, 146,
 151
Coira Master, *68*
Collareta, Marco, 59
Conant, Kenneth John, 90
Conrad IV of Swabia, 127
Constance of Aragon, daughter
 of Peter III of Aragon, wife of
 Frederic II of Swabia, 127
Constance of Sicily, daughter of
 Roger II of Sicily, wife of
 Henry VI, mother of Frederic
 II of Swabia, 126
Constantine, Emperor, *54*
Coppo di Marcovaldo, 142
Costance of Castile, wife of
 Peter I ("the Just") of Portugal,
 179
Courajod, Louis, 182
Courtrai, Counts of , 171
Damian, Peter, Saint, 20
Dante Alighieri, 131, 138, 139,
 142, 151

Dati, Gregorio, 139
De Castro, Iñes , *179*
De Grassi, Giovannino, 180, *181*
De Mâlle, Louis, Count of
 Flanders, 171
De Santi, Andriolo, 169
Della Scala, Cansignorio, *178*
Desiderius, Abbot of
 Montecassino (later Pope
 Victor III), 18, 58, 62, 75, 82
Despuig, Ramon, *114*
Destorrents, Ramon, 174
Disney, Walt, 109
Dollmann, Georg, *119*
Dondi, Giovanni, 24
Duccio di Buoninsegna, 130,
 144, **146–149**, 152
Ekkehard di Meissen, margrave,
 109, 110
Eleanor di Sicily, wife of Peter
 IV of Aragon, 174
Elia of Canosa, Bishop, 83
Emmerich, King of Hungary,
 127
Engelram, German master, 61
English master (or Master of the
 Wilton House Diptych), 180,
 181, 182
Enlart, Camille, 118
Enzo, son of Frederic II of
 Swabia, 127
Ferdinand I of Leon, 61
Ferdinand II, King of Galicia-
 León, 40, 70
Févret de Saint Mémin, Charles-
 Balthazar-Julien, 71
Flavius Josephus, 76
Florentine Master, *69*
Focillon, Henri, 13
Fontaner de Glera, monk, *174*
Franco-Apulian stonework, 20,
 21
Frederic I Barbarossa, 42, 57, 58,
 168
Frederic II of Swabia, 126, 127,
 136
French stonework, *54*
French Master (or the Wilton
 House Diptych master), 180,
 181, 182
French or Anglo-Saxon art, *61*
Frugoni, Chiara, 31
Gener, Guerau, *174, 176*
Gentile da Fabriano, *133*, 182
Gerlachus, **34**, 73
German art, *64, 65*
Gerville Duhérissier, Charles de,
 10, 118
Ghiberti, Lorenzo, 141, 158
Gilabertus, 8
Gilduino, *see* Bernardo Gilduino
Gionata, Archbishop, 55
Giottino (Giotto di Maestro
 Stefano), **166**
Giotto, 120, *122*, 128, 130, 131,

138, 139, 142, *144*, 145, 146,
 150–153, 154, 157, 166, 168, 169
Giovannetti, Matteo, 180
Giovanni Pisano, 38, 107, *111*,
 120, 130, **136–137**, 138, 167
Giovannino de' Grassi, *see* De
 Grassi
Gislebertus, **32–33**, 48, 81
Giusto de' Menabuoi, 169
Gofridus, *13*, 20, *21*
Guariento di Arpo, 169
Gudesteiz, archbishop, 40
Guglielmo, **38**, 39
Guillelmus David, 54
Gundulf of Rochester, Bishop,
 93
Gwernerus, Prior, 42
Henry III, emperor, 136
Henry VI, emperor, 126
Hesdin, Jacquemart de, *see*
 Jacquemart de Hesdin
Hippocrates, 174
Honnecourt, de, *see* Villard
Hugo "pictor," 72
Hugo, master, *see* Master Hugo
Hugo, Victor, 116
Huizinga, Johan, 133, 181
Idris, Abu Abdullah Mohammed
 Al, 53
Innocenct III, Pope, 126
Isabel of England, wife of
 Frederic II of Swabia, 127
Isabella Yolanda of Brienne, wife
 of Frederic II of Swabia, 127
Islamic workshop of Palermo,
 14
Jacopo di Cione, called
 "Robiccia," *162*
Jacquemart de Hesdin, 171
Jacques de Baerze, *132*, 171
James the Great, Saint,
 (Santiago), 13, 41, 48, 51, *169*
Jean de Marville, 172
Joele of Casauria, Abbot, 63
John, Saint, Evangelist, 41, 51
Jourdain de Blaye, 182
Kingsley Porter, Arthur, 48
Kubach, Erich, 84
Lanfranco, **28–29**
Le Goff, Jacques, 31, 104
Le Prévost, Auguste, 10
Leonate, Abbot, 52, 53, 75
Leone of Montecassino, *75*
Limbourg, brothers, 172
Limbourg, Paul de, *119*, 172
Limoges art, *17*
Lippi, Filippino, 54
Longhi, Roberto, 42, 146
Lorenzetti, Ambrogio, 97, 98,
 120, 129, 130, 131, **158–161**
Lorenzetti, Pietro, 128–131,
 158–161
Lorenzo de' Medici, *see* Medici
Lorenzo Monaco, *183*
Louis IX, King of France, *112*

Louis VII, King of France, 104, 110
Lower Saxony production,
Ludwig II of Bavaria, 116, *119*
Luffa, Ralph de, 79
Lupi, Bonifacio, Marquis of Soragna, 169
Magister Gregorius, 50, 55
Maitani, Lorenzo, 122, **171**
Mâle, Émile, 48
Malouel, Jean, 133, *180*
Malraux, André, 33
Manfred of Swabia, 126, 127
Marcus Aurelius, 54
Marguerite of Brabant, wife of Henry III, *111*, 136
Mark, Saint, Evangelist, *144*
Martin of Tours, Saint, *63*
Martini, Simone, 130, 131, **154–157**, 158, 180
Martorell, Bernardo, 133
Maso di Banco, 166
Master Francke, *see* Meister Francke
Master Guglielmo, 69
Master Hugo, 72, 73
Master Mateo, 31, **40–41**, 106, *107*
Master Matteo of Pisa, *10*
Master of the "Triumph of Death," 164, *see also* Buffalmacco
Master of the Justice Column, 109
Master of the Trebona altar (or Wittingau Master), 181
Master Teodorico Teofilo (pseudonym of Roger of Helmarshausen), 58, 60, 62, 64, 76
Master Theodoric of Prague, 181
Matieu (or Mathieu) d'Arras, 181
Mauro, Amalfi merchant, 62
McLean, Alick, 178
Medici, Lorenzo de', 98
Meister Francke, *183*
Memmi, Lippo, *155*
Metge, Guillem, *114*
Meuse artist, *57*
Milanesi, Gaetano, **167**
Miró, Joan, 75
Modenese miniaturist, *28*
Montagut, Berenguer de, *114*
Montfaucon, Bernard de, 103
Mozarabic art, 74, 75, 77
Naumburg Master, 109, *110*
Navarro Barrachina, Jaime, 37
Nicholas III, Pope, 144
Nicholas IV, Pope, 170
Nicholas of Mira, (Nicholas of Bari), Saint, 57, 161
Nicholas pilgrim, Saint, 52
Nicholaus, sculptor, 80, *81*, 89
Nicodemo, master, **35**

Nicodemus, disciple of Jesus, 65
Nicola Pisano, 120, **136–137**, 138
Nicolaus de Verdun, **42–43**, 59
Nino Pisano, 107, *108*, 109
Nordic master, *56*
Norman production,
Odalricus of Rheims, Archbishop, 59
Oderisio of Benevento, 62, 63
Orcagna, Andrea, 120, *131*, **162–163**, 168, 170
Otto IV of Braunschweig, *42*
Otto of Cappenberg, 58
Ottonian, Germanic dynasty, 18
Oursel, Raymond, 50
Pace, Valentino, 63
Panofsky, Erwin, 106
Pantaleone, Amalfi merchant, 63
Pantaleone, monk, 55
Paolo Uccello, *150*
Paris, Matthew, 51
Parler, Heinrich, *116*
Parler, Peter, *116*, 181
Parri Spinelli, *see* Spinelli
Pere Ça Anglada, *175*
Peruzzi, Florentine bankers, 151
Peter I of Portugal (Don Pedro), 179
Peter II of Aragon, 127
Petrarch, Francis, 131, 154
Philip the Bold, Duke of Burgundy, 172, 181
Philostrates the Younger, *10*
Picasso, Pablo, 72, 75
Picaud, Aimery, 50, 51
Pier Damiani, *see* Damian, Peter, Saint
Piero di Iacopo, 39
Pietro d'Aragona, master sculptor, 179
Pisanello (Antonio Pisano), 182
Pisano, Giovanni, Nicola, Nino, Tommaso, *see* respective names
Pleydenwurff, Hans, 133
Pliny the Elder, Gaius Plinius Secundus, 74
Plotinus, 101
Prache, Anne, 90
Pseudo-Dionysius (Dionysius Areopagite), 101
Quatremère de Quincy, Antoine Chrysostome, 114
Rainaldo, 25, 38, *52*
Ralph Glaber, 16, 17, 94
Raphael Sanzio, 114
Raymond IV, Count of Saint Gilles, 26
Reichenau *Scriptorium* (Germany), 74, *75*
Reinald of Dassel, Archbishop, 42
Renier de Huy, 62
Rhine art, *see* school, Meuse
Ricchi, Andrea, known as Tafo, 164

Richard II, King of England, 180, *181*
Riedel, Eduard, *119*
Roberto of Anjou, *see* Anjou
Roberto, sculptor, **35**
Roger II, King of Sicily, 126
Roger of Melfi, 63
Rogerio, father of Roberto sculptor, 35
Roman art, **55**
Rosanese dei Negusanti, *see* Blessed Humility
Rosci, Marco, 79
Rusuti, Filippo, 140
Sacchetti, Franco, 133, 139, 164
Sagot, Émile, *90*
San Giorgio Codex Master, 164
Sancha, Queen of Leon, wife of Ferdinand I, 61
School, Aachen, 58
School, Anglo-Norman, *76*, *77*
School, Anglo-Westphalian, 79
School, Beauvais, *60*
School, Cassino, 75
School, Catalan, *68*, *7*
School, Conques, 59
School, French, *59*, *181*
School, German, *78*
School, León, *70*
School, Limoges, *59*
School, Meuse, 59, 62
School, Poitiers, *70*
School, Rhine, 59, 62, *183*
School, Saint Sever, *76*
School, Tuscan, *77*
School, Westphalia, *78*
Scrovegni, Enrico, 153
Serra, brothers (Francisco, Serra, Jaime, Pedro), 174
Serra, Francisco, 174
Serra, Jaime, **174**, 180, *181*
Serra, Pedro, **174**, 175, 180, *181*
Sicilian school, 60
Sluter, Claus, **172–173**
Sot, Michel, 56
Sotio, Alberto, 69
Southern German miniaturist, *19*
Southern Italian miniaturist, 126, *127*
Southern mosaicist, *18*
Spinelli, Parri, 168
Spinello Aretino, **168**
Saint Thierry, Abbot of, 17
Stefano da Verona, *133*
Stefano, pupil of Giotto, 166
Stendhal (Henri Beyle), 118
Suger (or Sugerius) of Saint Denis, Abbot, 18, 58, *98*, 98–104, 106
Tafi, Andrea, *see* Ricchi, Andrea
Tani degli Ubaldini, Francesco, *167*
Terence, Publius Afer, 74
Theodoric of Prague, *see* Master Theodoric of Prague

Tino di Camaino, **167**
Tomaso da Modena, 181
Tommaso Pisano, 107
Torriti, Iacopo, 140
Tudela, Benjamin de, 50, 55
Tuscan art, *64*
Tuscan artist, *17*
Tuscan marble-worker, 20
Urban II, Pope, 26, 57
Urraca, wife of Ferdinand II of Leon, 70
Uta, wife of Margrave Ekkehard, 109, *110*
Valois, Marie de, *167*
Van Eyck, Jan, 160
Vasari, Giorgio, 39, 114, 138, 142, 146, 154, 158, 159, 161, 164, 167
Victor III, Pope, *see* Desiderius
Villard de Honnecourt, *179*
Viollet-le-Duc, Eugène Emmanuel, 116, *119*
Virgil, Publius Maro, 74
Visij Brod (or Hohenfurt) Master, 181
Vuiligelmo, 29, **30–31**, 44, 81
Walpole, Horace, 116
Warenne, William of, Duke of Surrey, 85
Werl, Heinrich von, Bishop of Paderborn, 78
Yves of Chartres, Bishop, *60*

Index of Places

Aachen (Rheinland-Westphalia), 126
Abruzzo, 35, 52–53
Africa, 60
Alcobaça (Portugal), abbey church of Santa Maria, 179
Amalfi (Salerno, Campania), 61 duomo, 62
Amiens (Somme), 103, 109
Angoulême (Charente), Saint-Pierre, 53
Apulia, 52–53, 83, 126–127,
Aquitaine, 81
Arezzo (Tuscany), 168 San Domenico, *143* Santa Maria, *128*
Arles (Bouches-du-Rhône), 20 Saint-Trophime, *11*, 85
Arnstein-an-der-Lahn (Middle Rheinland), abbey, 34
Arras (Artois), *182*
Assisi, 154 basilica of Saint Francis, 142, *144*, 150, *157*, 158
Aunis (Saintonge), Notre-Dame de Surgères, *54*
Auvergne, 49, 65, 90
Auros (Pallars Sobirà, Cataluña), 68

Austria, 16
Autun (Saône-et-Loire),
 Musée Rolin, 32
 Musée Salle capitulaire, 33
 Saint-Lazare, 32, 33, 48, 81,
 88, 92
Avignon (Vaucluse, Provence),
 154, 181
 Palais des Papes, 181
Bamberg (Bavaria),
 cathedral, 110, 112, 113
 Historisches Museum, 112
Barcelona, 174, 175
 Museu Frederic Marès, 37
 Museu Nacional d'Art de
 Catalunya, 20, 22, 65, 68, 71,
 174, 175, 180, 181
 Santa María del Mar, 114
Bari (Apulia), 49, 52
 San Nicola, 83
Batalha (Portugal),
 Santa María da Vitória, 116
Bayeux (Calvados), 14
 Musée de la Tapisserie, 16
Bergamo,
 Biblioteca Municipale, 180, 181
Berlin, ex Kaiser-Friedrich
 Museum, 34
Berzé-la-Ville (Saône-et-Loire,
 Burgundy), 71
Blois (Loir-et-Cher), 16
Bohemia, 131, 180, 181
Bologna, 169
Borgo San Donnino (Fidenza,
 Parma), 44
Borgo San Lorenzo (Florence),
 150
Borgund (Norway), 95
Boston (Mass.),
 Isabella Stewart Gardner
 Museum, 80
Boulou (Aude), 367
Bourgueil (Indre-et-Loire), 66
Brindisi (Apulia), 52
Brunswick (Lower Saxony),
 Sankt Blasius, 65
Brussels (Belgium), 172
Buonconvento (Siena), 167
Burgundy (France), 13, 49, 93,
 171, 172, 181, 182
Byzantium, 59, 76, 86, 87
Cagliari, 38
 Santa Maria di Castello, cathe-
 dral 38
Cairo, 86
Cambridge (England),
 Corpus Christi College, 51, 72
 Fitzwilliam Museum, 37
Campania, 61
Campiglia Marittima (Livorno),
 San Giovanni, 10
Canosa di Puglia (Bari), 83
 Bohemond's mausoleum, 63
Canterbury (England), 72, 73
 Cambridge University Library,

Christ Church, 76
Cathedral, 72
Capitanata, see Apulia
Cappenberg (Rheinland-
 Westphalia),
 collegiate of San Giovanni, 58
Carcassonne (Aude), 119
Casauria (Torre dei Passeri,
 Pescara), see San Clemente
Castel del Monte (Andria, Bari),
 126, 127
Castelfiorentino (Florence)
 Pinacoteca, 144, 146
Castellappiano (Bolzano), 73
Castile (Spain), 79
Castle Acre (Norfolk), 84, 85
Cataluña, 8, 65, 68, 174–175, see
 also Catalan art
Champmol, see Dijon
Chantilly (Oise),
 Musée Condé, 119, 179
Chartres (Eure-et-Loire), 18,
 109
 Notre Dame, 100, 102, 104,
 105, 106, 179
Chauvigny (Vienne), 20, 21
 collegiate church of Saint
 Pierre, 13
Chichester (Sussex),
 Cathedral, 79
Citeaux (Côte-d'Or), 17, 93
Cividale (Friuli Venezia Giulia),
 Museo Archeologico
 Nazionale, 75
Clairvaux (Aube, France), 17, 90
Clavijo (Navarre), 51, 132, 134
Cluny (Saône-et-Loire), 10, 13,
 17, 26, 49, 50, 71, 80–81, 85, 90,
 92
 Musée Lapidaire, 80
Coira (Grisons), see Saint-
 Martin in Zillis
Colle di Vespignano (Vicchio,
 Florence), 150
Colle val d'Elsa (Florence), 138
Cologne (Rheinland),
 cathedral, 42, 43, 115
Como, Lake, 44
Compostela, see Santiago de
Conisborough (Doncaster,
 Yorkshire), 94
Conques-en-Rouergue
 (Aveyron), 59
 Sainte Foy, 17, 48, 51
Cordova (Andalusia), 86
Corneilla-de-Conflent
 (Roussillon, Pyrénées
 Orientales), 64
Constantinople, 62, see also
 Byzantium
Courtrai, Kortrijk in Flemish
 (Western Flanders, Belgium), 171
Cuenca (Castilia-La Mancha),
 Museo Diocesano Catedralicio,
 15, 56

Cugnoli (Pescara), 35
Dijon (Côte-d'Or), 172
 Charterhouse of Champmol,
 132, 171, 179, 183
 Musée des Beaux-Arts, 132,
 171, 172–173
Durham (County Durham),
 cathedral, 13, 46
Emilia Romagna, 81, 89
England, 14, 61, 64, 67, 73, 76,
 85, 112, 116, 131, 183
Errondo (Navarre), 37
Ferrara, 17, 81
Flanders, 171, 172, 181
Florence, 69, 124, 129, 151, 158,
 162, 166, 167
 Baptistery, 29, 39, 67, 69, 142
 Biblioteca Medicea
 Laurenziana, 77
 cathedral campanile, 122
 Uffizi Gallery, 69, 97, 98, 130,
 133, 145, 146, 147, 152, 155,
 159–161, 162, 166, 183
 Galleria dell'Accademia, 162
 Museo dell'Opera del duomo,
 139
 Museo Diocesano di Santo
 Stefano al Ponte, 150, 158
 Museo di Santa Croce, 131,
 143, 162
 Museo Bardini, 167
 Museo Nazionale del Bargello,
 59, 60, 61, 112
 Ognissanti, 152
 Oratorio dell'Antella (Ponte a
 Ema), 168
 Orsanmichele, 162
 Palazzo dei Priori (or Palazzo
 della Signoria, or Palazzo
 Vecchio), 138, 178
 Piazza della Signoria, 178
 San Miniato al Monte, 20, 85,
 168
 San Procolo, 161
 San Remigio, 166
 Santa Croce, 124, 125, 131,
 138, 142, 151, 162
 Santa Maria del Fiore,
 cathedral, 122, 138, 139, 162
 Santa Maria Novella, 146, 152
 Santa Trinita, 145
Fontenay (Cote-d'Or,
 Burgundy), 93
Fonthill (Wiltshire), 116
Fossanova (Latina, Latium), 122
France, 16, 49, 66, 85, 87, 89, 90,
 107, 112, 116, 131, 158, 180,
 181, 182, 183
Frankfurt-am-Main , 126
Freudenstadt (Baden-
 Württemberg),
 Alpirsbach monastery, 64
 Stadtkirche, 64
Galicia, see Santiago de
 Compostela

Genoa, 44
 Museo di Sant'Agostino, 111,
 136
Germany, 16, 18, 49, 62, 65–67,
 78–79, 90, 116, 126, 131, 180,
 see also German art
Gerona (Cataluña), 37, 175
Gropina (Arezzo),
 San Pietro, 17, 83
Guardiagrele (Chieti), 35
Gubbio (Perugia),
 Palazzo dei Consoli, 178
Haarlem (Netherlands), 172
Halberstadt (Saxony-Anhalt), 83
 Liebfrauenkirche, 78
Helmarhausen (Rheinland), 58
Helsinki,
 Museo Kansallis, 183
Hesdin (Artois), 171
Hildesheim (Lower Saxony), 78
 cathedral, 175, 176
 San Michele, 12, 68, 92
Holy Land, 48, 50–51, see also
 Jerusalem
Horn (Detmold, Rheinland-
 Westphalia), 78
Hungary, 169, 179
India, 60
Intelvi, Valley (Como), 44
Italy, 10, 67, 76, 77, 85, 89, 107,
 180
Jaca (Aragon), 26
 San Pedro, 16
Jerusalem, 13, 28, 48, 49, 51, 78,
 91
Jumièges (Seine-Maritime,
 Haute-Normandie),
 Notre-Dame, 8, 9
Karlstein, see Prague
Klosterneuburg (Vienna),
 abbey church, 42, 43
Laon (Aisne, France),
 Notre-Dame, 117
Le-Puy-en-Velay (Haute-Loire),
 64
 Musée Crozatier, 55
 Saint-Miguel de l'Aguilhe, 50
Lausanne, 17
Lesina (Foggia), Lake, 53
Lewis (Surrey), 85
Liegi (Belgium), 62
Liguria, 44
Lille (Nord-Pas-de-Calais,
 Picardy), 171
Loches (Indre-et-Loire,
 Touraine), 94
Lom (Norway), 95
Lombardy, 73, 89, 124, 182
London,
 The National Gallery of Art,
 162, 180, 182–183
 Strawberry-Hill, 116
 The Victoria & Albert
 Museum, 61, 102
 White Tower, 193

Lower Saxony, 62, 175, *176*
Lucca, 24, 65, 69
 Biblioteca Statale, *19*
 San Frediano, 36
 San Martino, *64*
Lusignan (Poitou), *119*
Madrid,
 Museo Arqueológico Nacional,
 61
 Museo della Fondazione
 Lázaro Galdiano, *17*
Mainz (Rheinland-Pfalz), *91*,
 109, 126
Manfredonia (Foggia, Apulia),
 52
Manresa (Barcelona), 174
Massa Marittima (Grosseto),
 Museo Archeologico, *158–159*
Meissen (Saxony), 109
Metz (Moselle), 109
Middle East, 76
Milan, 42, 169,
 Biblioteca Ambrosiana, 154
 Duomo, 124
 Sant'Ambrogio, *82, 88*
Modena, 28–29, 30–31, 44
 Archivio capitolare, *28*
 Duomo, 28, 29, 30, *31*, 90
Moissac (Tarne-et-Garonne),
 Saint-Pierre, 26, 79, *80*, 81
Monreale (Palermo), 63
 Duomo, 39, 66, *67*
Montalcino (Siena),
 Sant'Antimo, 36, 37
Monte Sant'Angelo (Foggia,
 Apulia), 36, 52, 53, 62, *63*
Montecassino (Frosinone), 10,
 18, 62, *75*, *82*
Monteriggioni (Siena), *118*
Mont-Saint-Michel (Manche,
 Lower Normandy), *50*
Moscufo (Pescara), 35
 Santa Maria del Lago, *35*
Münster (Westphalia), 34
 Westfalisches Landesmuseum,
 34
Naples, 138, 140, 151, 154, 167
 duomo, *140*
 Santa Chiara, *167*
 Santa Maria Donnaregina, 140
Narbonne (Aude), , 26
Naumburg (Saxony-Anhalt), 109
 Saint Peter und Paul, cathedral,
 110
Neuschwanstein (Füssen,
 Bavaria), *119*
New York,
 The Metropolitan Museum of
 Art, 59
 The Cloisters Museum of
 Medieval Art, 37, 38, 80, *182*
Nuremberg (Bavaria),
 Frauenkirche, *116*
Normandy, 8
Norway, 61, 94

Norwich (East Anglia), *91*
Noyon (Oise), 109
Orvieto (Terni, Umbria), 103,
 120, 139, 154, 162, *163*, 170
 Santa Maria Assunta in Cielo,
 cathedral, *122, 124, 133,*170
Otranto (Lecce, Apulia), 49, 52
 Cathedral, 55, 67
Oxford (England),
 Bodleian Library, 73, 77
Paderborn (Westphalia), 78
Padua, 151, 169
 Arena (or Scrovegni) chapel,
 131, 151, 152, *153*
 basilica del Santo, 132, *134*, 169
 Museo Civico, *182*
 San Giorgio oratory, 169
Palermo, 24, 39, 61, 67
 Palatine chapel, 66, 69
 San Cataldo, *87*
Paris, 58, 103
 Bibliothèque Nationale, *76,
 112, 179,* 180, *181*
 Musée du Louvre, *57, 60, 61,
 98, 99,*100, *150, 180, 183*
 Palais de la Cité, *179*
 Sainte-Chapelle, *179*
Parma, 44
 Baptistery, 44
 Duomo, *44, 45,* 83
Perelada (Cataluña),
 Museo de Castillo, *36, 37*
Périgueux (Dordogne),
 Saint-Front, 87
Perugia, 138
 fountain, 136
 Galleria Nazionale
 dell'Umbria, *138*
Pisa, 20, 24, 38, 39, 69, *136*, 137,
 142, 154, 167, 168
 baptistery, 136
 campanile (or Leaning Tower),
 24–25
 cemetery, *86,164–165, 167*
 duomo, 20, *24–25,* 29, 38, *39,*
 62, 86, 87, *136–137,* 167
 Museo dell'Opera Primaziale,
 38, 52
 Museo Nazionale di San
 Matteo, *108,* 109
 San Nicola, *25*
 Santa Maria della Spina, 109
Pistoia, 24
 Sant'Andrea, 136
Poitiers (Vienne),
 Notre Dame la Grande, *12, 84,
 85,* 86
Pomposa (Ferrara),
 Santa Maria, 8, *9*
Ponte a Ema, *see* Florence
Pontevedra (Galicia), 40
Portugal, 122, 179, 180
Prague (Bohemia, Czech
 Republic), 181
 Karlstein, castle, 181

Narodni Galerie (national
 gallery), *183*
Provence 20, 44
Puente la Reina (Navarre), *50*
Ravello (Salerno),
 Duomo, 39, *63*
Reichenau (Baden-
 Württemberg), 74
Rheims (Marne), 43, 103
 Notre-Dame, 107, *117, 179*
 Palais du Tau, *59*
Rieux-Minervois (Aude), 37
Rimini (Emilia Romagna), 151
Ripoll (Gerona, Cataluña),
 Santa Maria, 89, *91*
Rome, 18, 20, 24, 35, 48, 50, 51,
 72, 139, 140, 142, 144, 151, 178
 Saint Peter's basilica, 90
 Biblioteca Apostolica Vaticana,
 126, *127*
 Campidoglio, 54
 Laterano, piazza del, 35, 54,
 55
 Musei Capitolini, 55
 Pantheon, 86
 San Clemente, 66
 Santa Cecilia in Trastevere, 140,
 141
 Santa Maria sopra Minerva, *54*
Rosciolo (L'Aquila),
 Santa Maria in Valle Porclaneta,
 35
Saint-Albans (London),
 Monastery, 51
Saint-Béat (Haute-Garonne), 26
Saint-Denis (Ile-de-France), 66,
 98, 100, 102, 103, 104, 107, 112
Saintes (Saintonge), 54
Saint-Gilles-du-Gard
 (Camargue, Provence), 20
Saint-Hilaire (Aude), 37
Saint-Martin in Zillis (Coira,
 Switzerland), 68
Saint-Martin-du-Canigou
 (Pyrénées Orientales), 8
Saint-Maurice d'Augune (Valais,
 Switzerland), *56, 58*
Saint-Michel-de-Cuxa (Pyrénées
 Orientales), 20, *21*
Saint-Papoul (Aude), 37
Saint-Savin-sur-Gartempe
 (Vienne), *70, 71*
Salerno (Campania), 20, 61
 Cathedral, *82*
Salisbury (Wiltshire), 103
Salzburg (Austria),
 cathedral, *101*
San Casciano Val di Pesa
 (Florence),
 Museo di Arte sacra, *36, 37*
 Oratory of Pieve Vecchia di San
 Leonardo in Sugana, 36
San Clemente a Casauria (Torre
 dei Passeri, Pescara), *52, 53, 63,*
 75, 88

San Clemente al Vomano
 (Teramo), 35
San Clemente di Tahull (Lérida,
 Cataluña), 20, 22, 71, 72
San Demetrio Corone (Cosenza,
 Calabria), *18*
San Galgano (Siena), 122
San Gimignano (Siena), *118*
San Leonardo di Siponto
 (Foggia, Apulia), *53*
San Millan de la Cogolla (Leon),
 61
Santes Creus (Alt Camp,
 Tarragona), *175–175*
Sant Pere de Rodes (Cataluña),
 36, 37
Sant'Isidoro di León (Castilia-
 Leon), *70*
 Palatine chapel, 61
Santiago de Compostela
 (Galicia), 13, 31, 40, 48, 49–51,
 89, 92
 cathedral, 40, *41,* 49, *107*
Santo Domingo de Silos
 (Castilia-León), 79
Sardinia, 24
Sarzana (La Spezia), *51,* 69
Scandinavia, 16, 60, 61, 95
Seu d'Urgell (Cataluña),
 Museo diocesano, 74
Seville (Spain), 174
Sicily, 14, 126–127
Siena, 120, 124, 137, 146, 154,
 158, 167, 168, 170
 Museo dell'Opera del duomo,
 146, *148–149*
 Ospedale (or Spedale) di Santa
 Maria della Scala, 158
 Palazzo Pubblico, *120, 129,
 156–157,158, 168*
 Santa Maria Assunta, cathedral,
 121, 122, 123, 136, 146, 148,
 149, 155, 160
Sijena (Huesca, Aragon), 174
Silos, *see* Santo Domingo de
Siponto, *see* San Leonardo di
Solignac (Haute-Vienne), 87
Solothurn (Switzerland),
 Kunstmuseum, *183*
Souillac (Haut-Quercy), 87
Spain, 49, 60, 67, 75, 89, 107,
 112, 122, 131, 175, 180
Speyer (Rheinland-Pfalz), 90, *91*
Spoleto (Perugia), 69
Strasburg (Alsace-Lorraine), 103
 Frauenhaus Museum, *109*
 Notre-Dame, *106,* 109, *114*
Susa, *see* Val di Susa
Switzerland, 16
Syria, 86
Tahull, *see* San Clemente de
Tarragona (Cataluña, Spain),
 Museo Diocesano, 174, *175*
Torcello (Venice),
 cathedral, *67*

Toulouse (Haute-Garonne),
 Musée des Augustins, 8
 Saint-Etienne, 8
 Saint-Sernin, 26, 27, 48, 82, *86*
Tournai (Belgium), 43
Tours (Indre-et-Loire),
 Saint-Martin, 51
Trani (Bari), cathedral 63
 San Nicola Pellegrino, 20, *21*,
 39, *52*
Trebona (Bohemia, Czech
 Republic), 181, 183
Troia (Foggia),
 Santa Maria Assunta, cathedral,
 7, 62, 63

Tuscany, 164, 168
Urnes (Norway), 95
Val di Susa (Piedmont),
 Sacra di San Michele, *51*
Valencia (Valencia, Spain), 175
Valladolid (Castilia-Leon),
 Biblioteca Universitaria, *74*
Vauclair, Molompize (Auvergne),
 64
Venice, 53, 169
 Palazzo Ducale, 119, *124*
 Saint Mark's Basilica, 24, 67, 87,
 90, 119, *124*
Vercelli (Piedmont),
 Sant'Andrea, 124

Verona, 17, 169
 Arche Scaligere, *178*
 Museo di Castelvecchio, *133*
 San Zeno, 80, *81, 89*
 Santa Anastasia, 169
Vézelay (Yonne), 89
 Sainte-Madeleine, 51, *80*, 81,
 88, 92
Via Francigena (or Romea), 51
Vic (Cataluña),
 Museo Episcopal, 68
Vicenza, 31
Vienna,
 Kunsthistorisches Museum, *14*
Vieste (Foggia, Apulia), 52

Visji Brod (Bohemia, Czech
 Republic), 181
Washington (DC)
 The National Gallery of Art,
 100
Wells (Somerset), *115*
Worms (Rheinland-Pfalz), *91*
Ypres (Belgium), 171
Zaragoza (Spain), 68
 Museo Municipal, 174
Zillis, *see* Saint-Martin in,

Photographs